Everybody's born with some different thing at the core of their existence. And that thing, whateve
it is, becomes like a heat source that runs each person from the inside. I have one too, of course
Like everybody else. But sometimes it gets out of hand. It swells or shrinks inside me, and it shakes
me up. What I'd really like to do is find a way to communicate that feeling to another person.

Haruki Murakami, *The Wind-up Bird Chronicle*

First published in the United Kingdom in 2008 by
Dewi Lewis Publishing
8 Broomfield Road, Heaton Moor
Stockport SK4 4ND, England
www.dewilewispublishing.com

The quote by Haruki Murakami is from *The Wind-up Bird Chronicle* (Vintage, 1997) and is reproduced by permission of the publishers.

ISBN: 978-1-904587-68-2

Layout: Per Folkver and Jacob Aue Sobol
Repro: Rune Pedersen, Mathias Frøslev Holm, Jacob Aue Sobol
Design: Dewi Lewis Publishing
Print: EBS, Verona, Italy

www.europeanphotopublishers.eu

Winner of the 2008 Leica European Publishers Award for Photography

The Jury comprised the seven publishers:
Benoît Rivero (Actes Sud, France)
John Demos (Apeiron, Greece)
Günter Braus (Edition Braus, Germany)
Dewi Lewis and Caroline Warhurst (Dewi Lewis Publishing, United Kingdom)
Andrés Gamboa and Javier Ortega (Lunwerg Editores, Spain)
Mario Peliti (Peliti Associati, Italy)
Maarten Schilt (Mets & Schilt, The Netherlands)

The external judge was Greg Hobson (Curator of Photography, National Media Museum, Bradford, UK) and David Bell (Managing Director, Leica Camera Ltd, UK) represented Leica.

Jacob Aue Sobol I, Tokyo

dewi lewis publishing

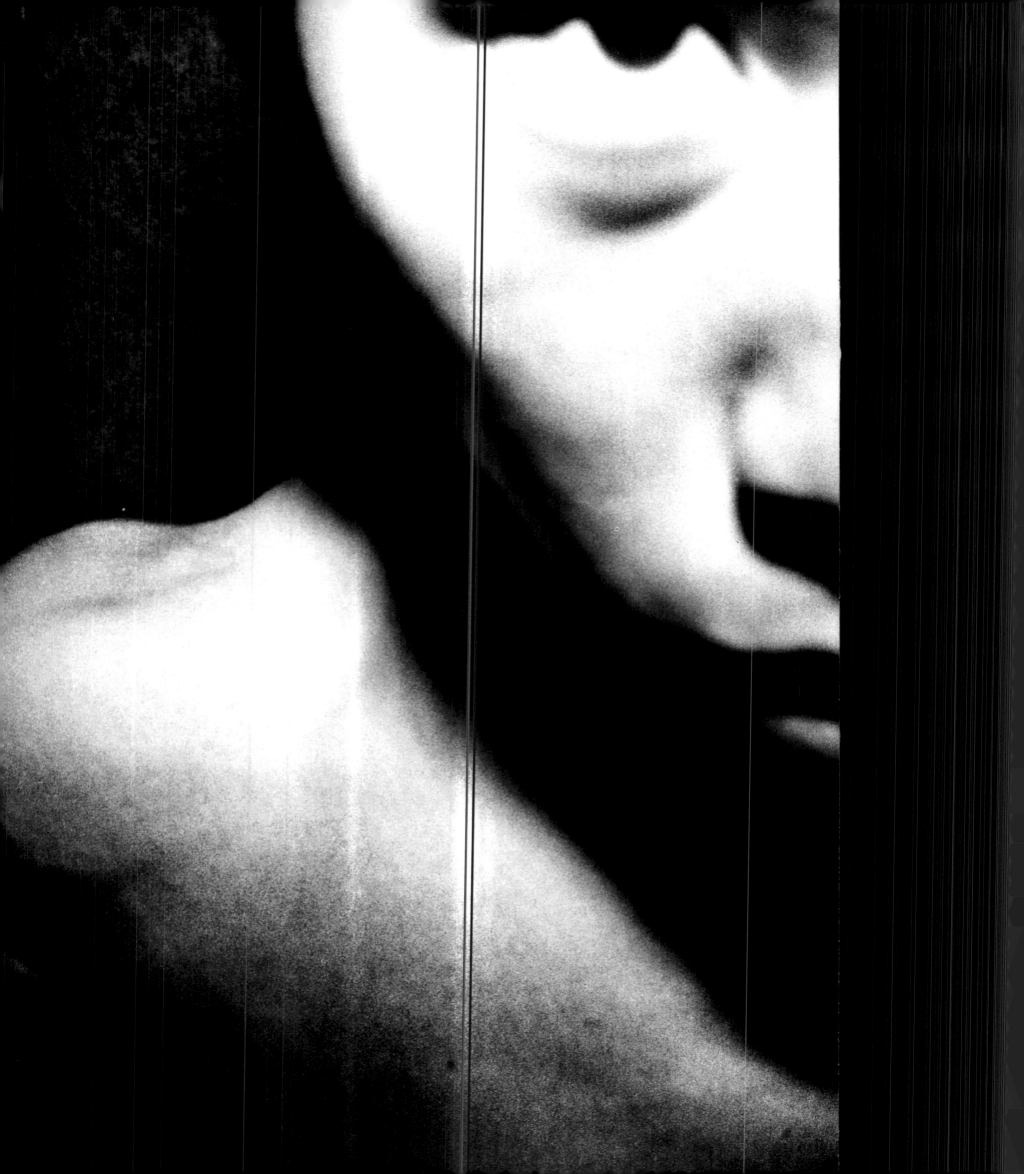

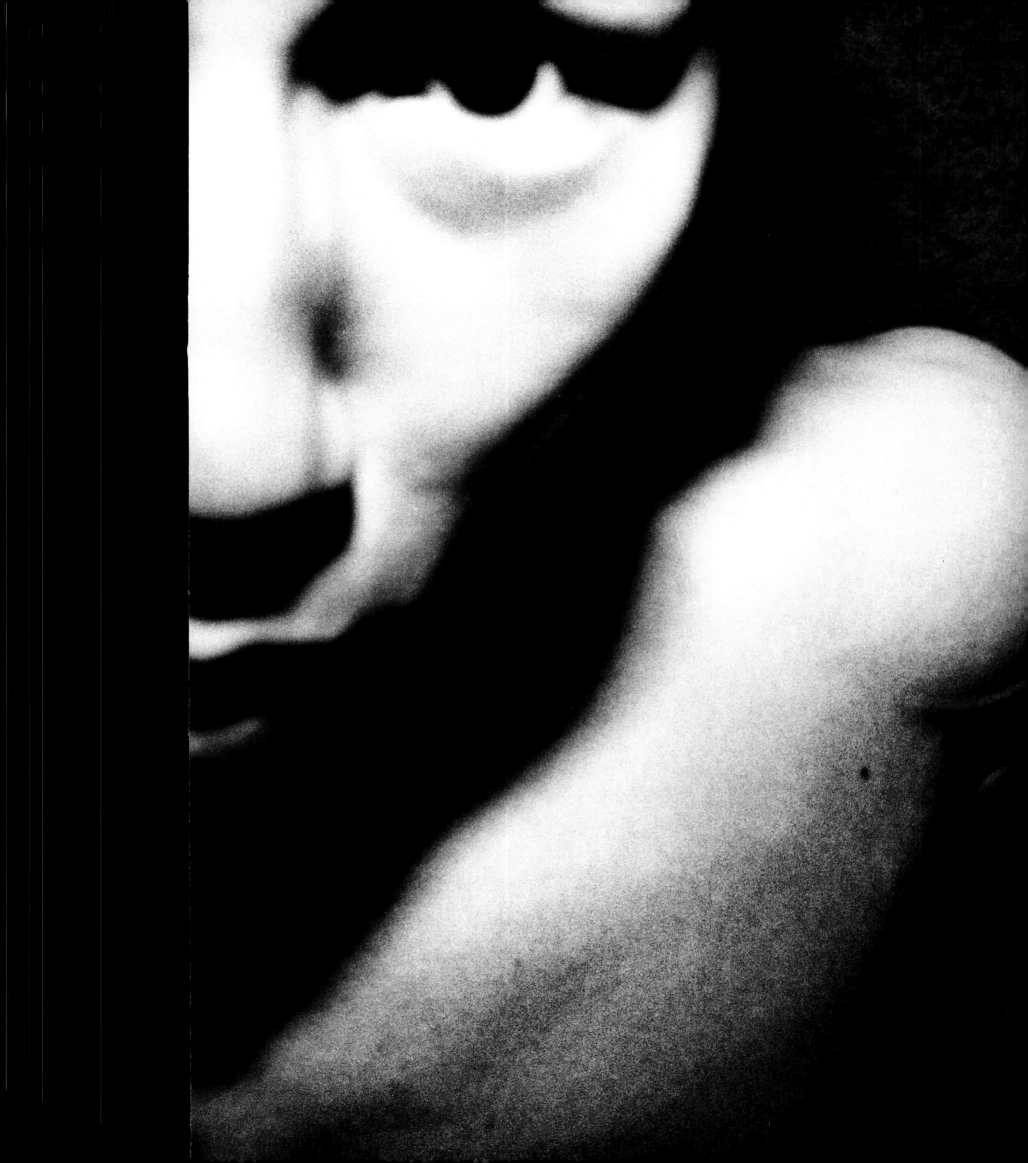

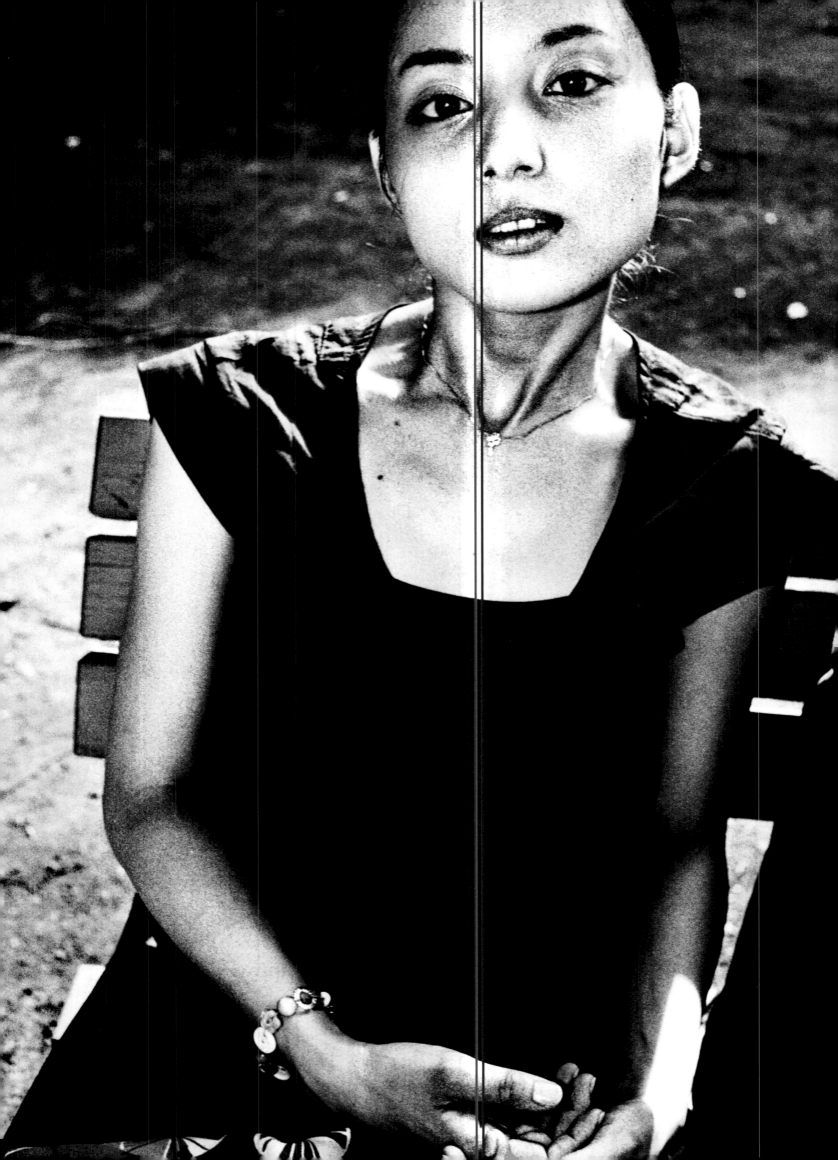

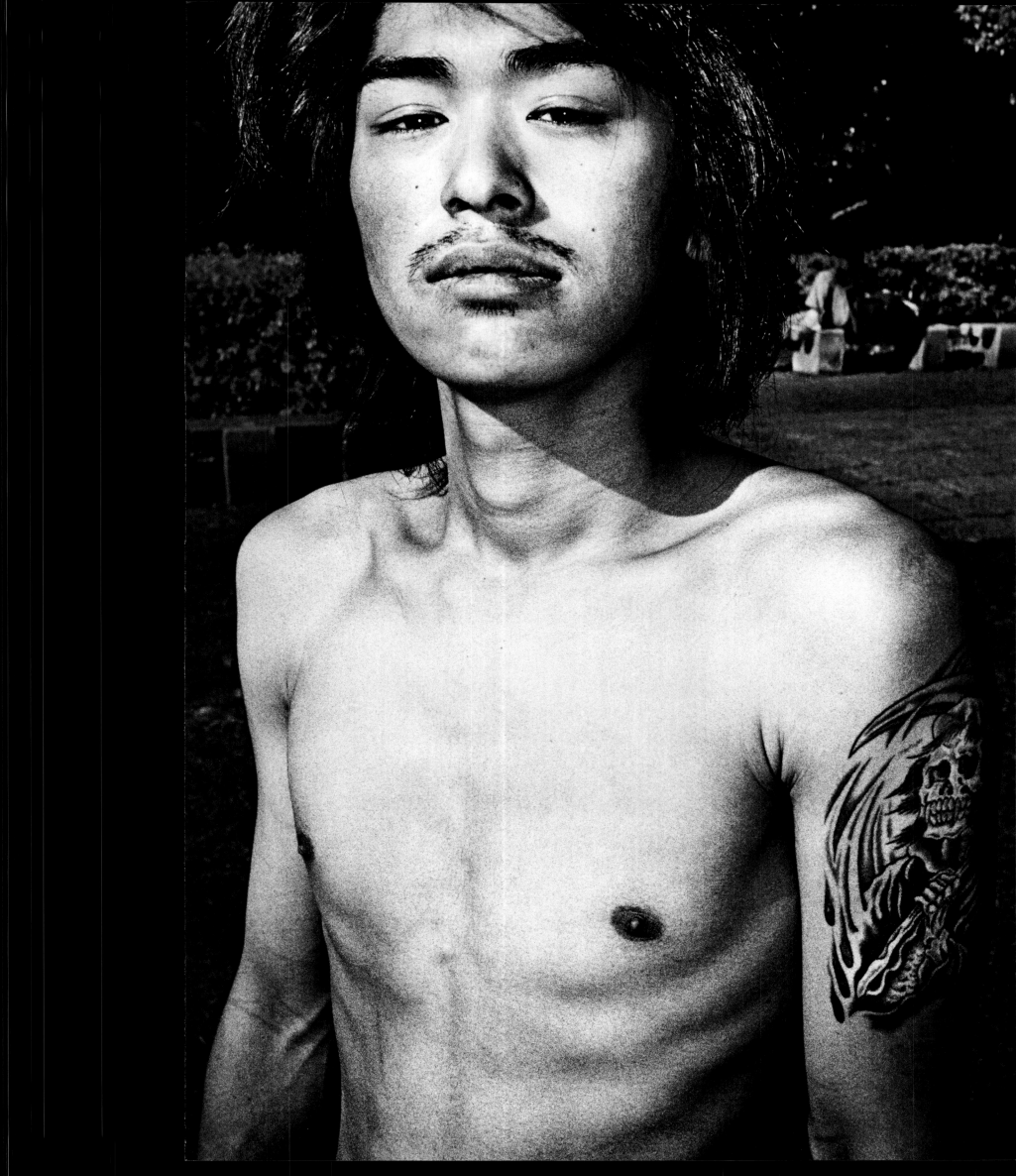

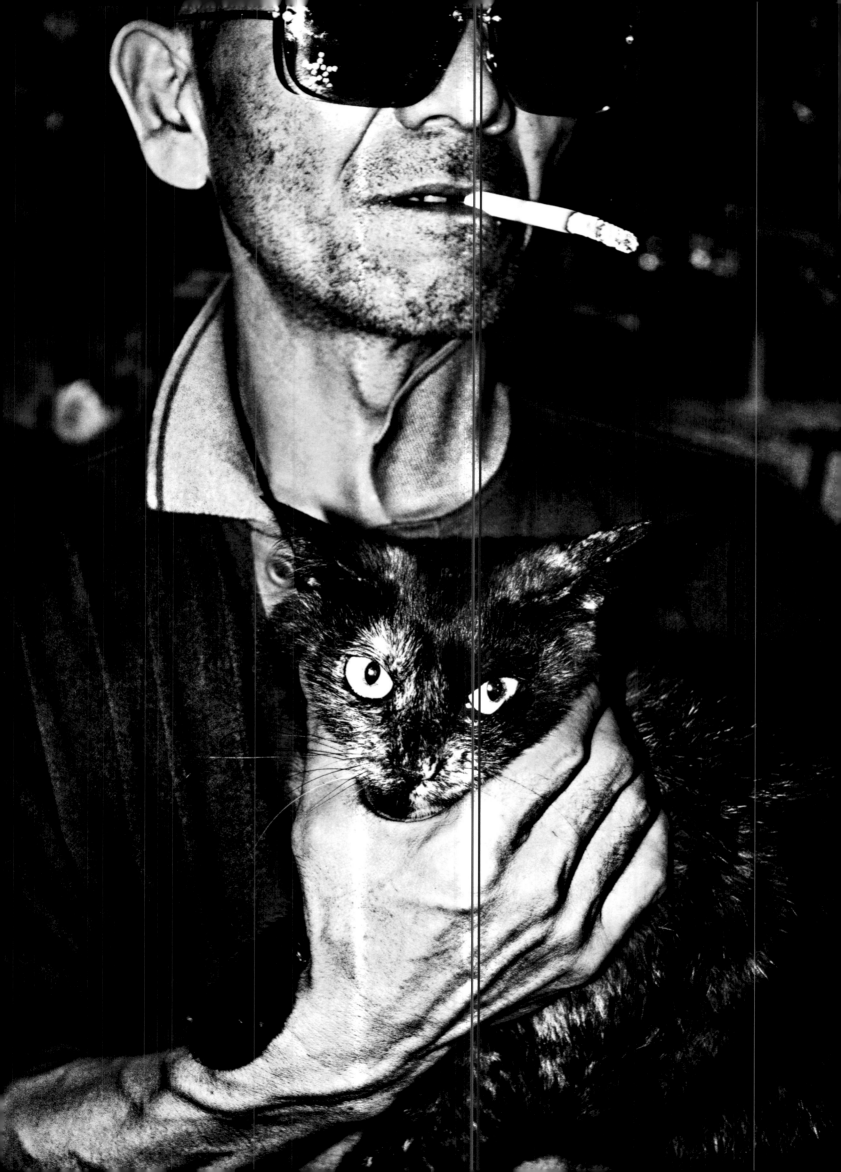

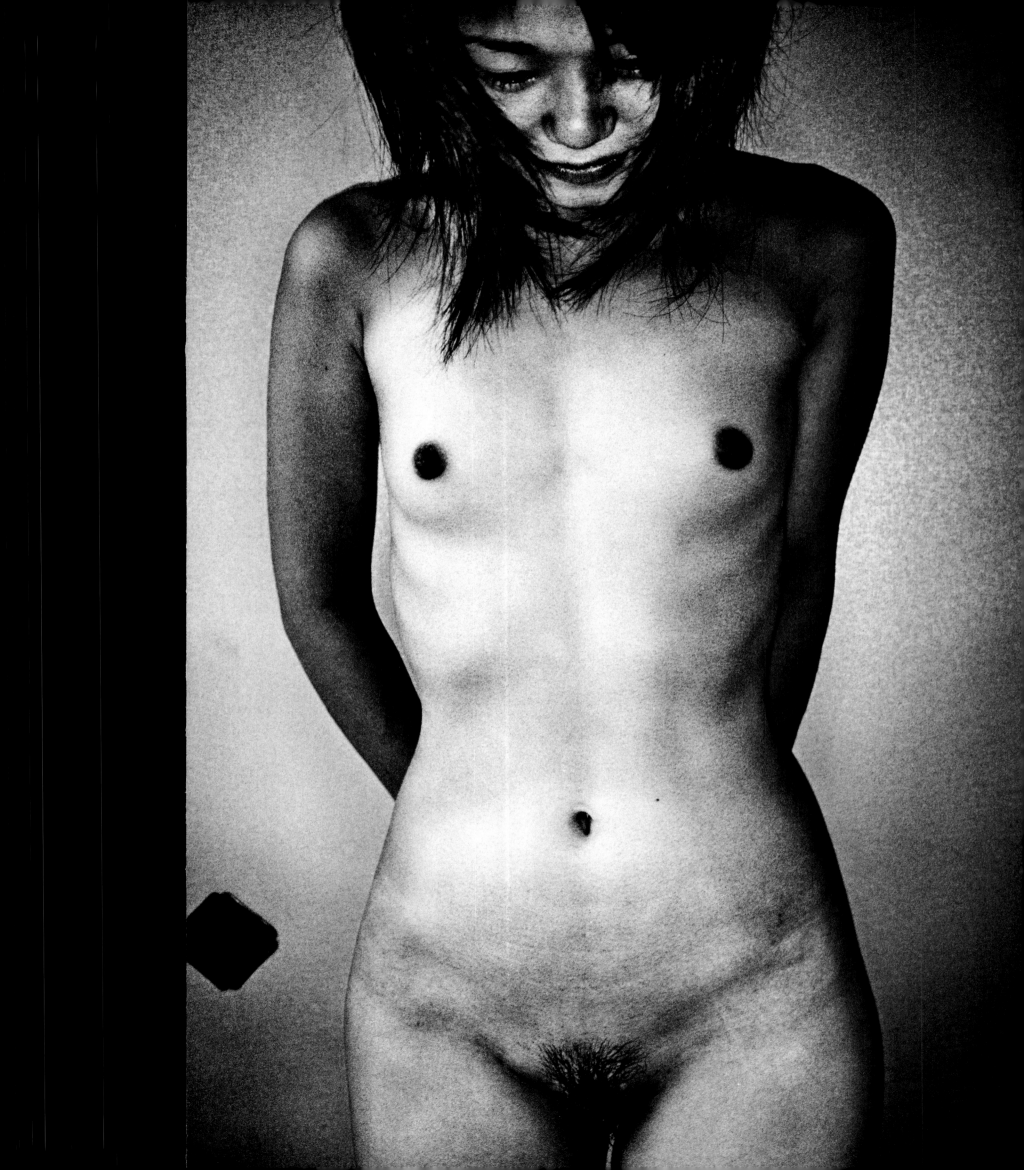

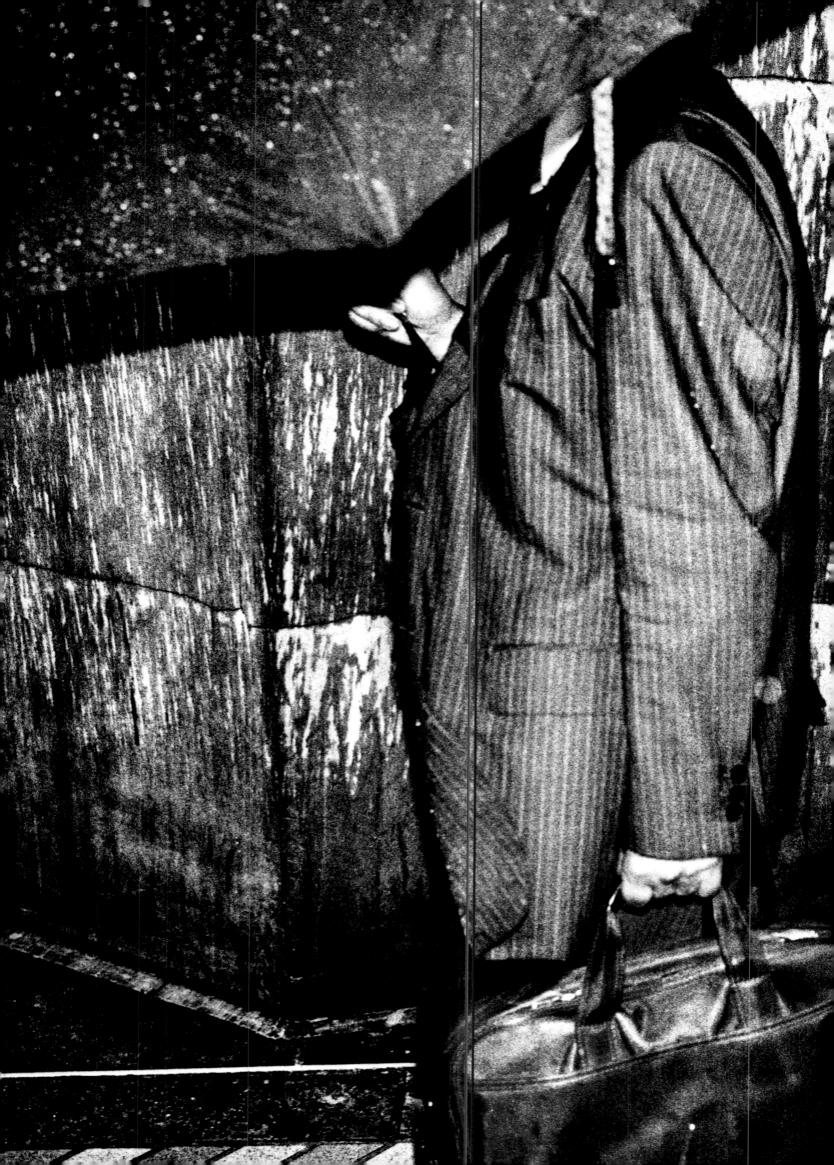

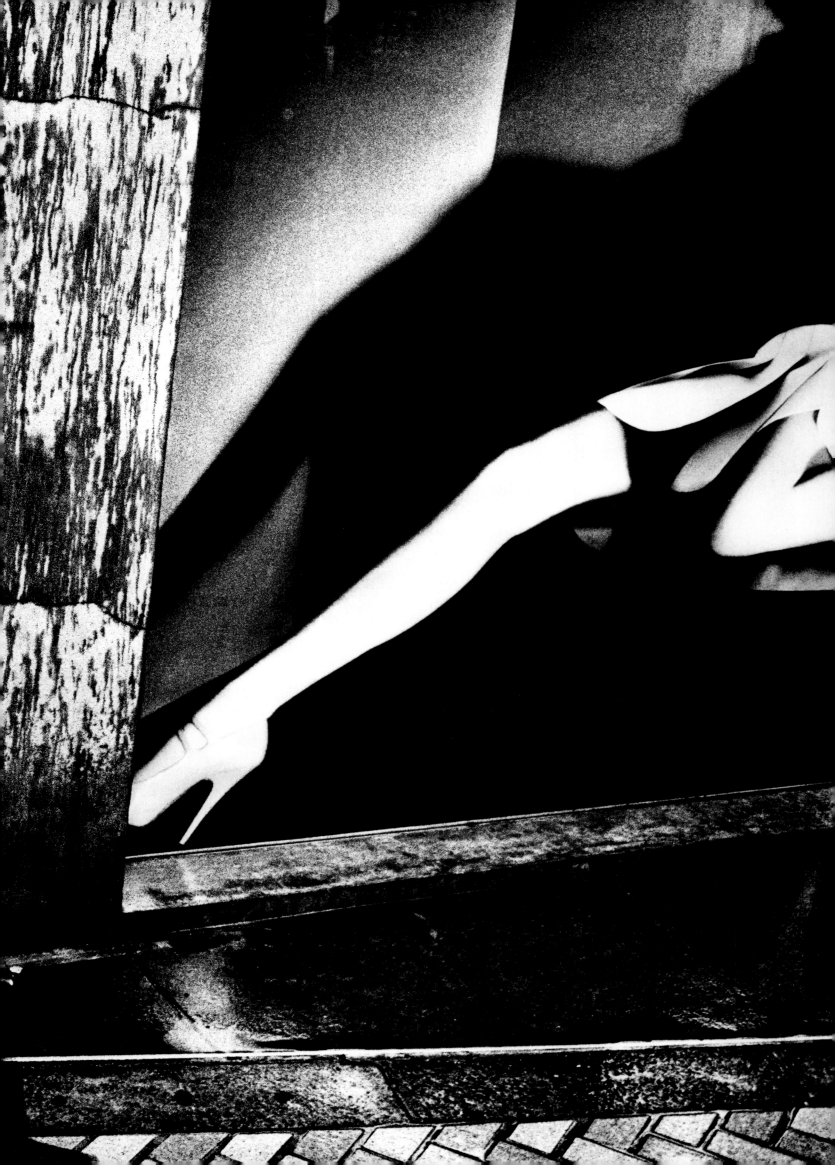

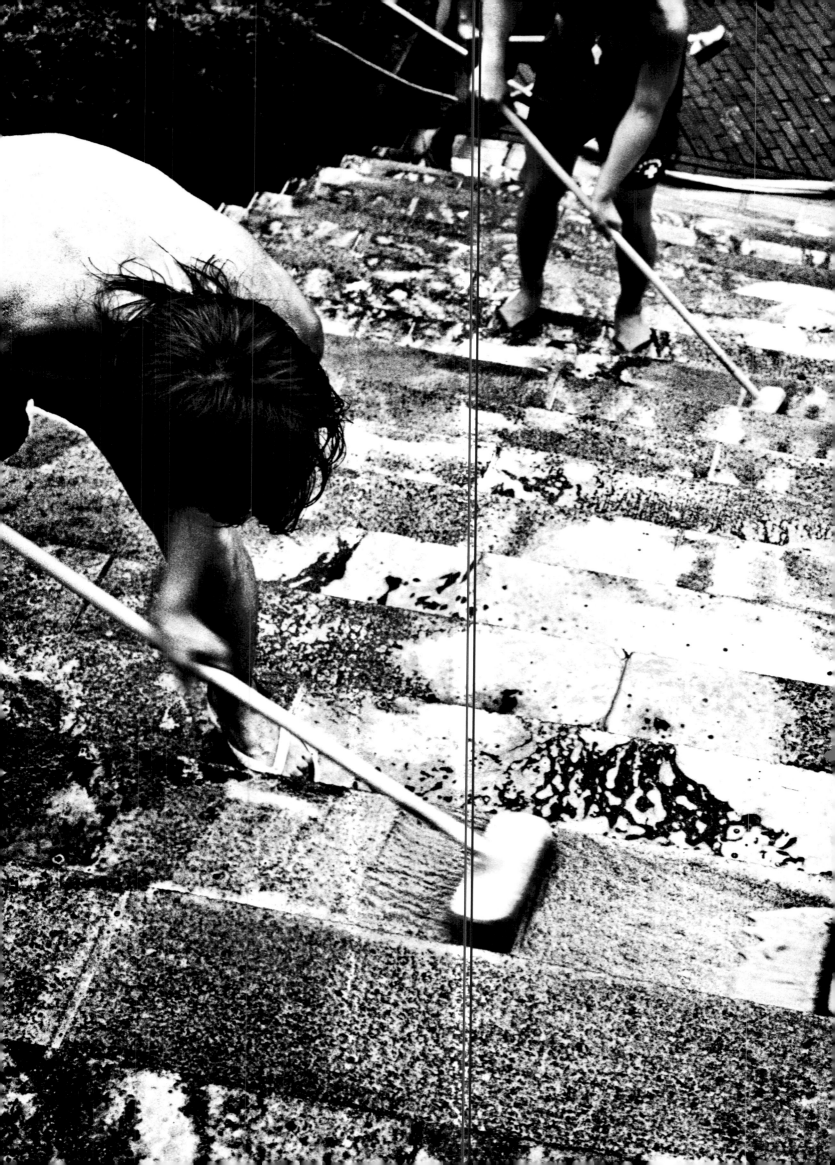

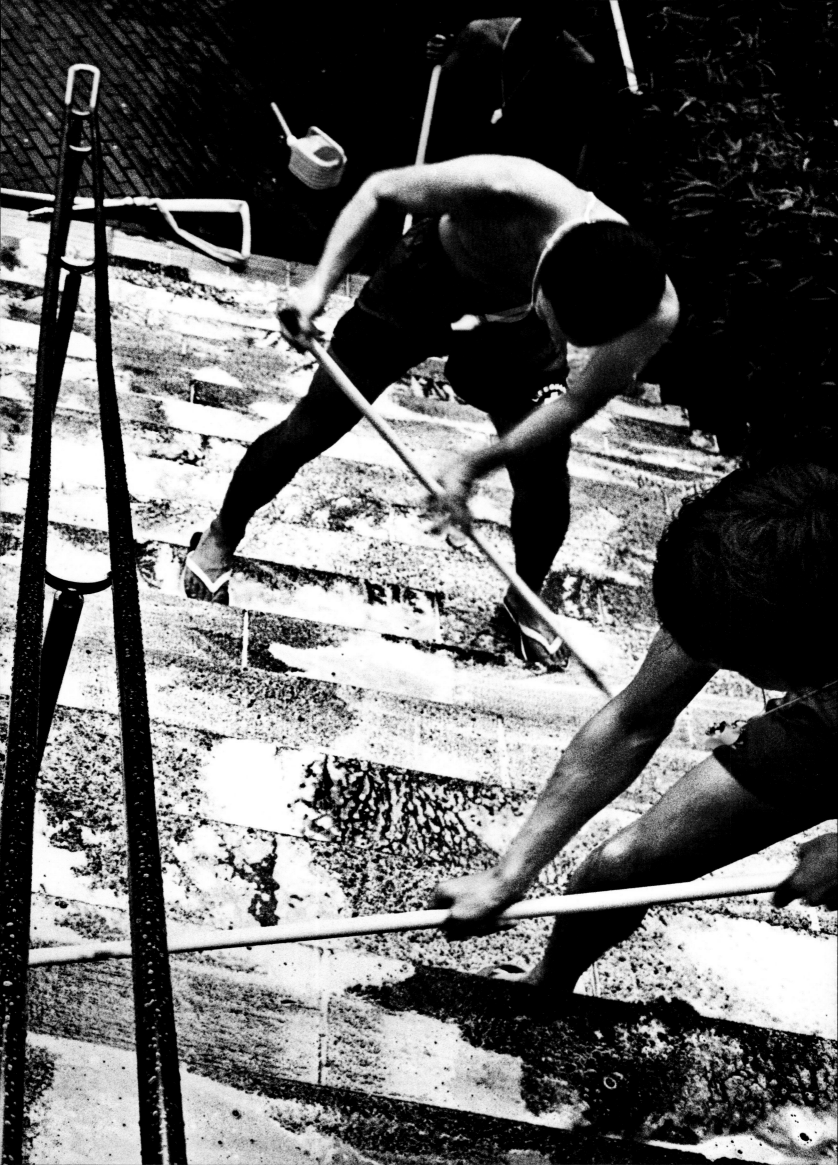

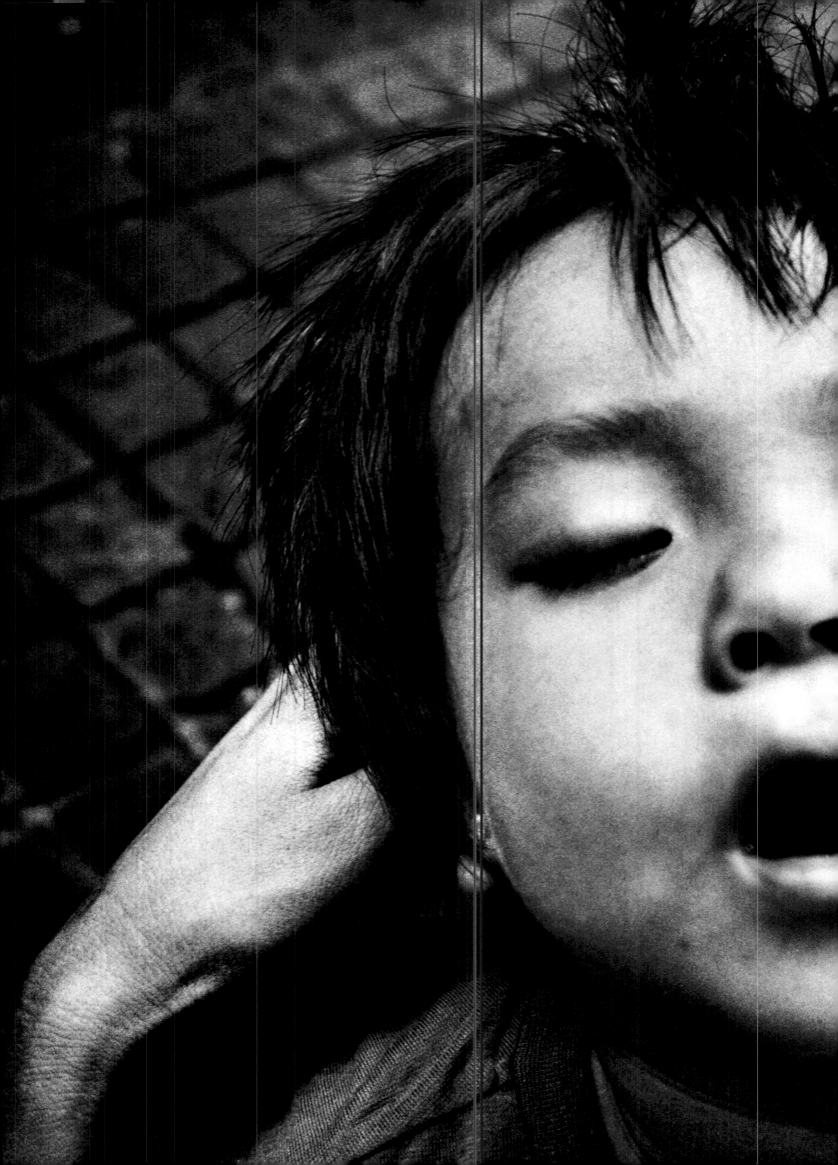

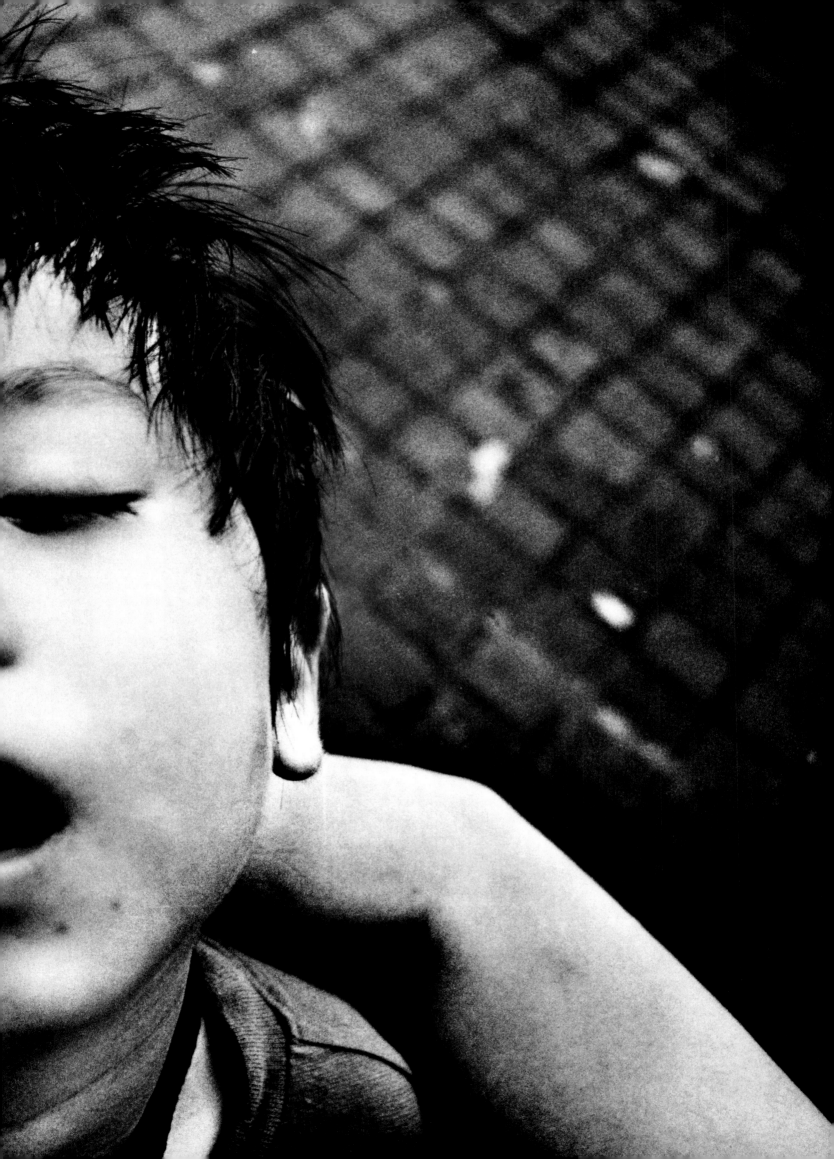

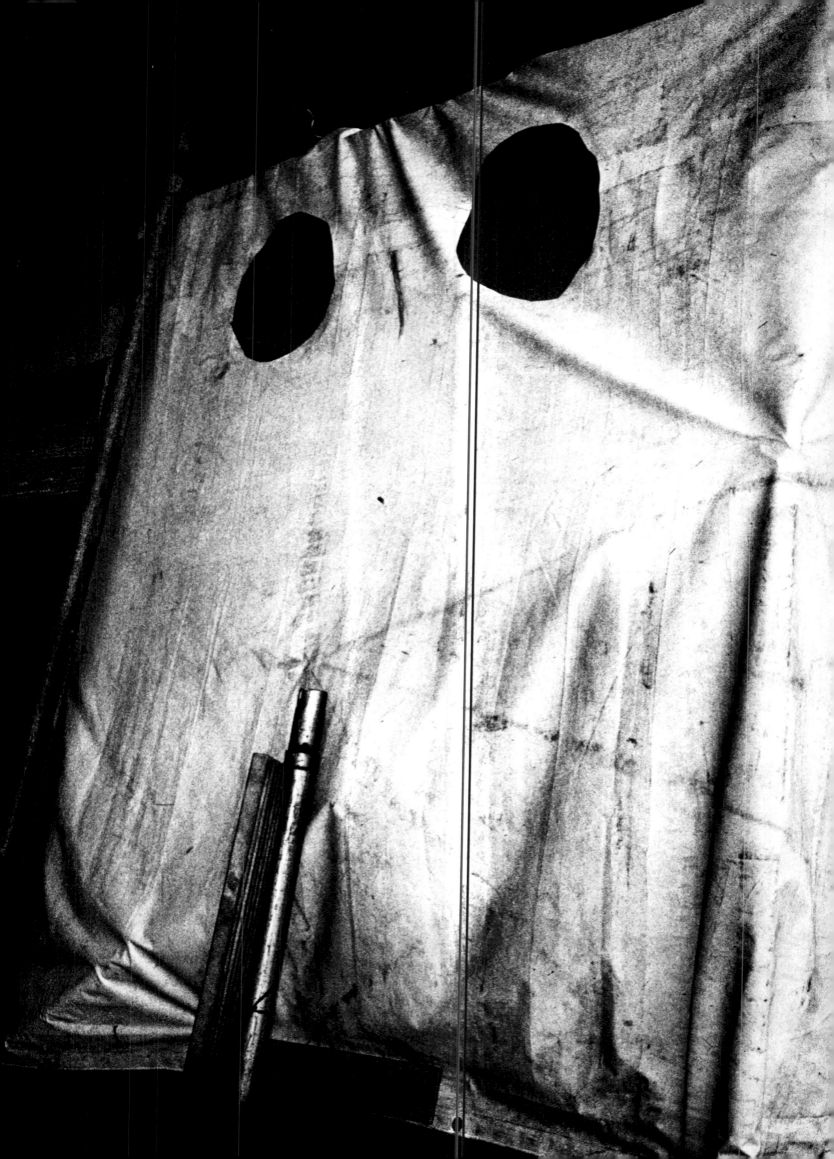

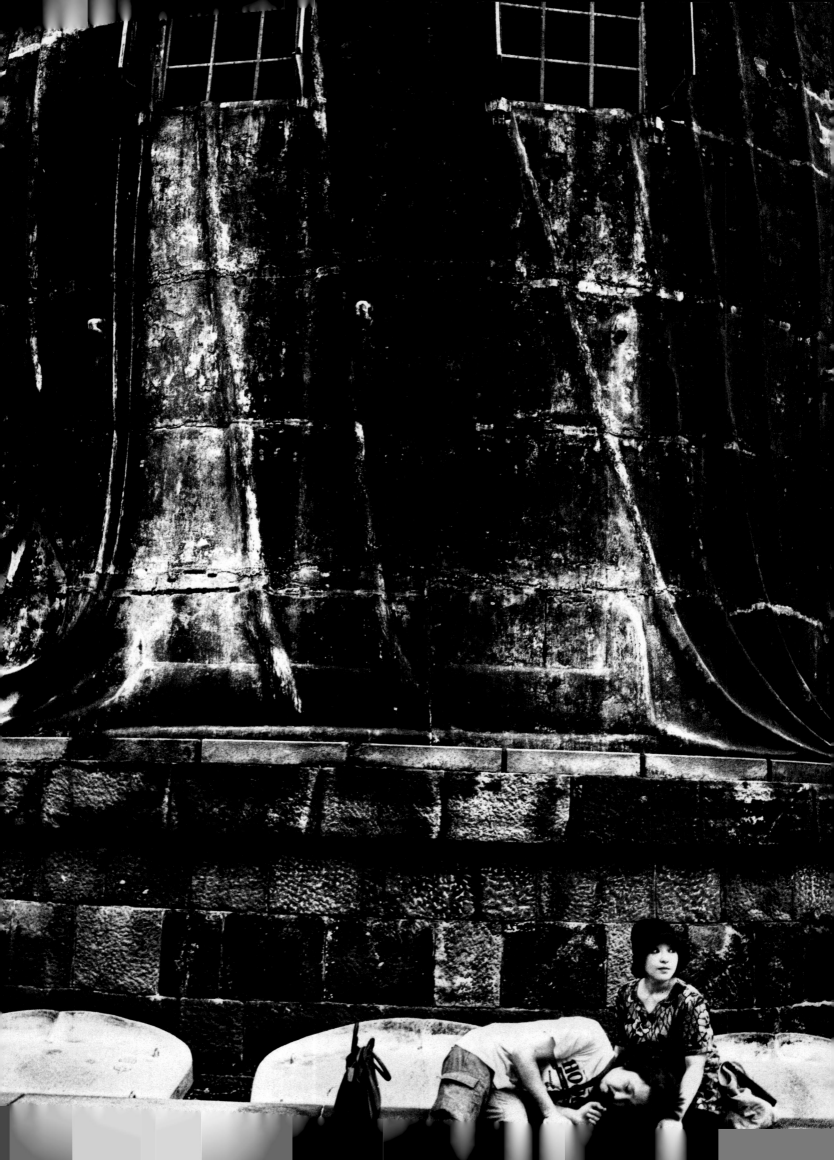

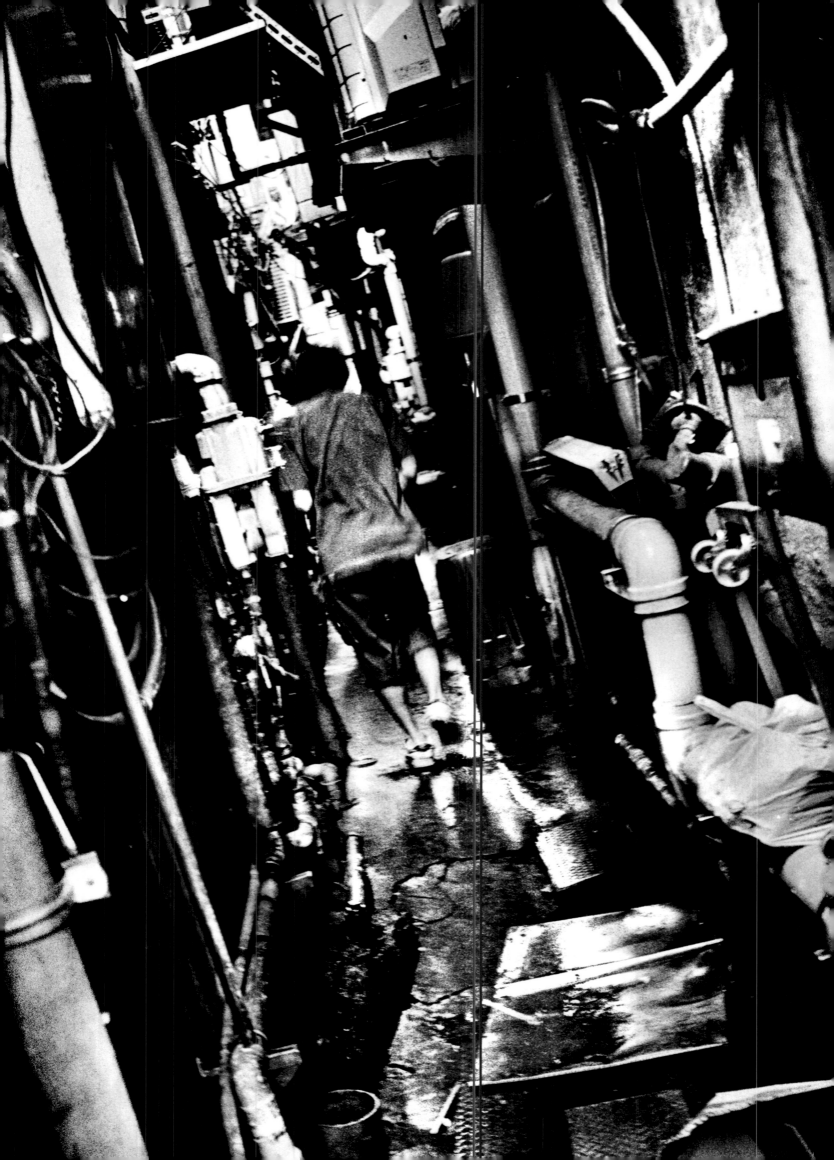

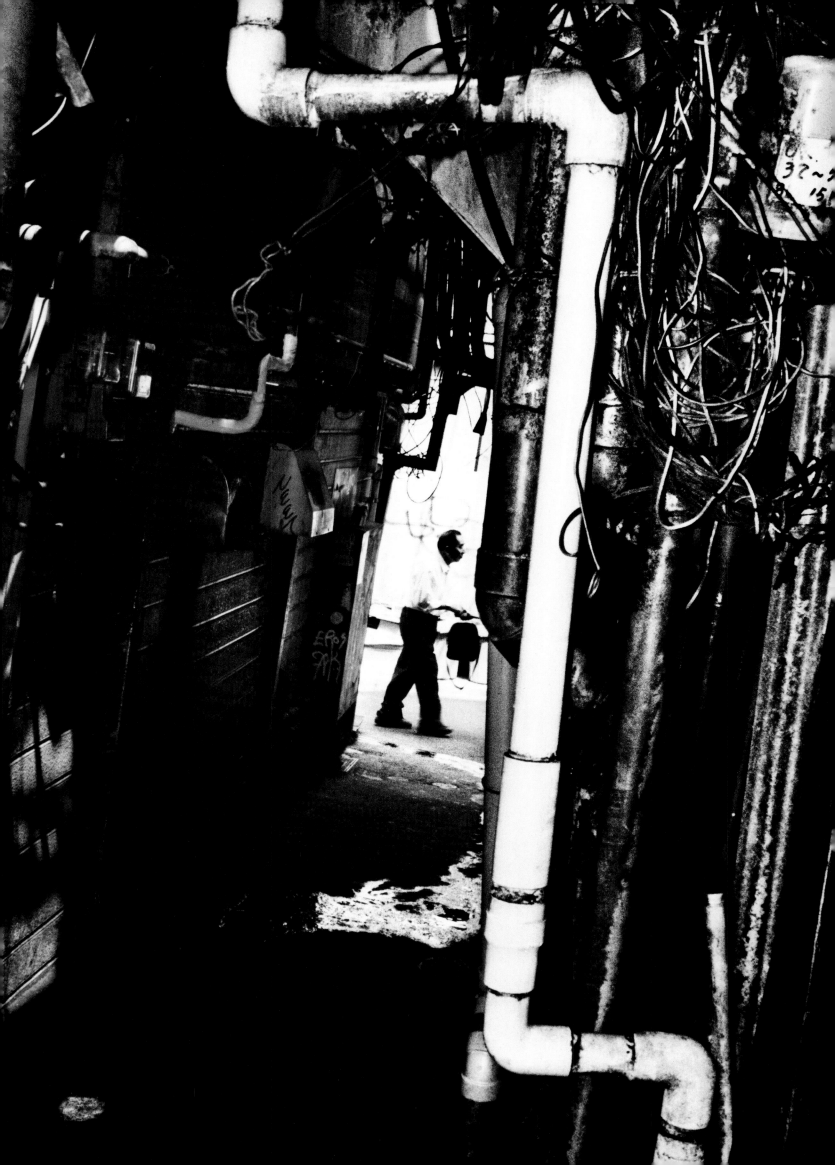

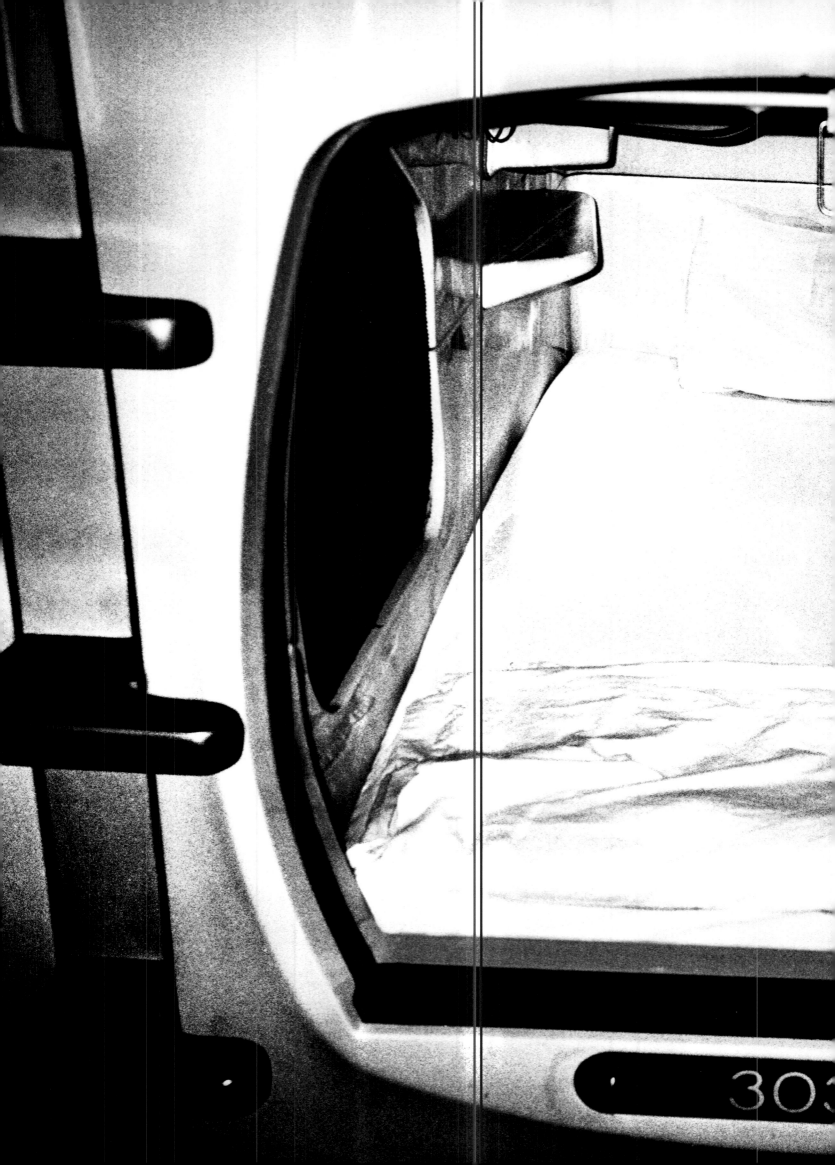

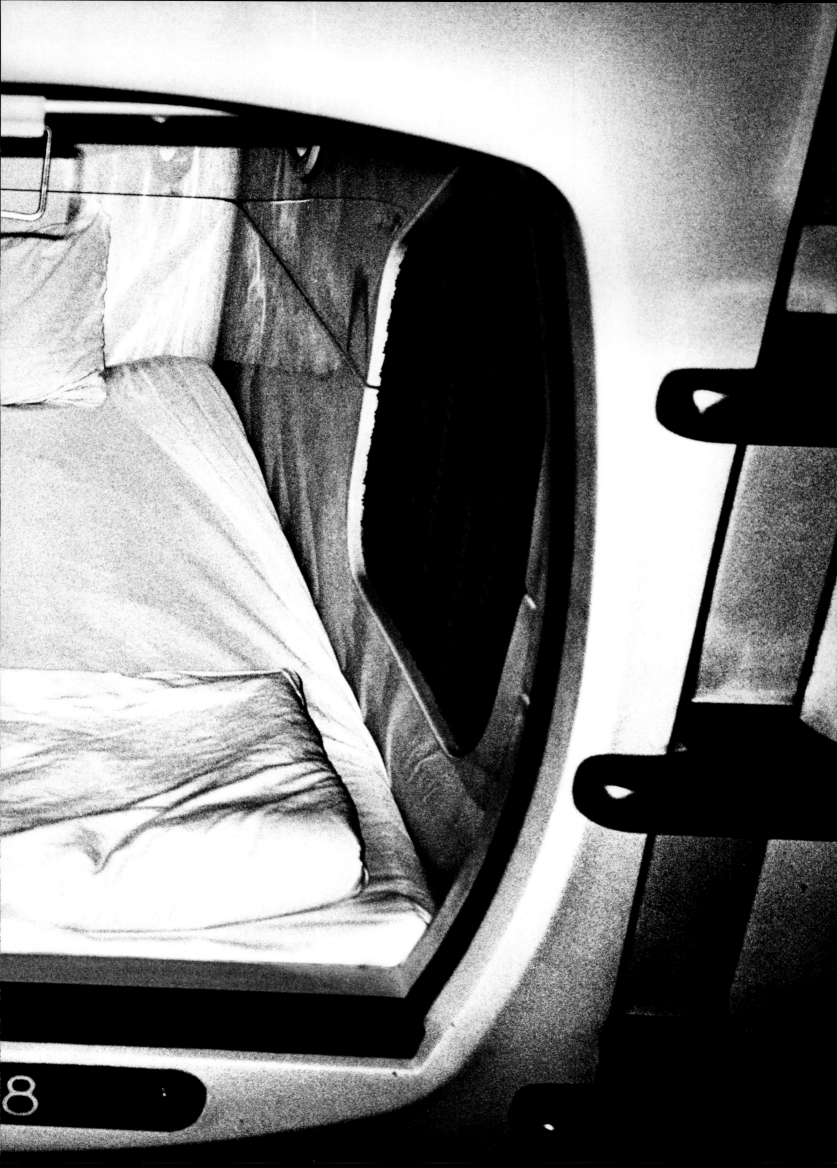

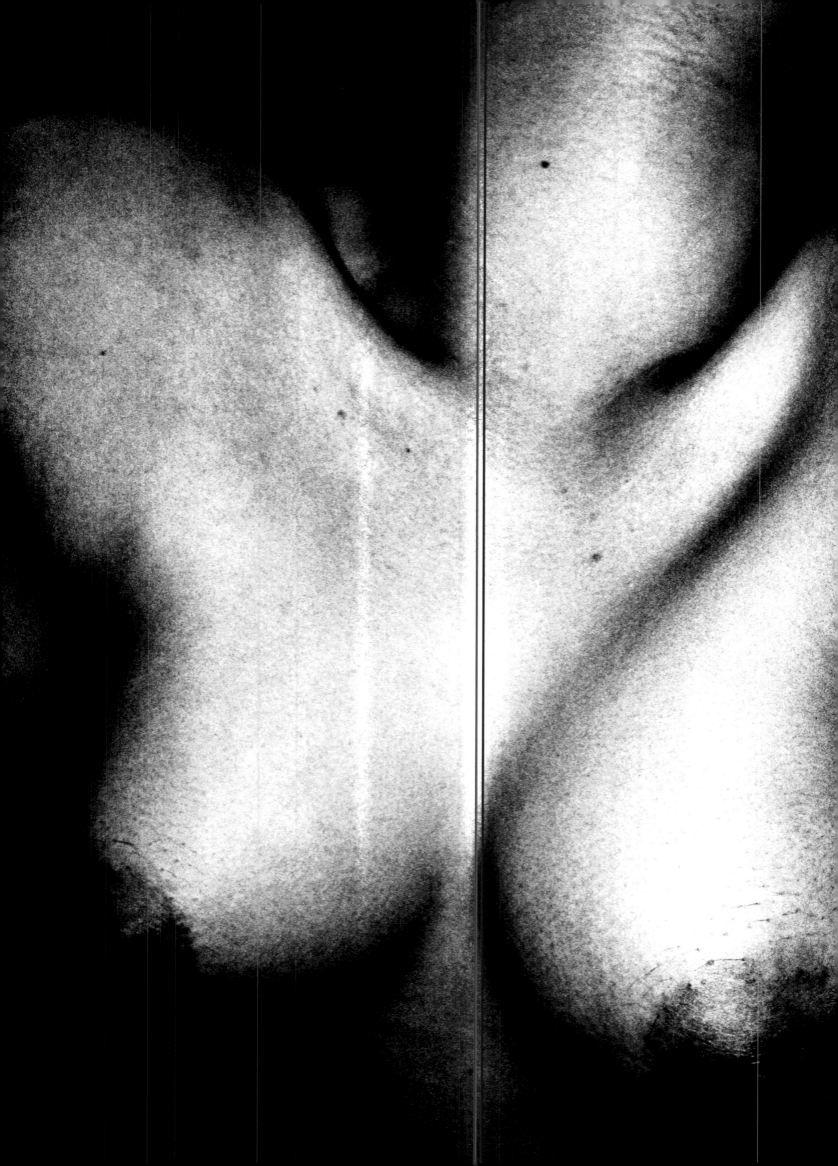

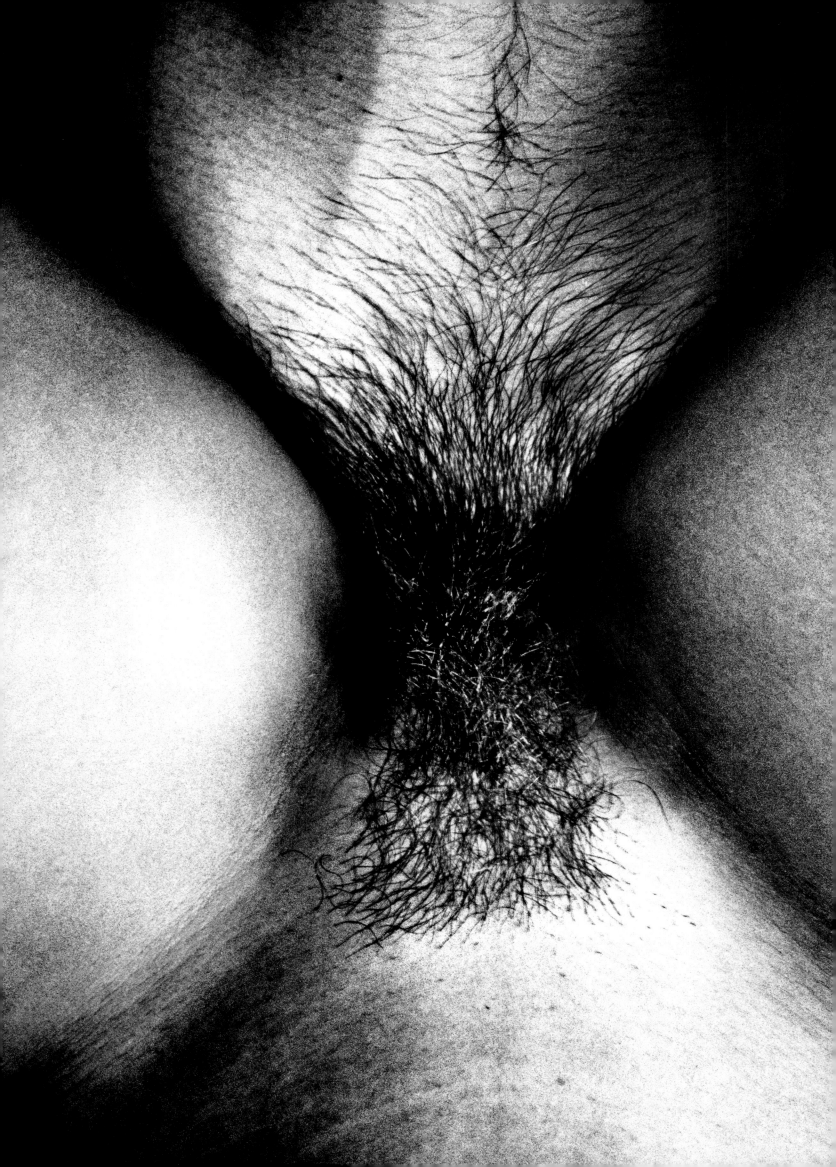

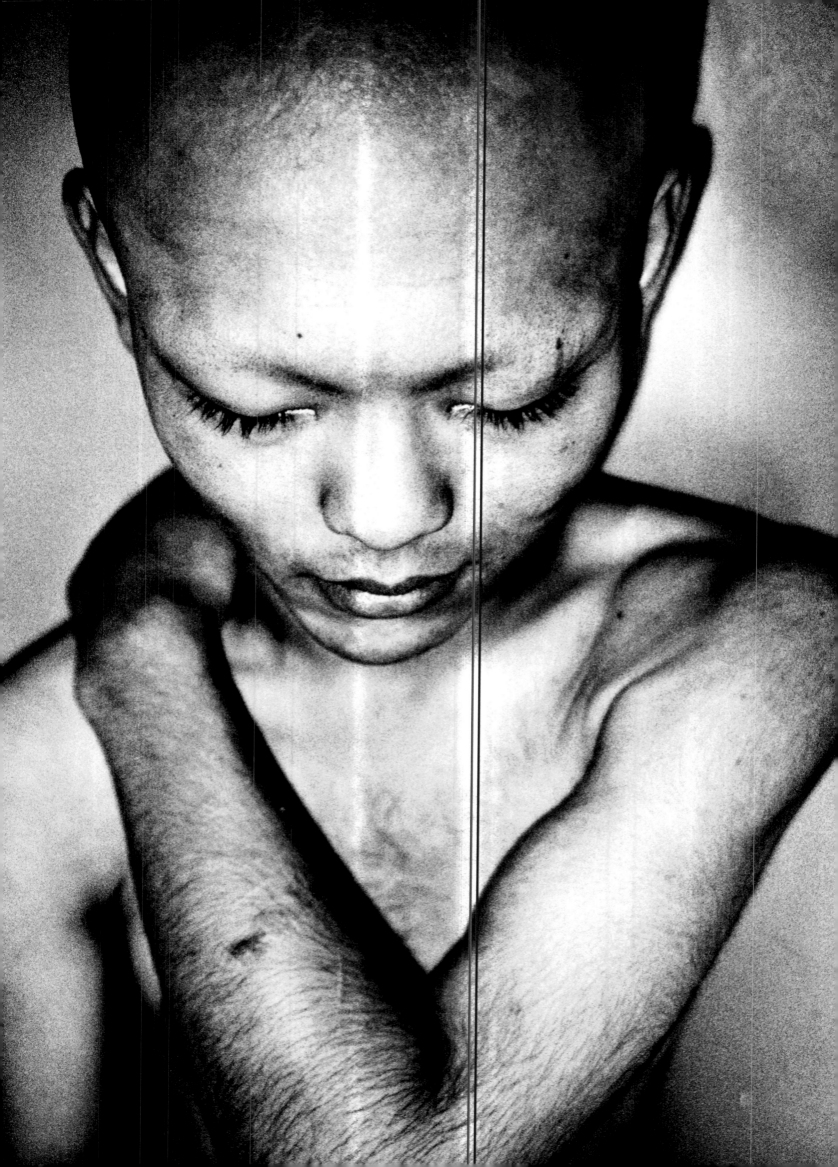

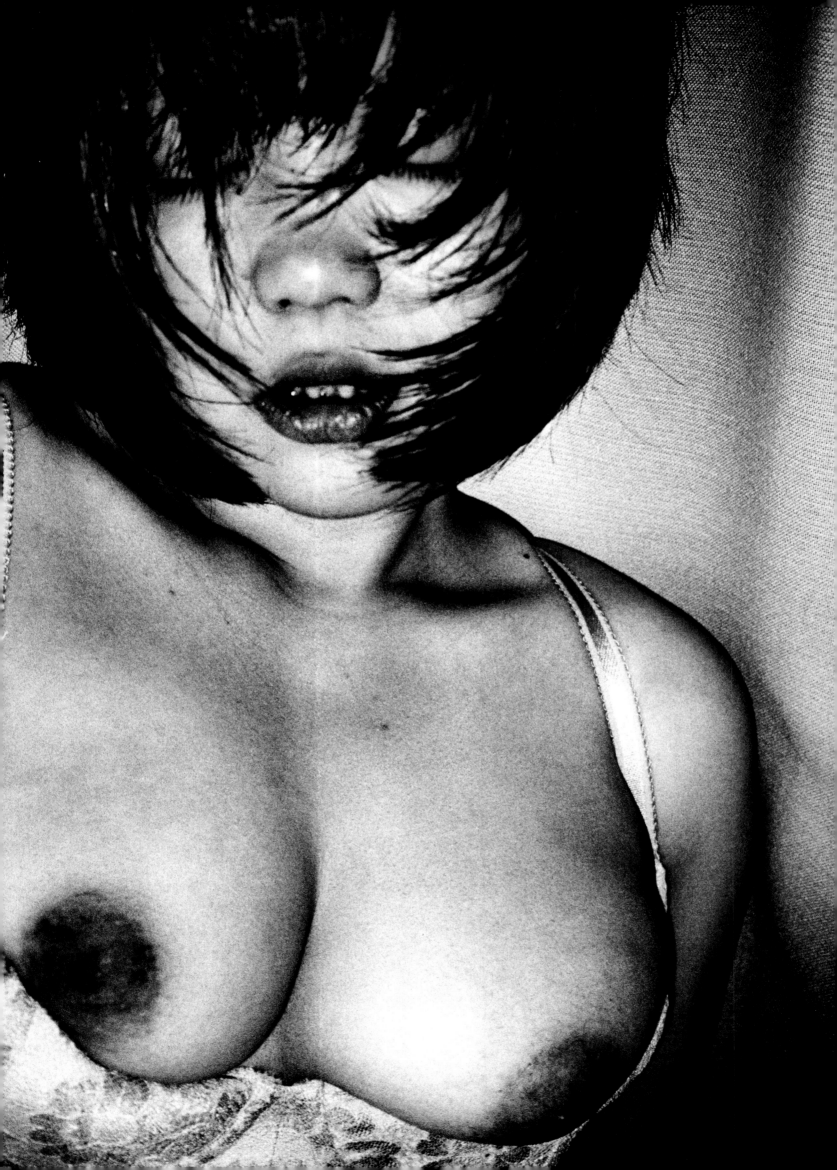

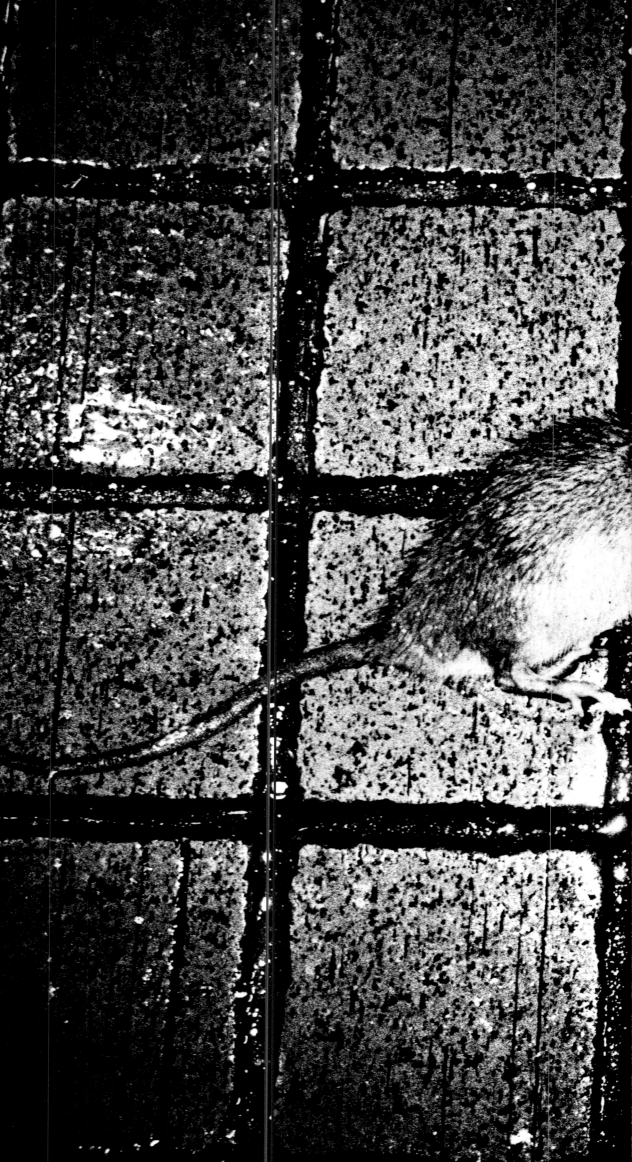

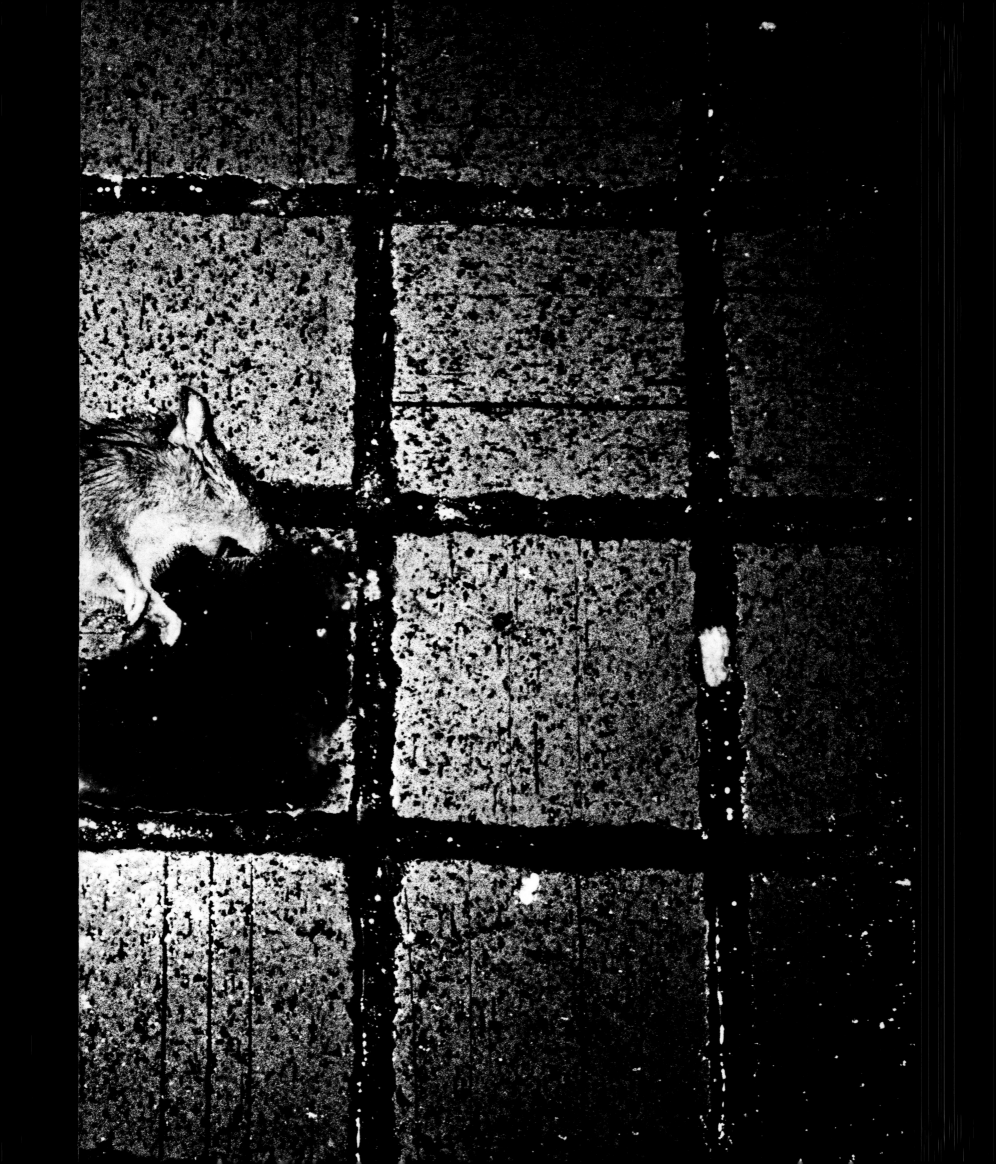

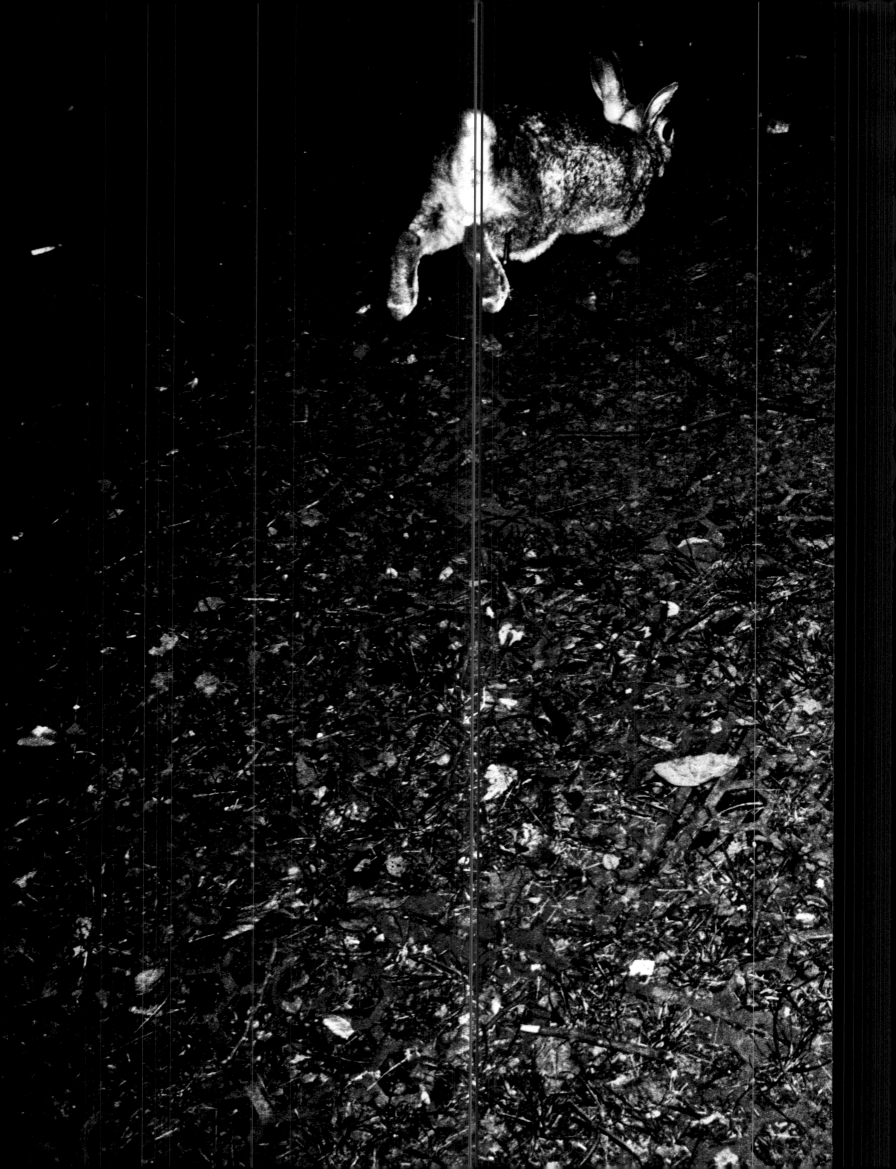

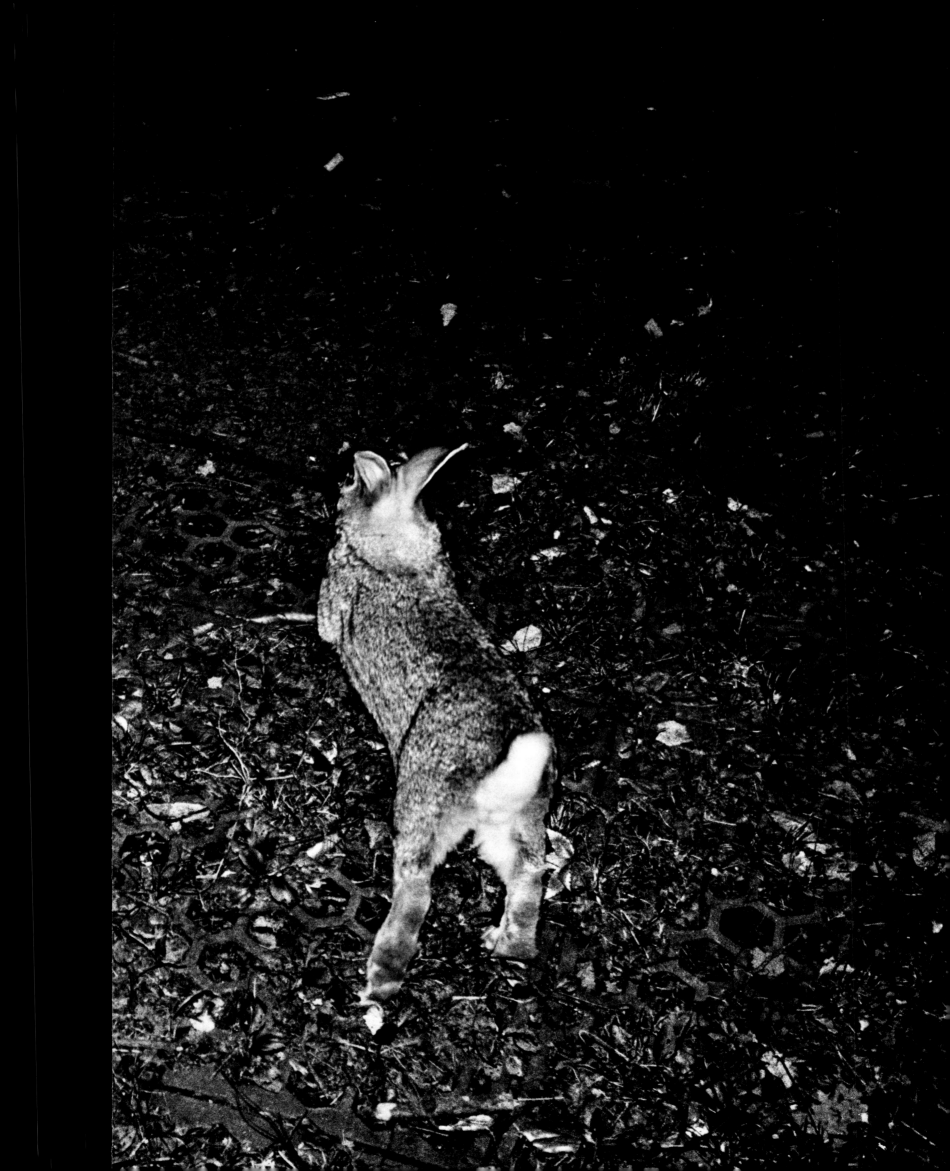

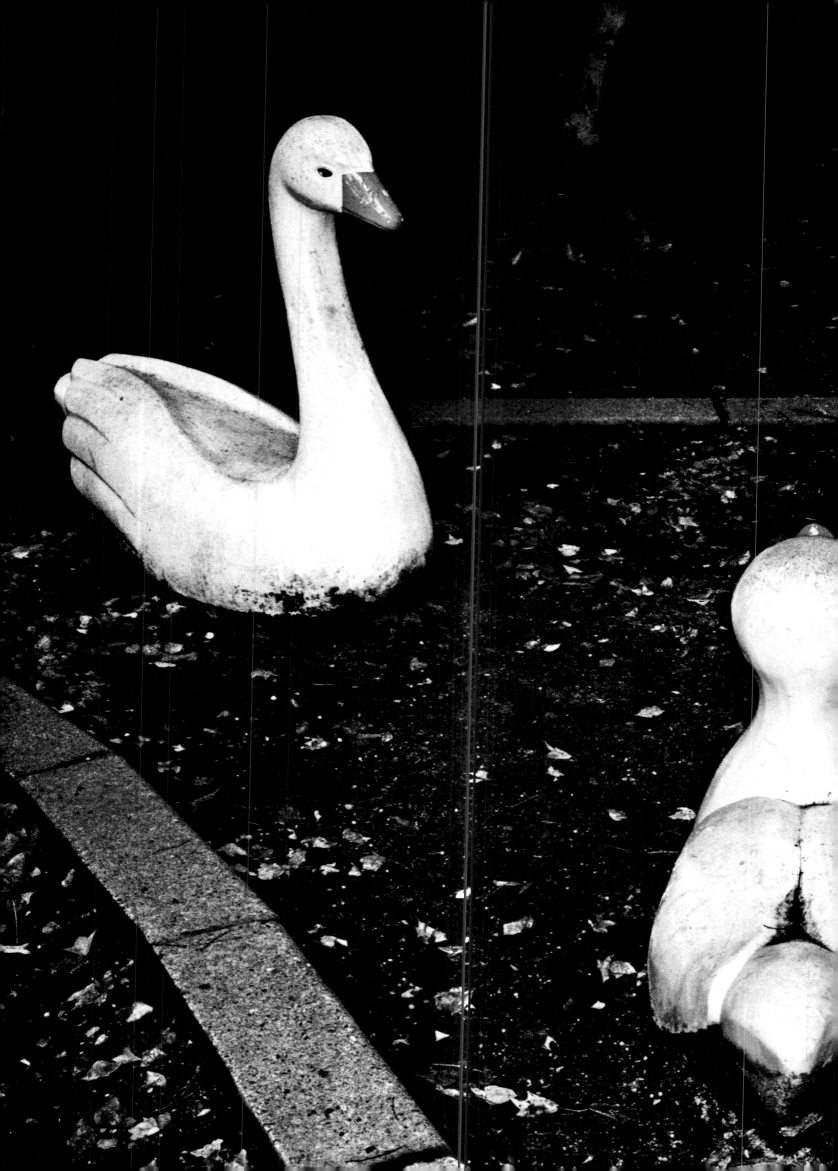

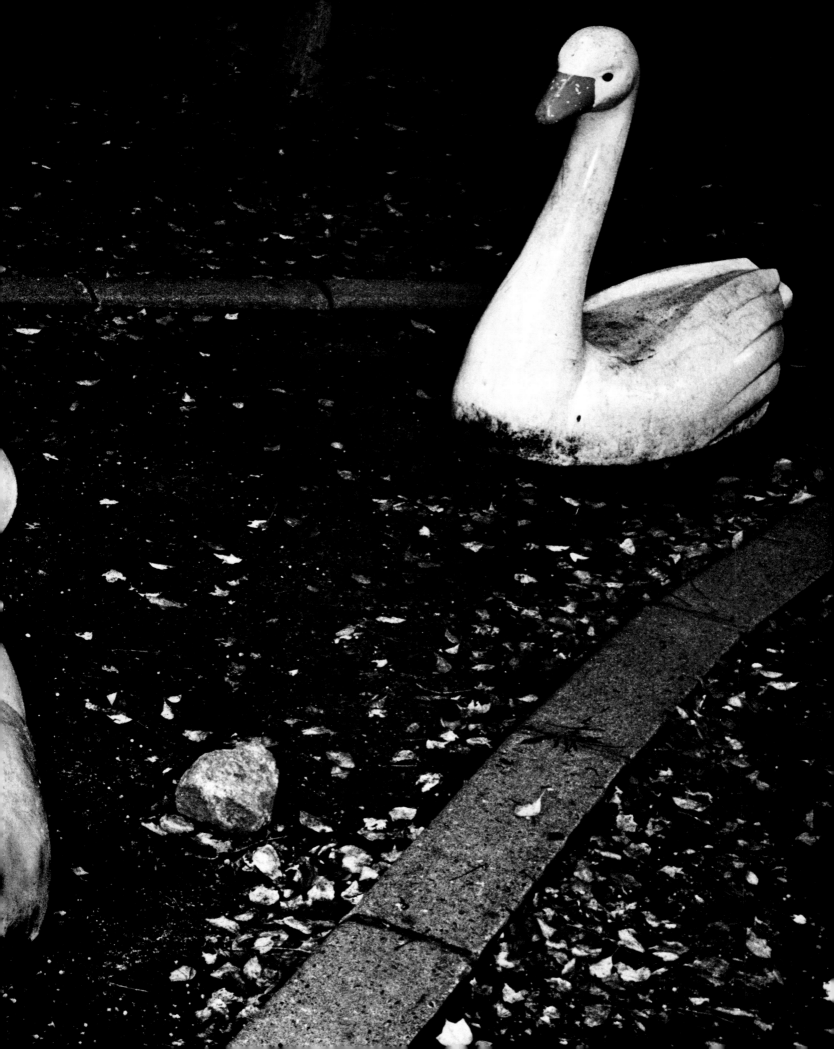

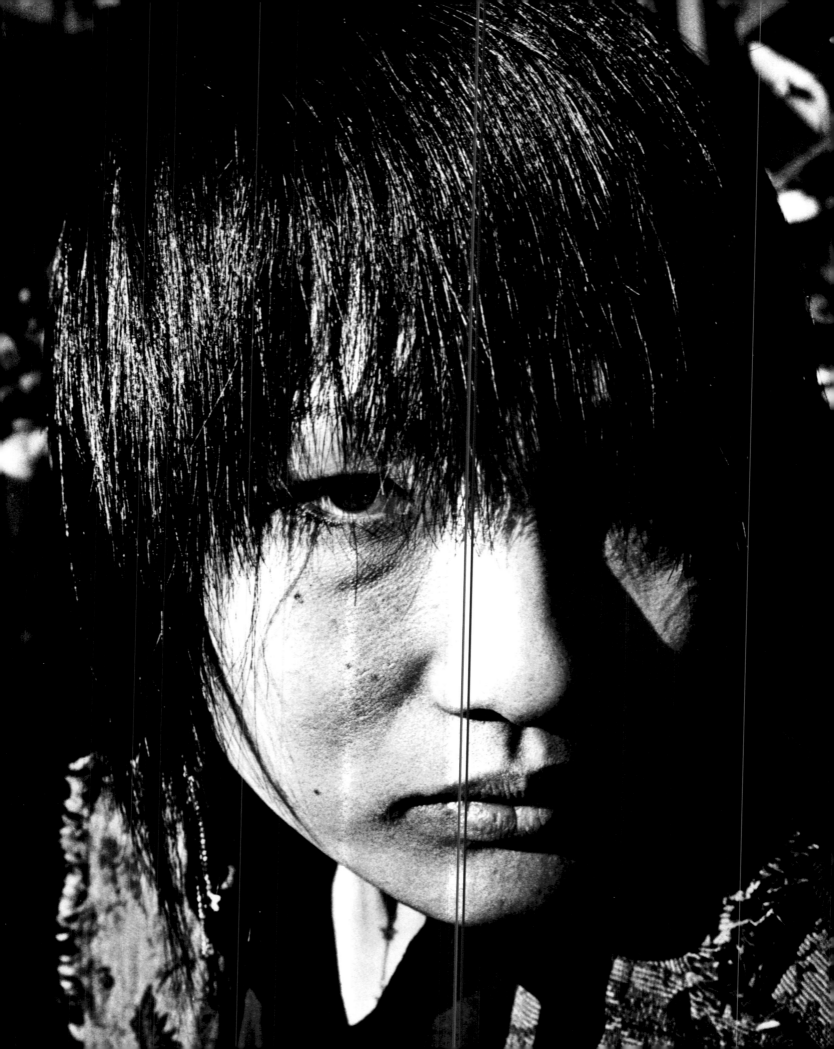

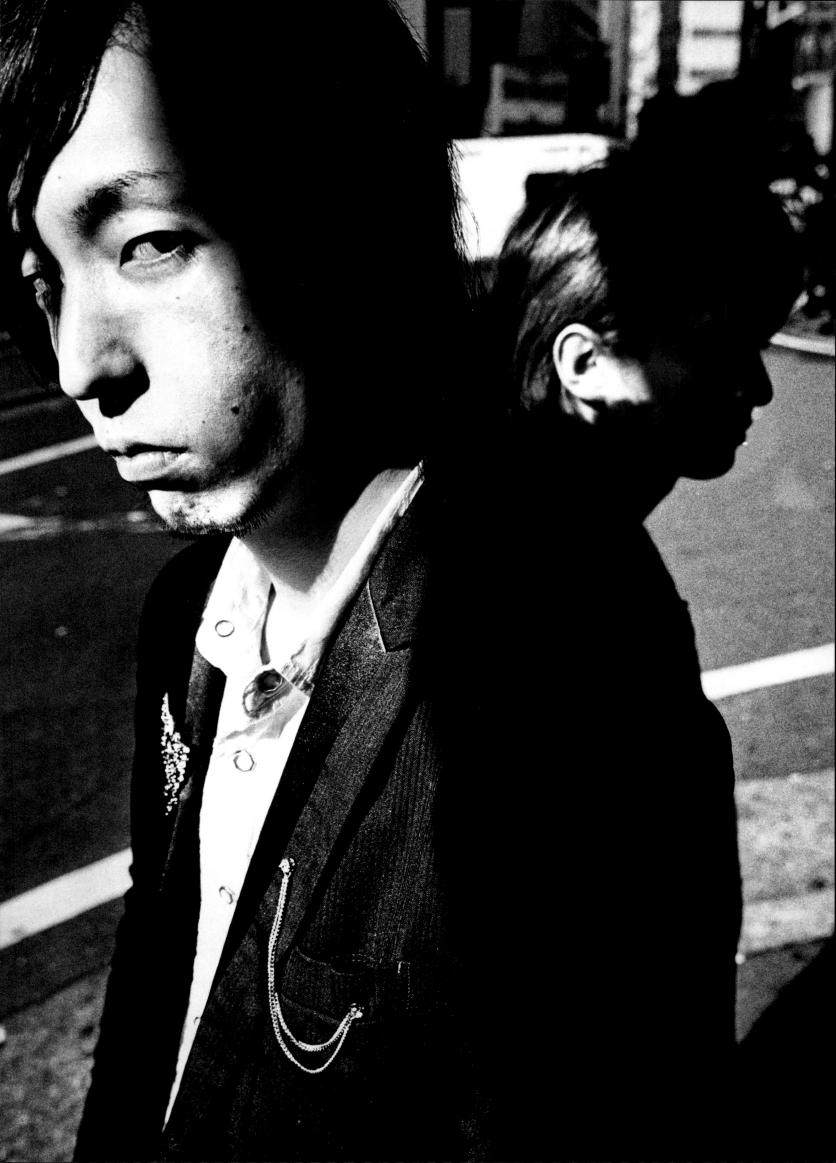

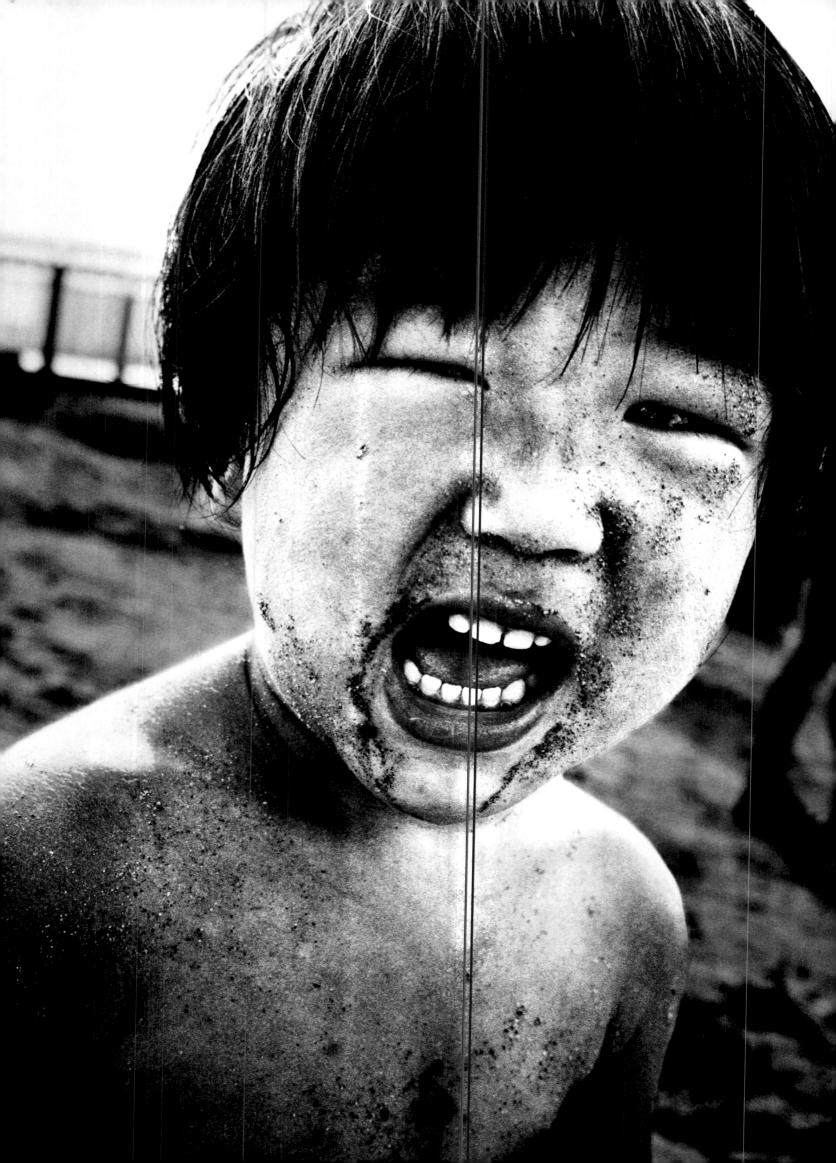

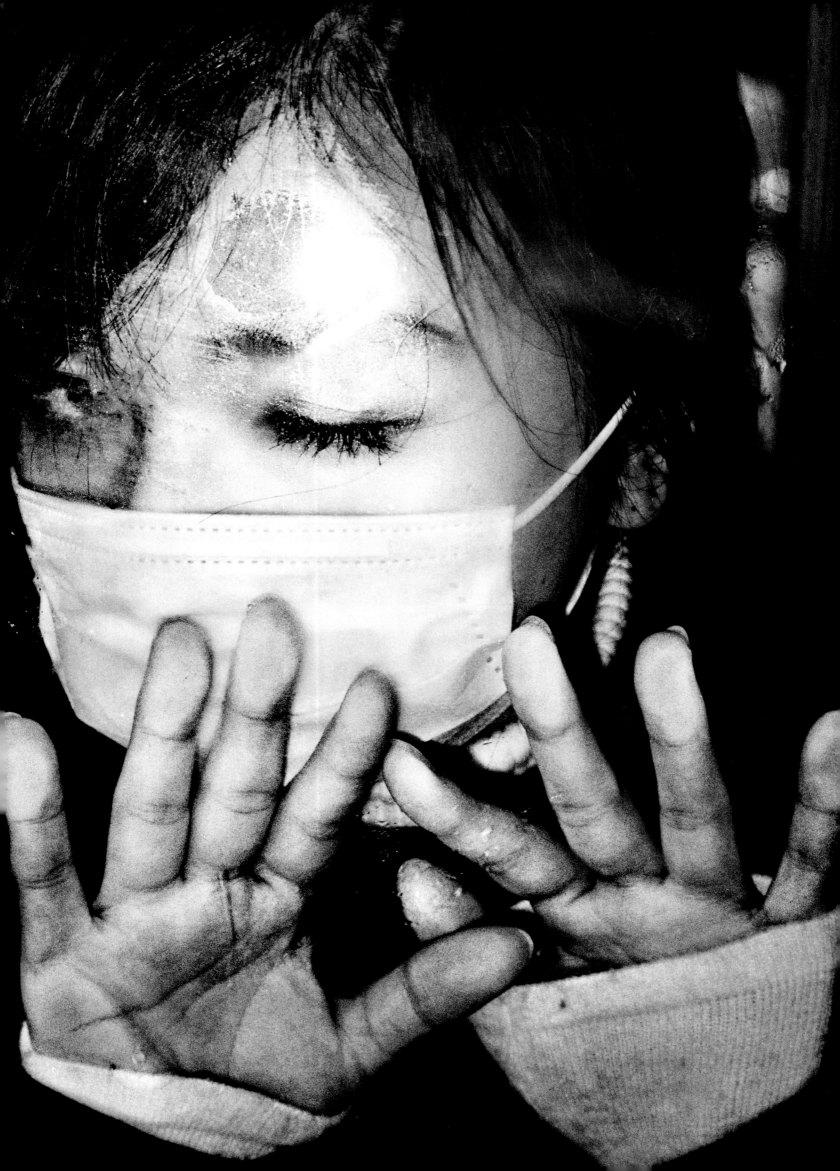

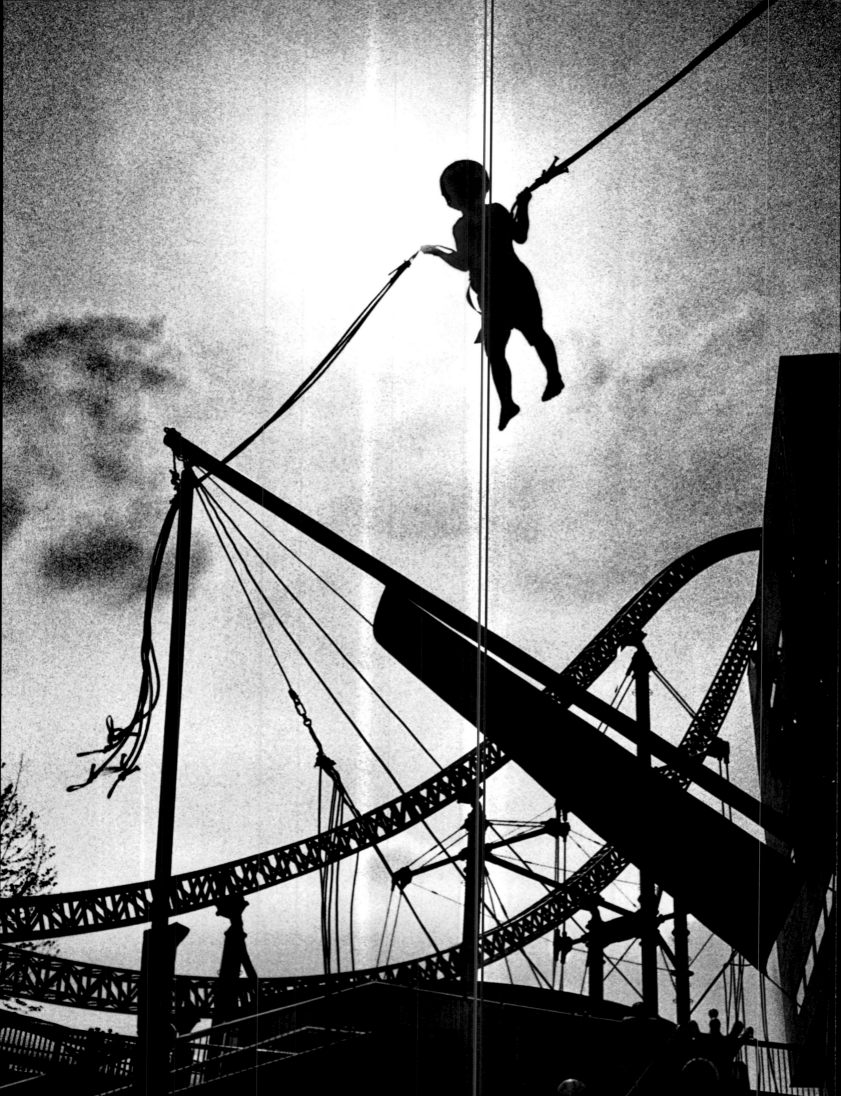

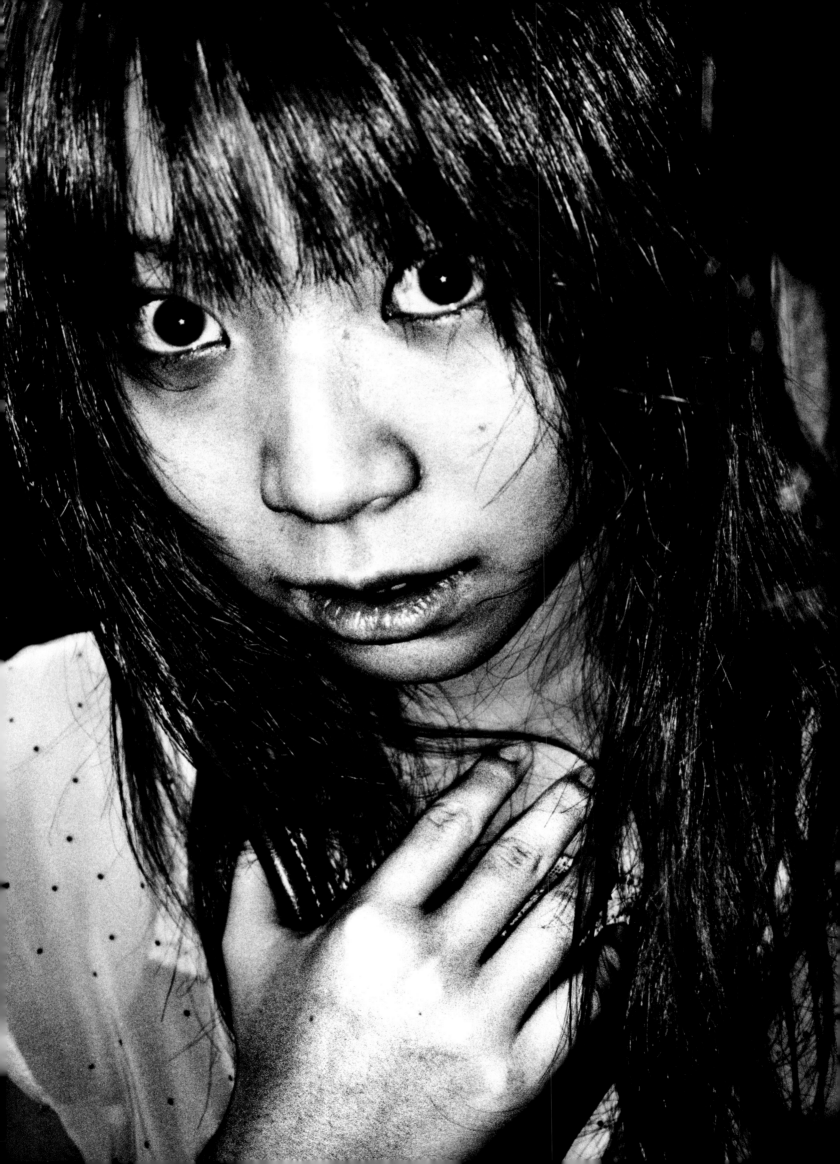

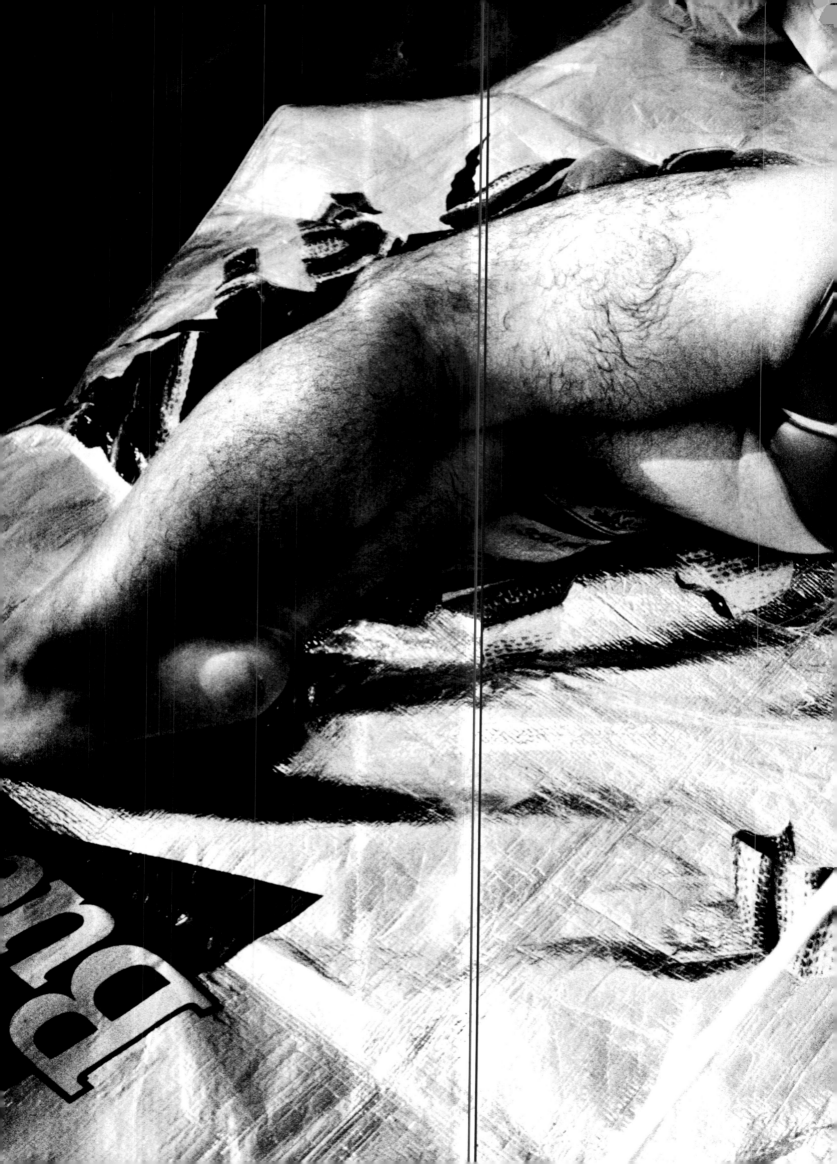

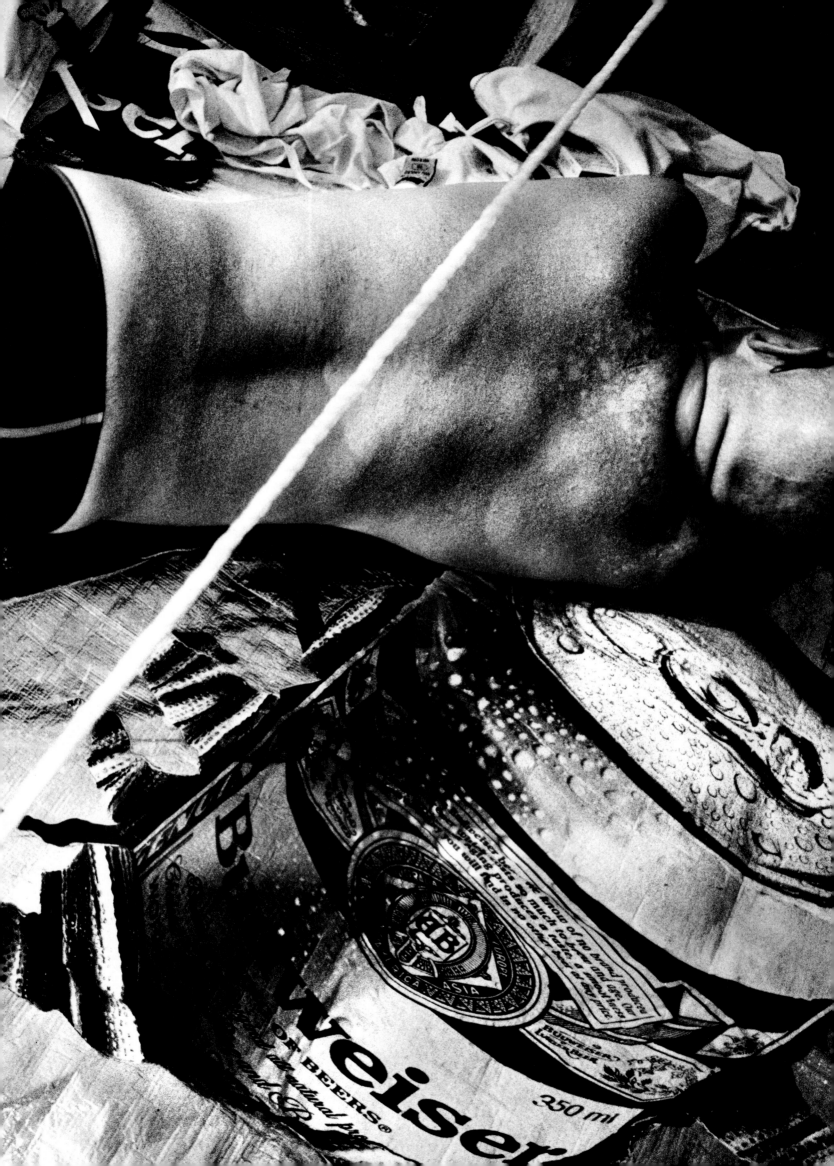

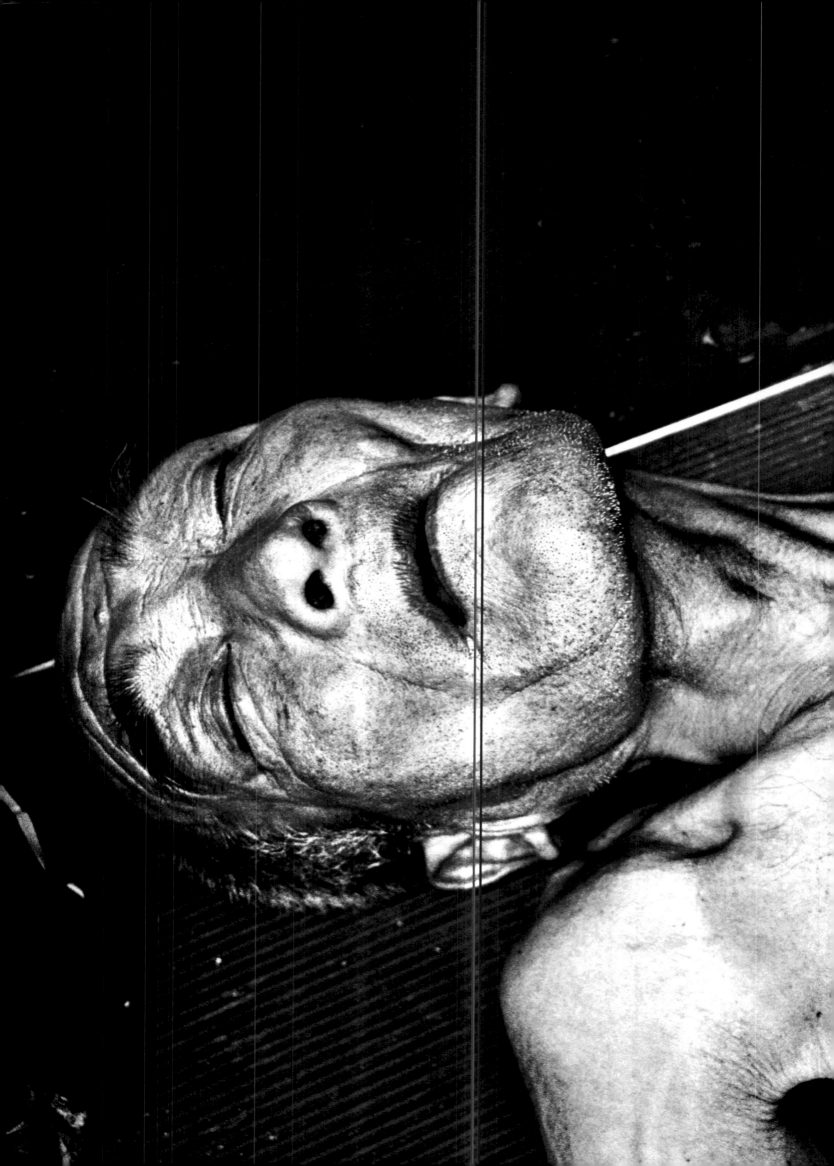

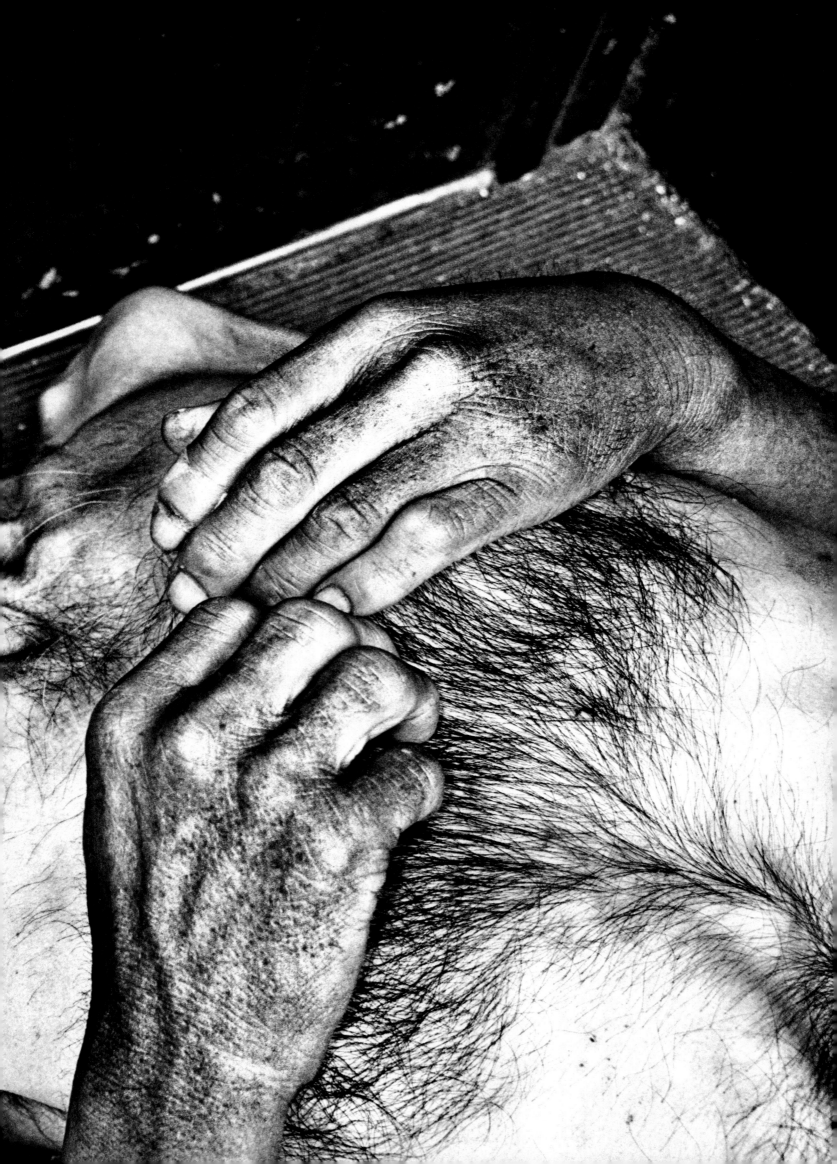

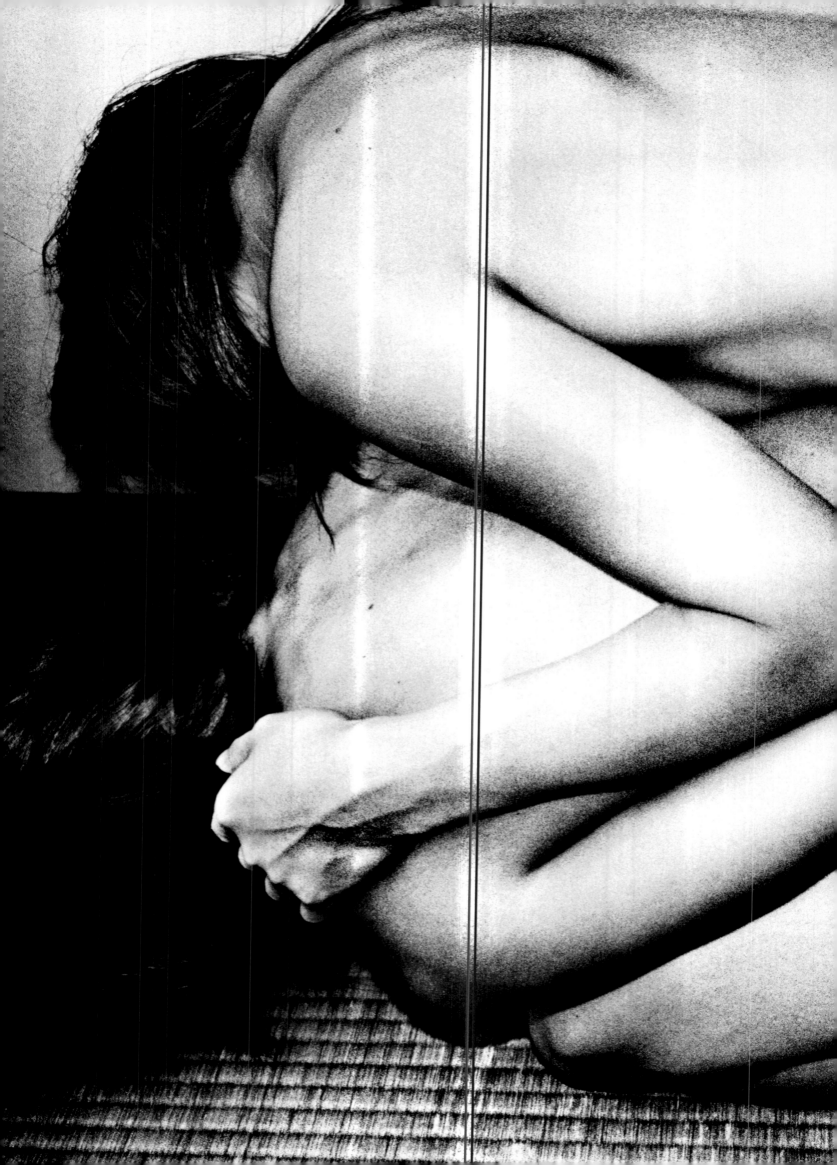

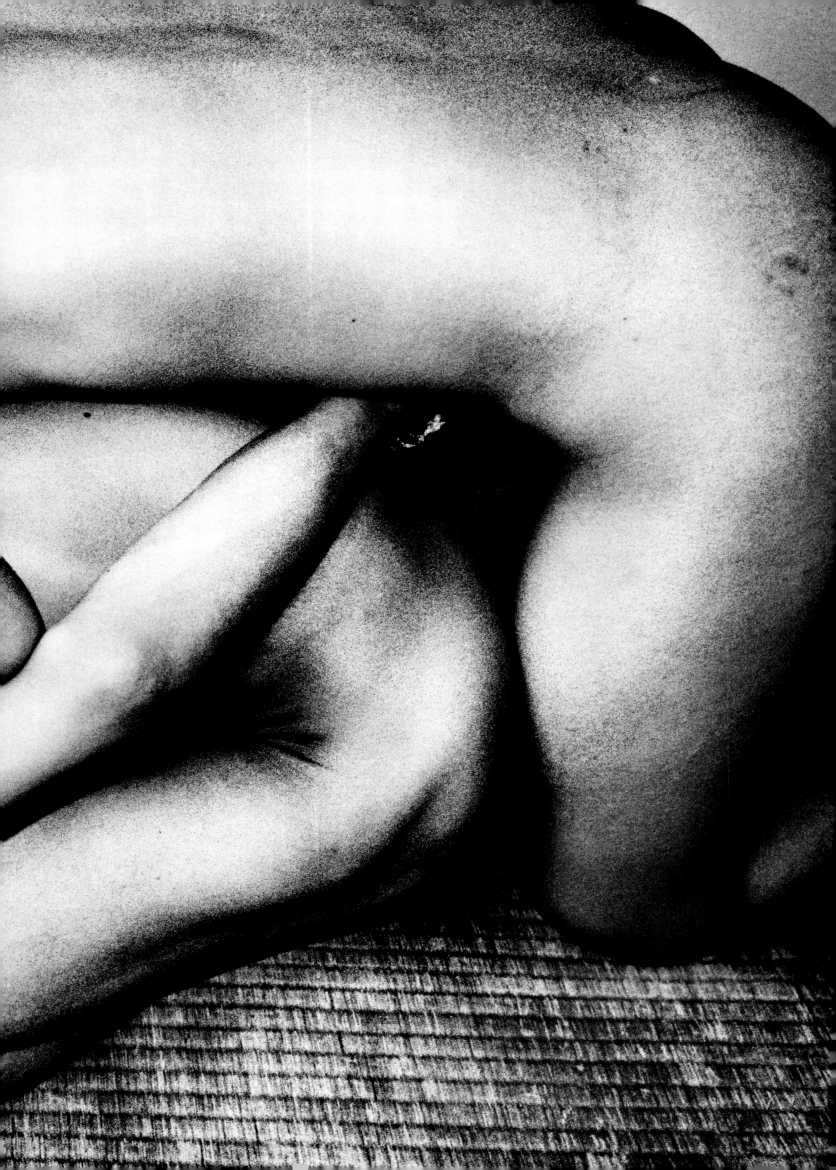

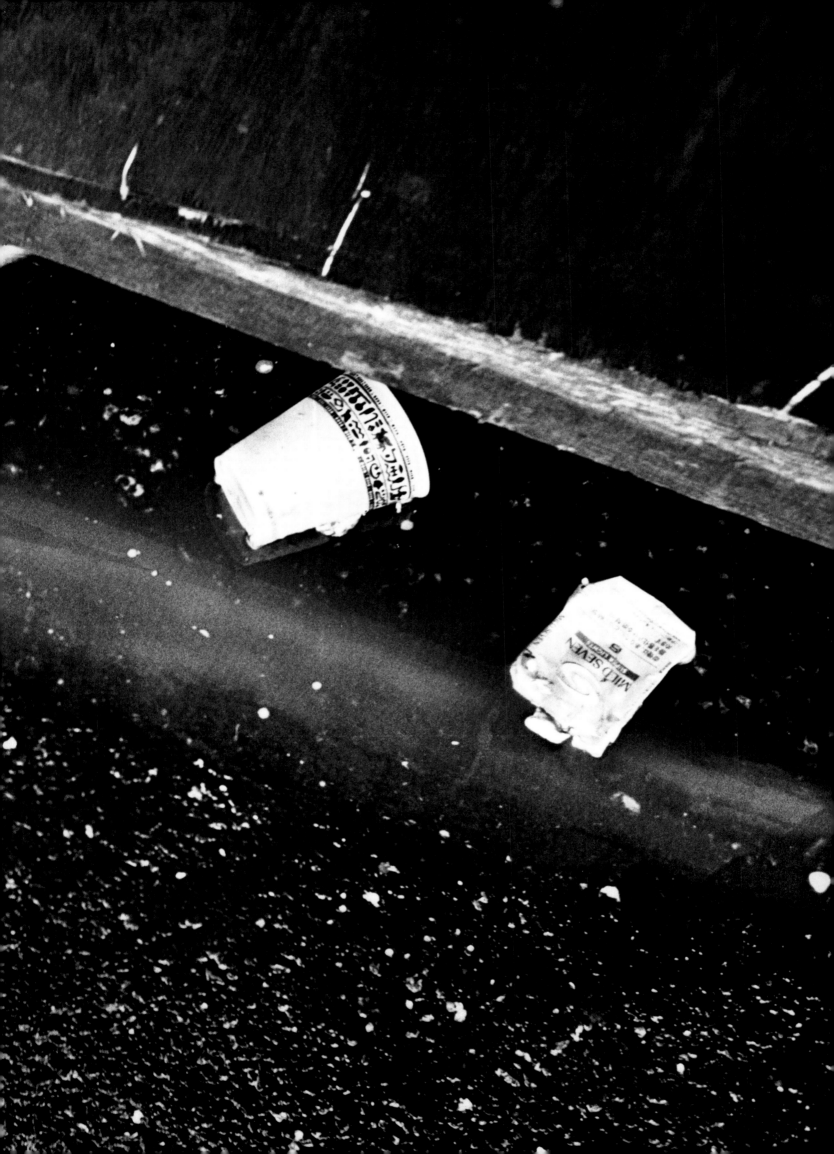

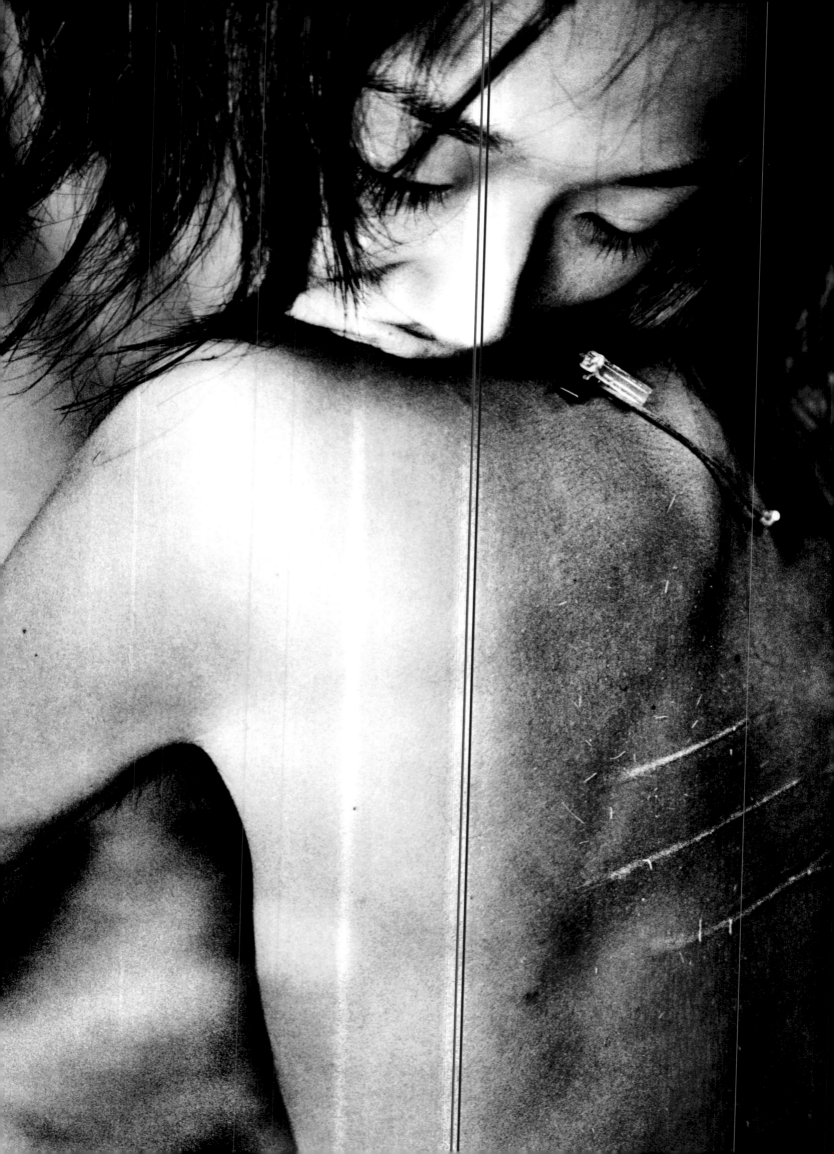

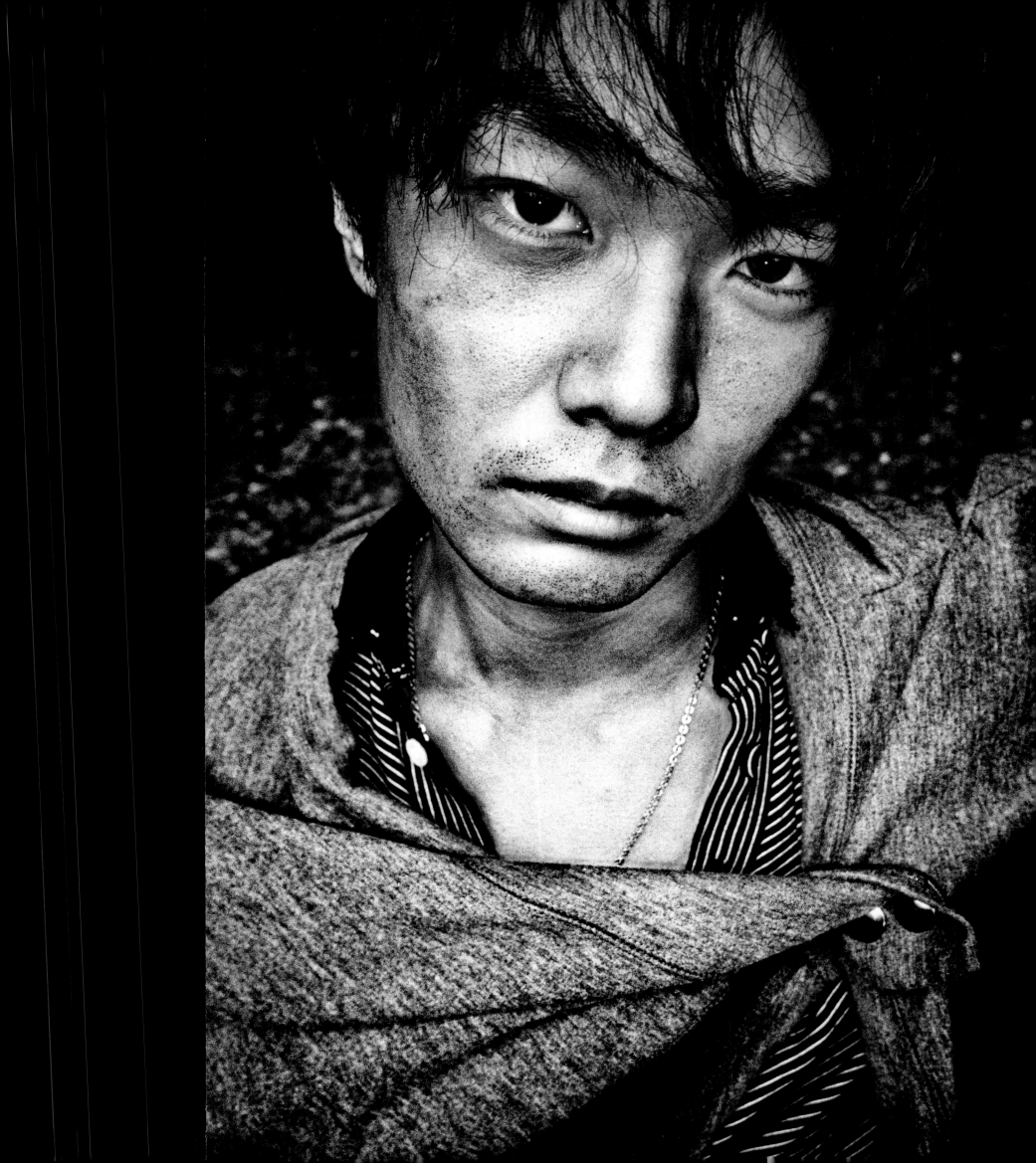

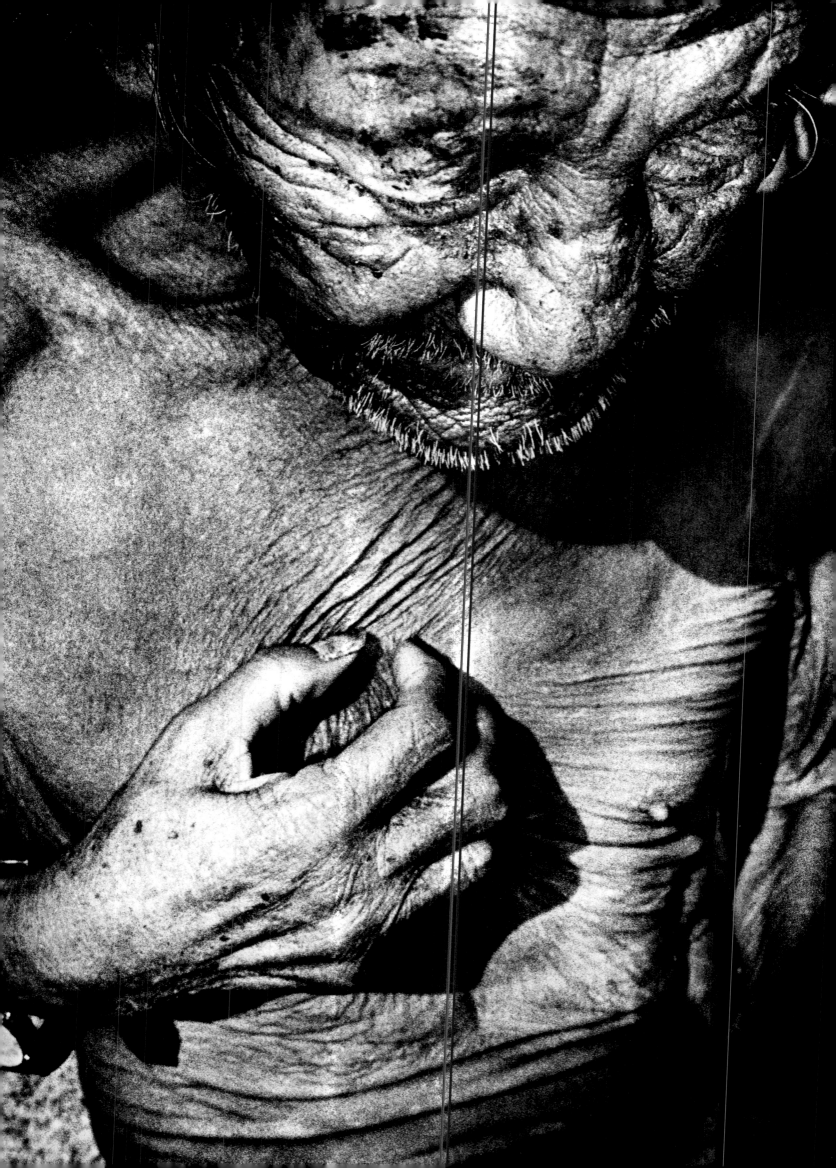

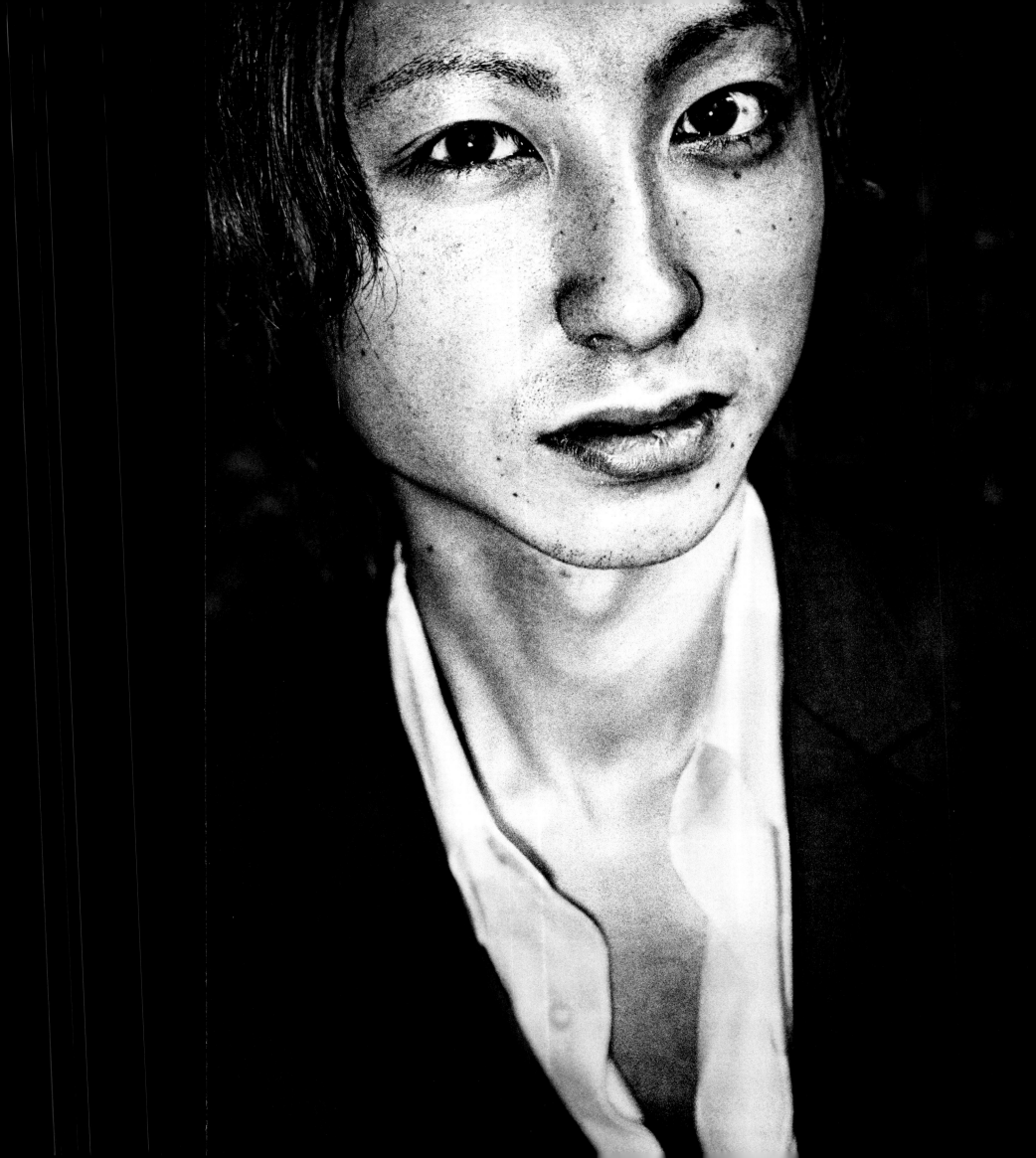

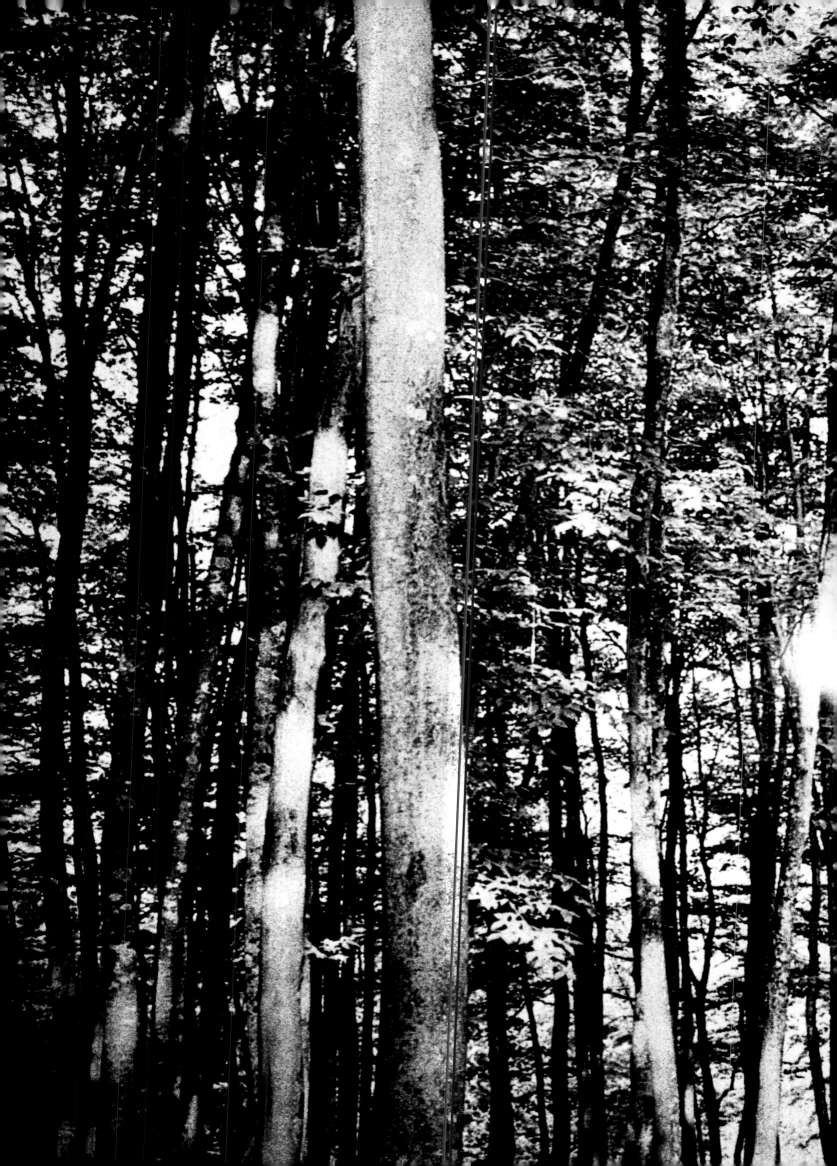

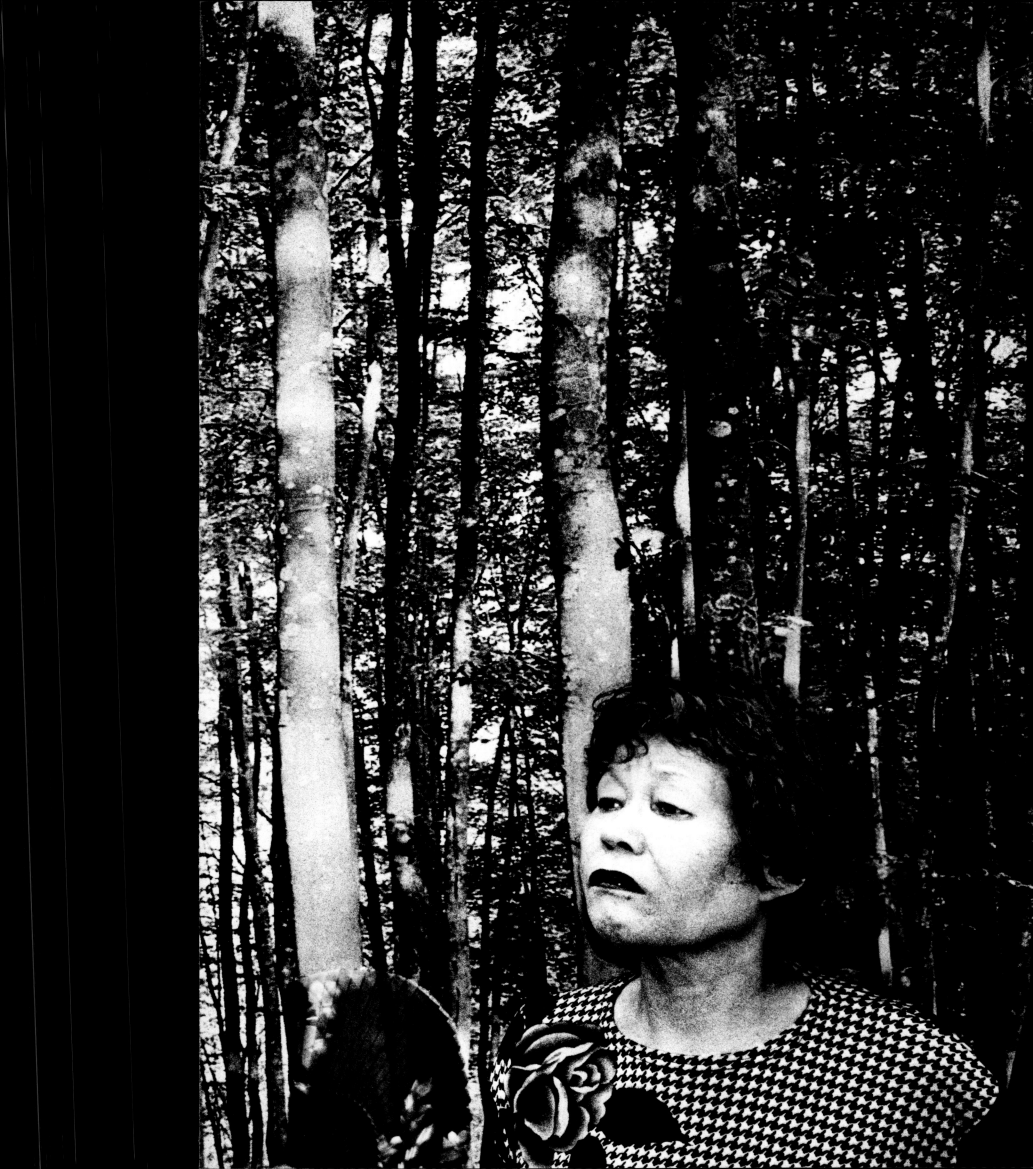

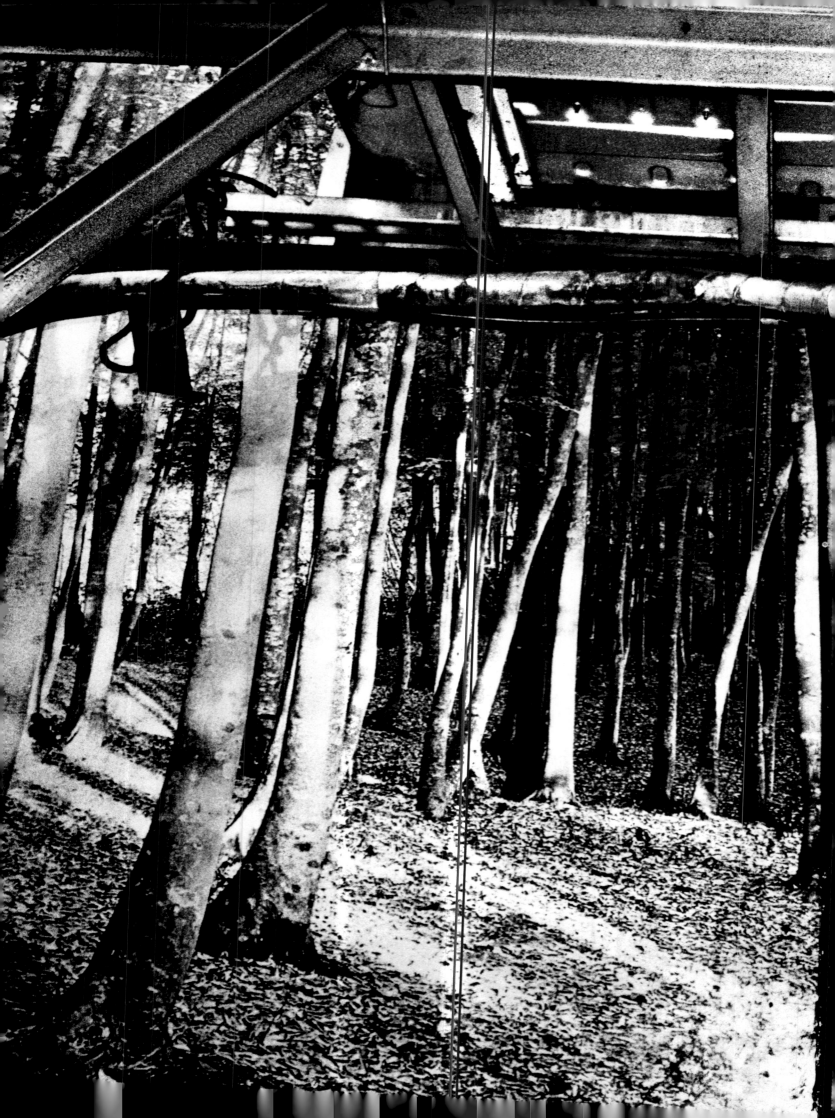

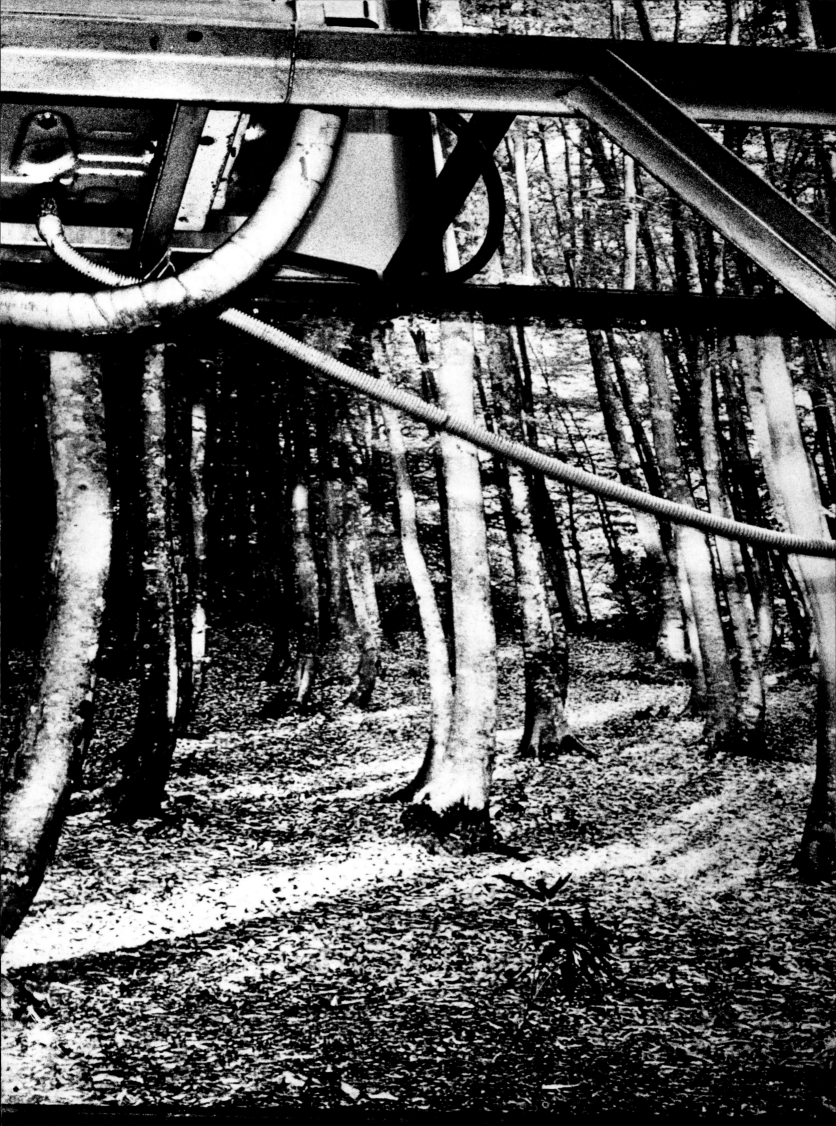

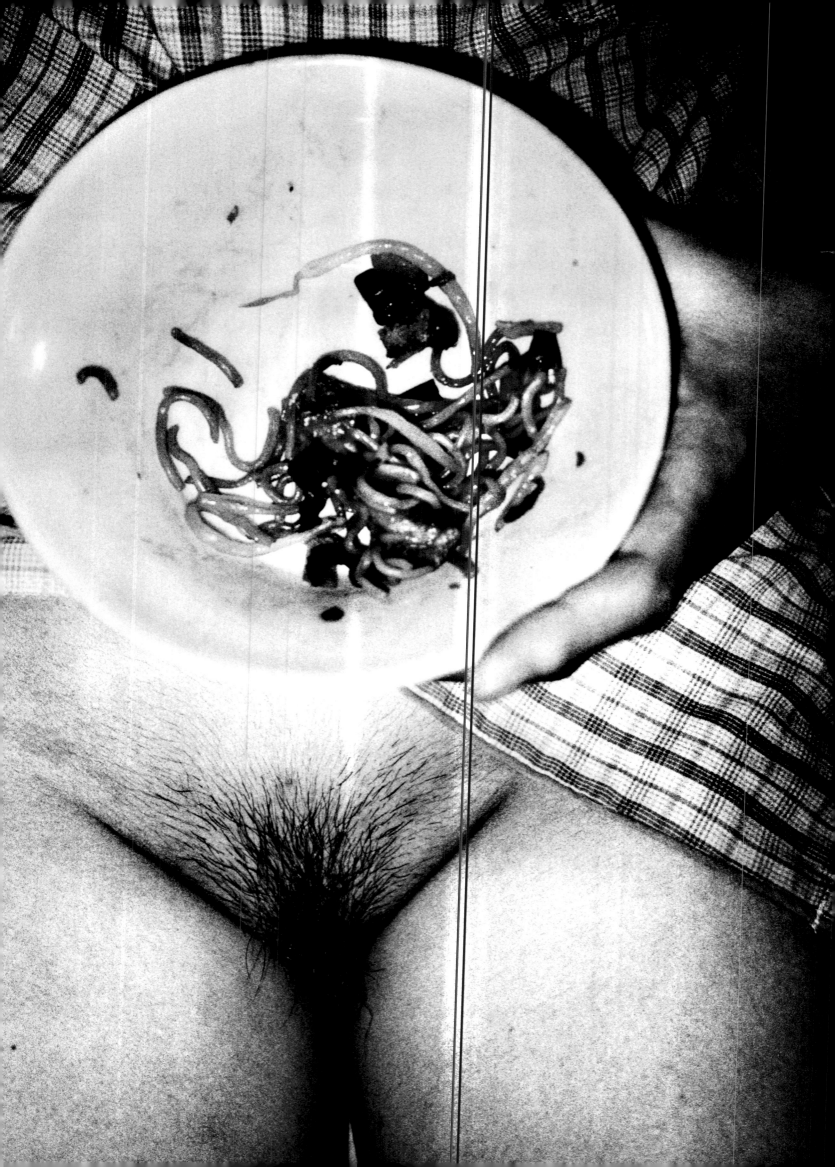

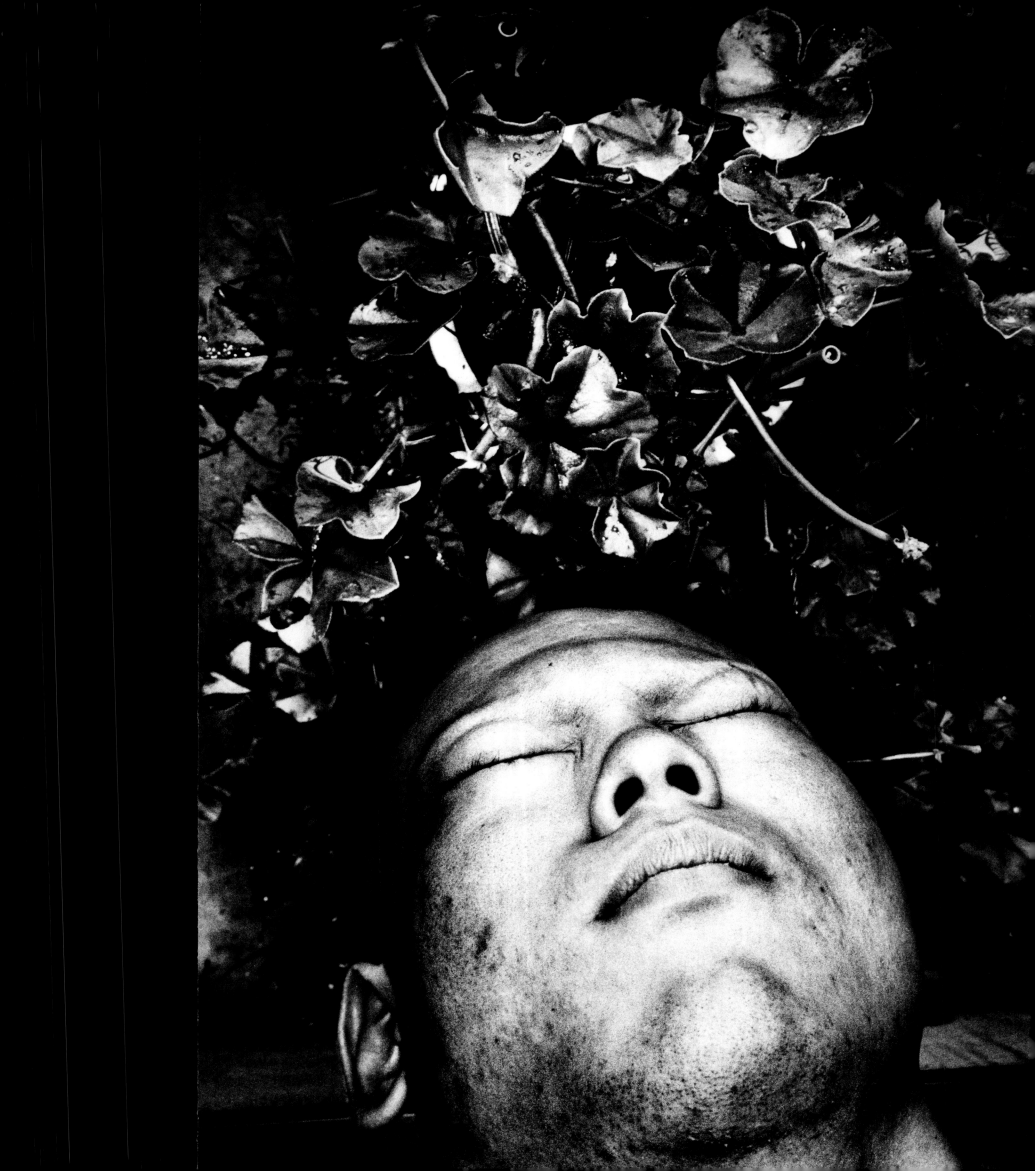

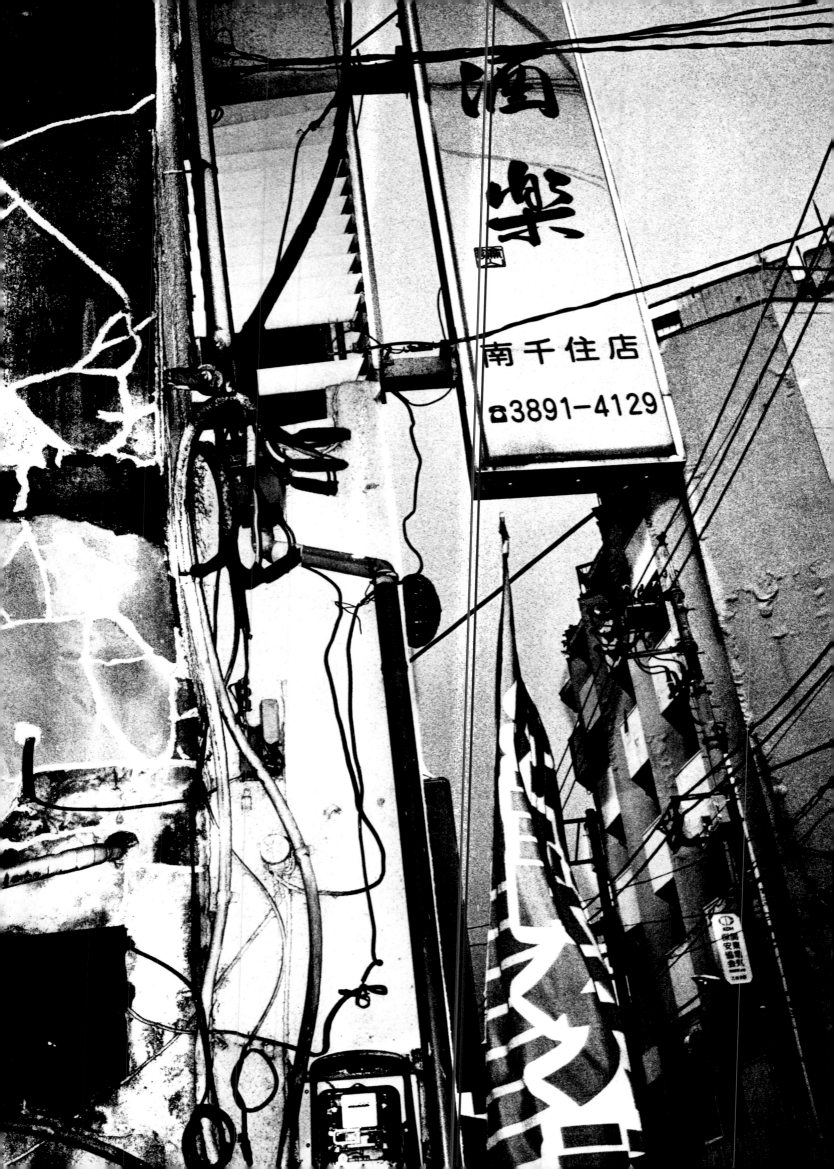

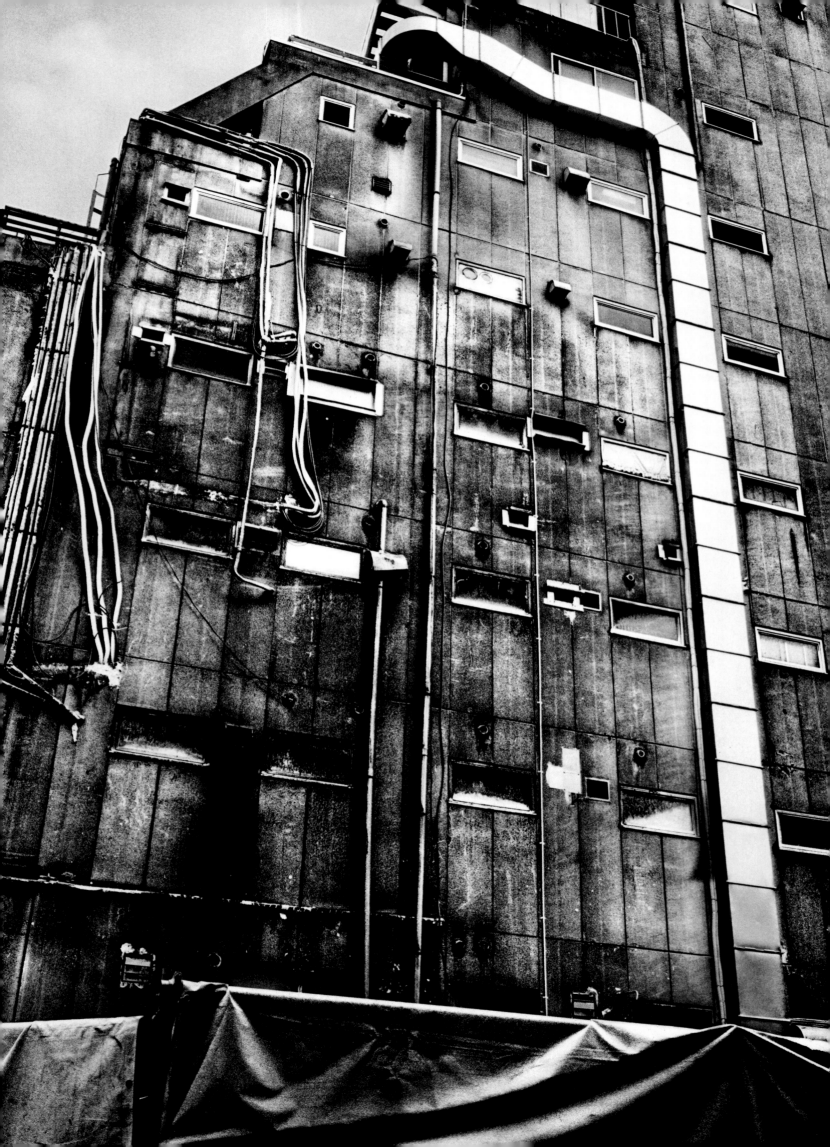

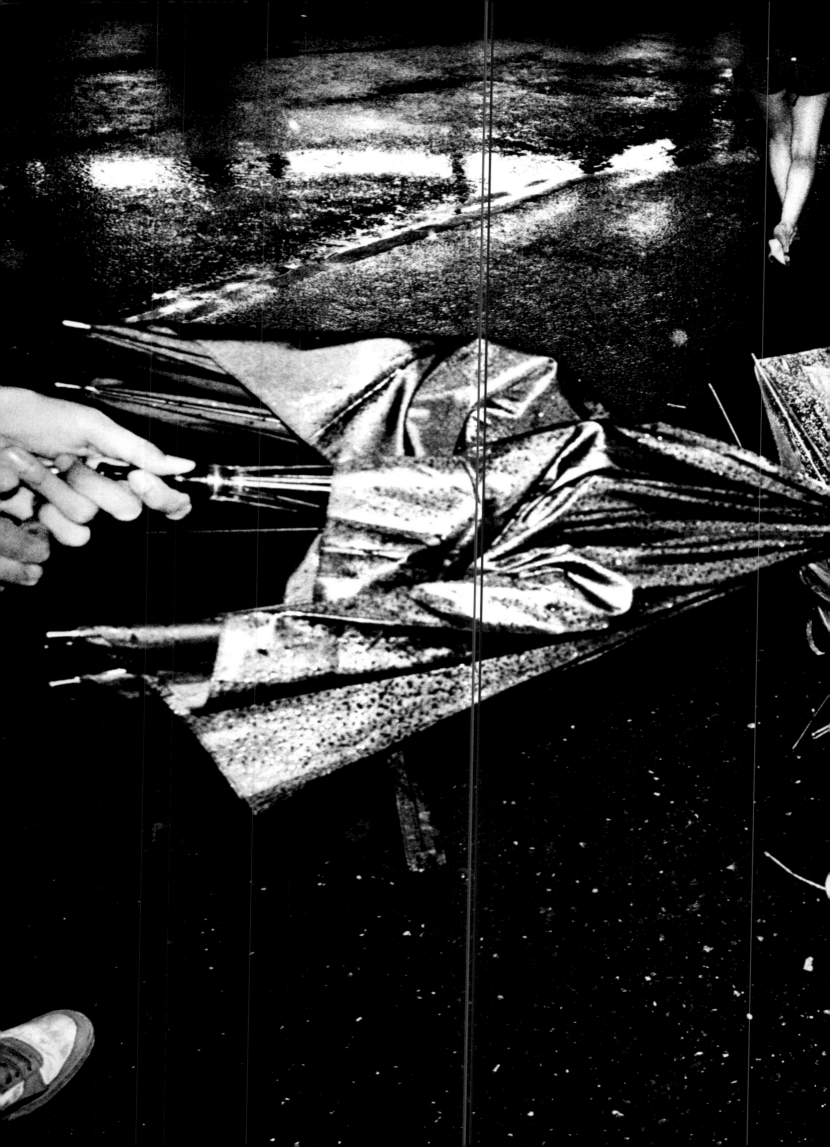

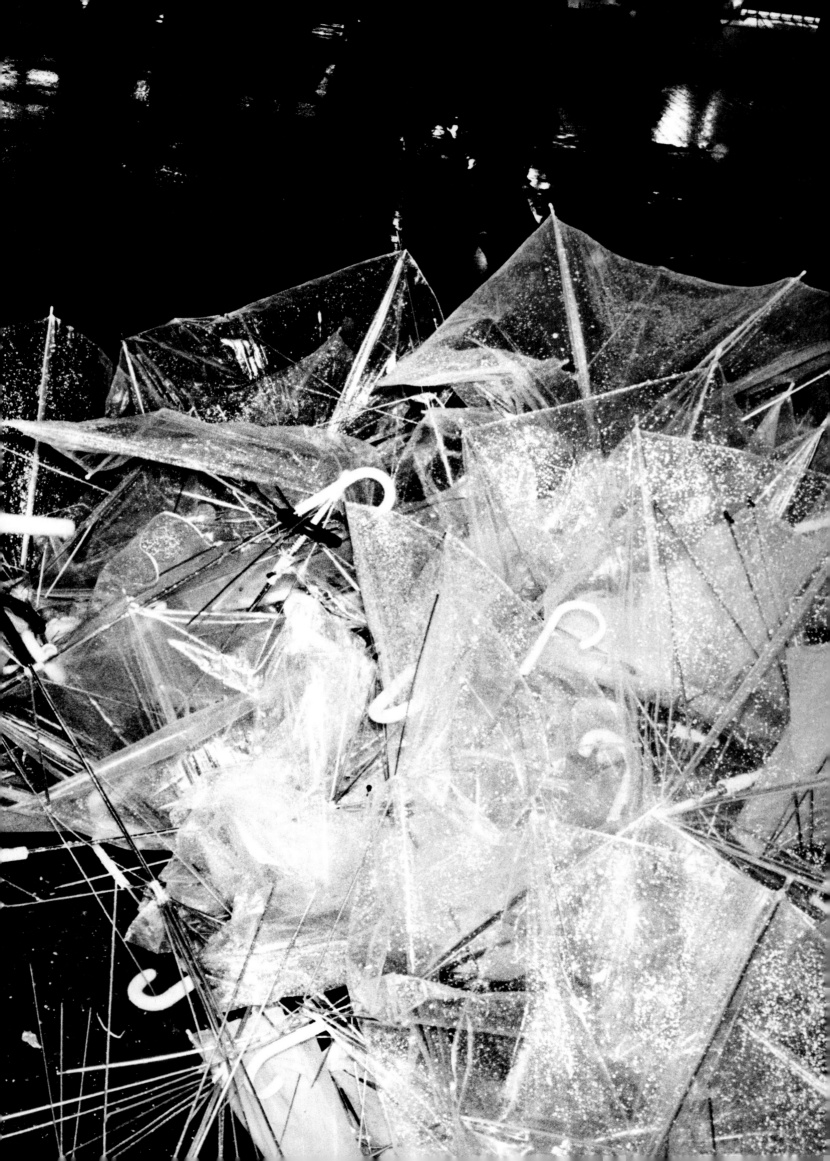

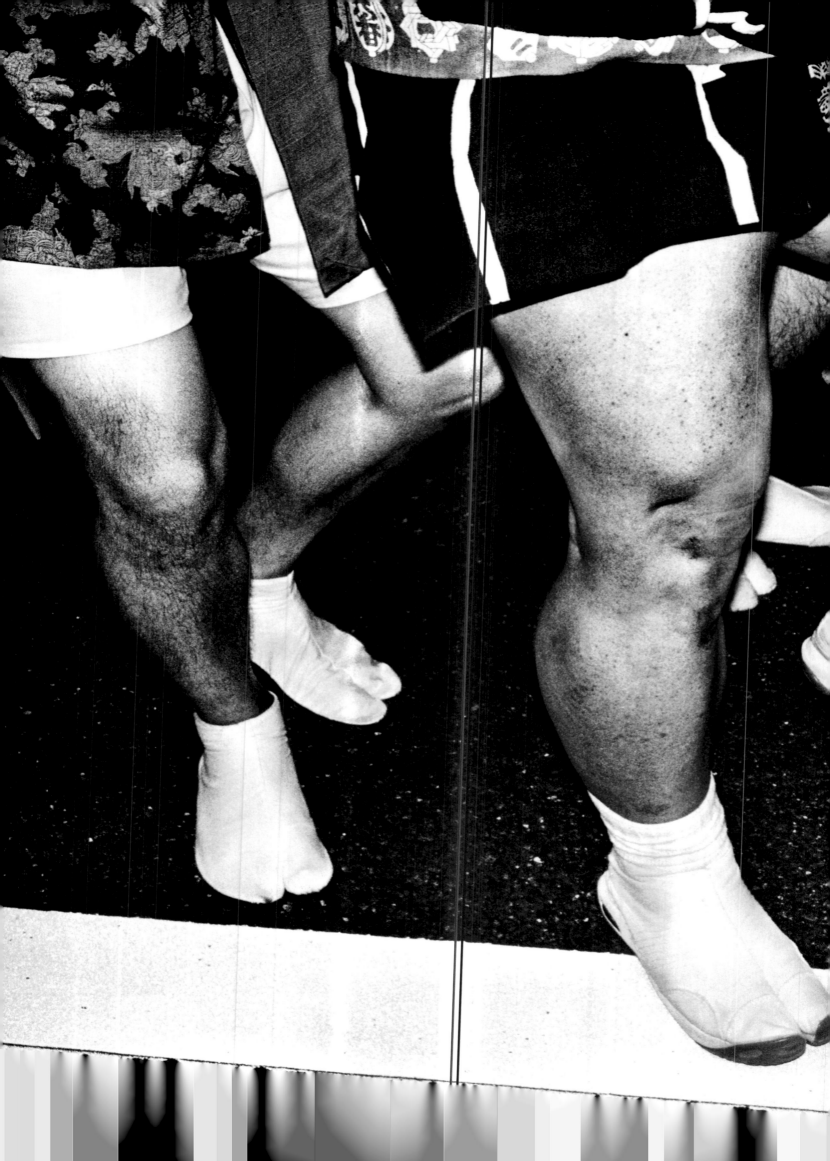

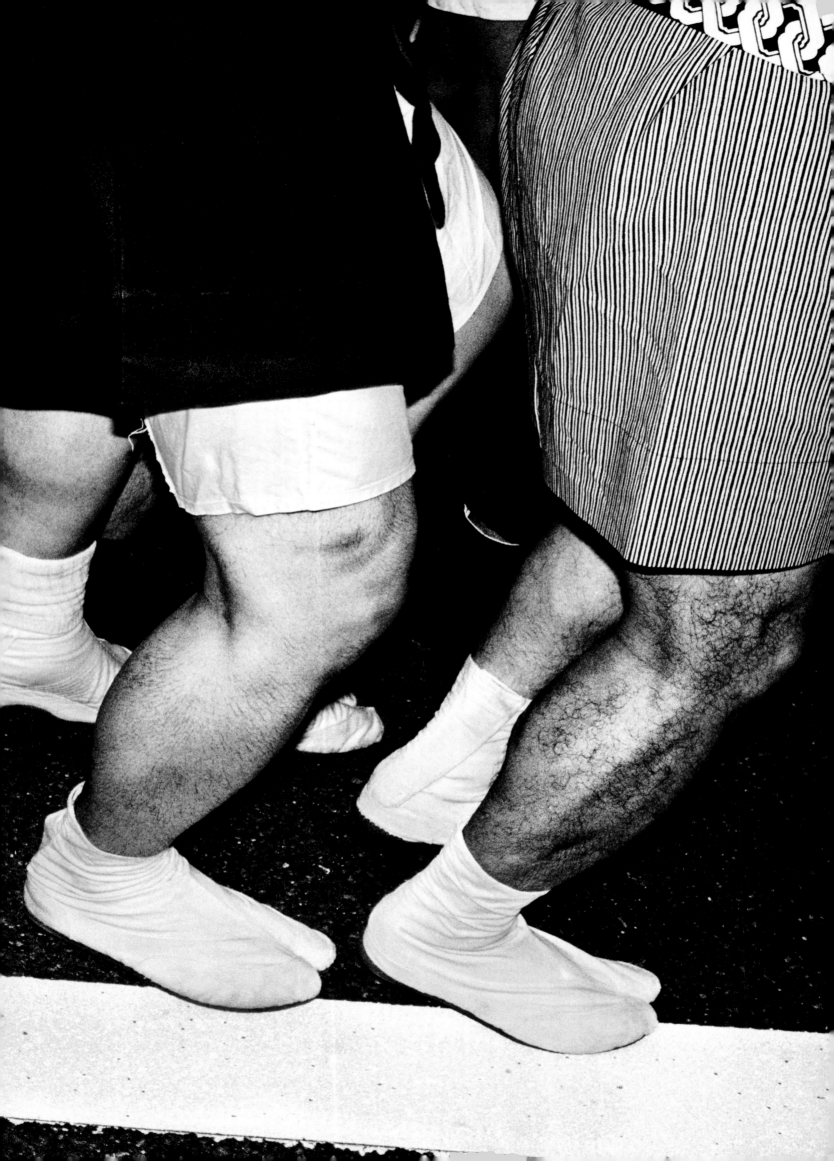

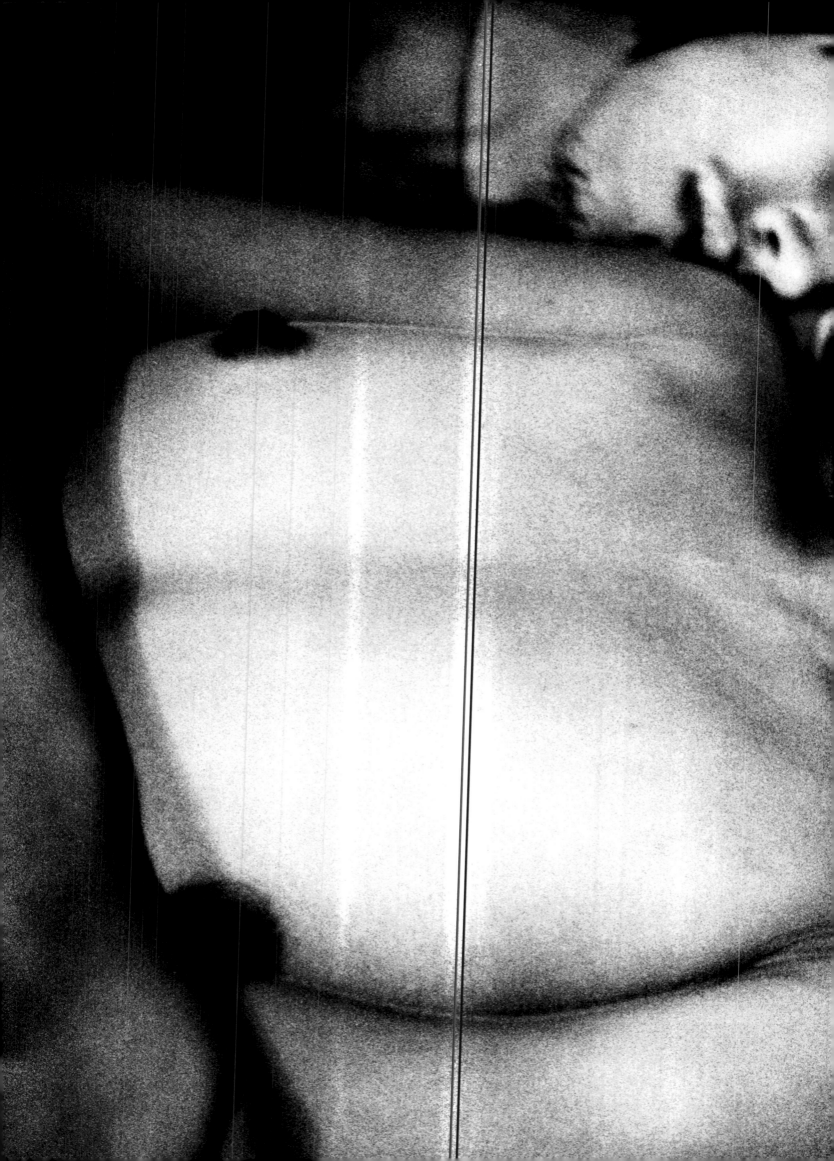

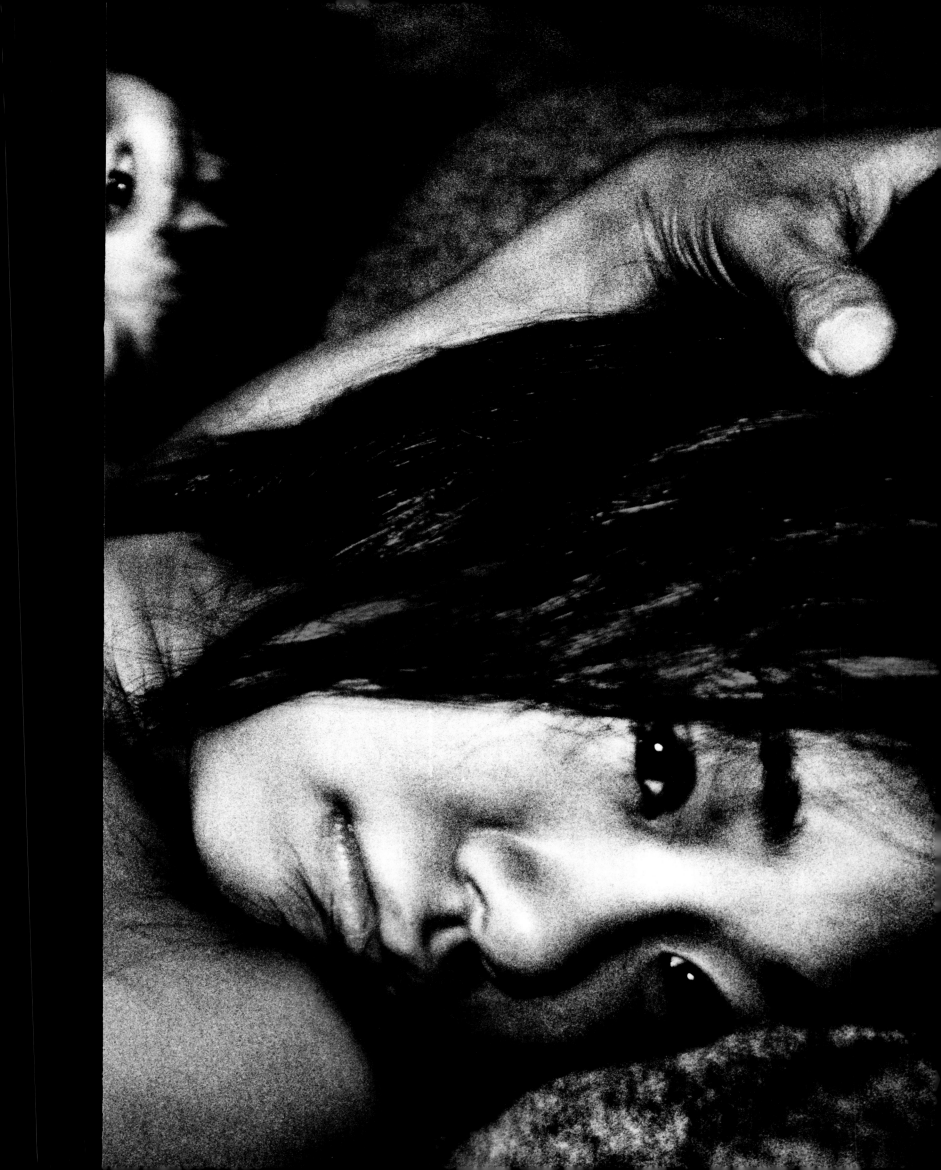

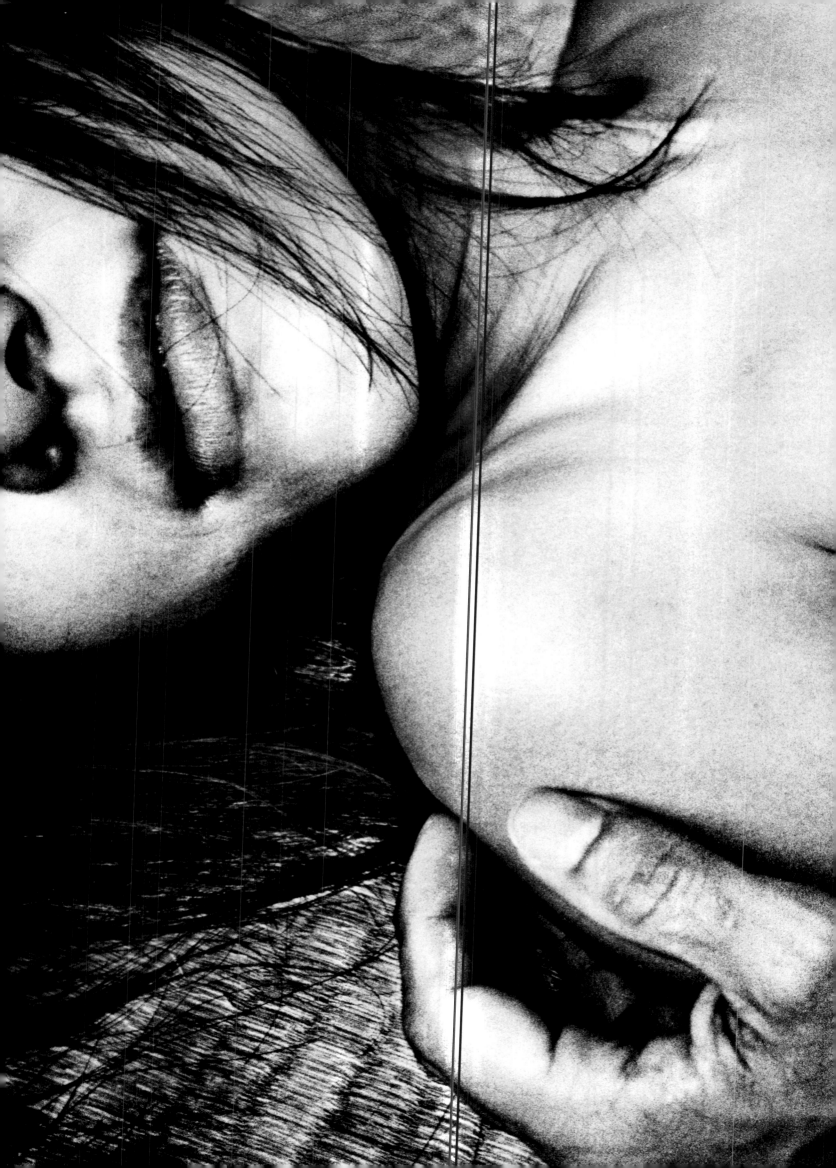

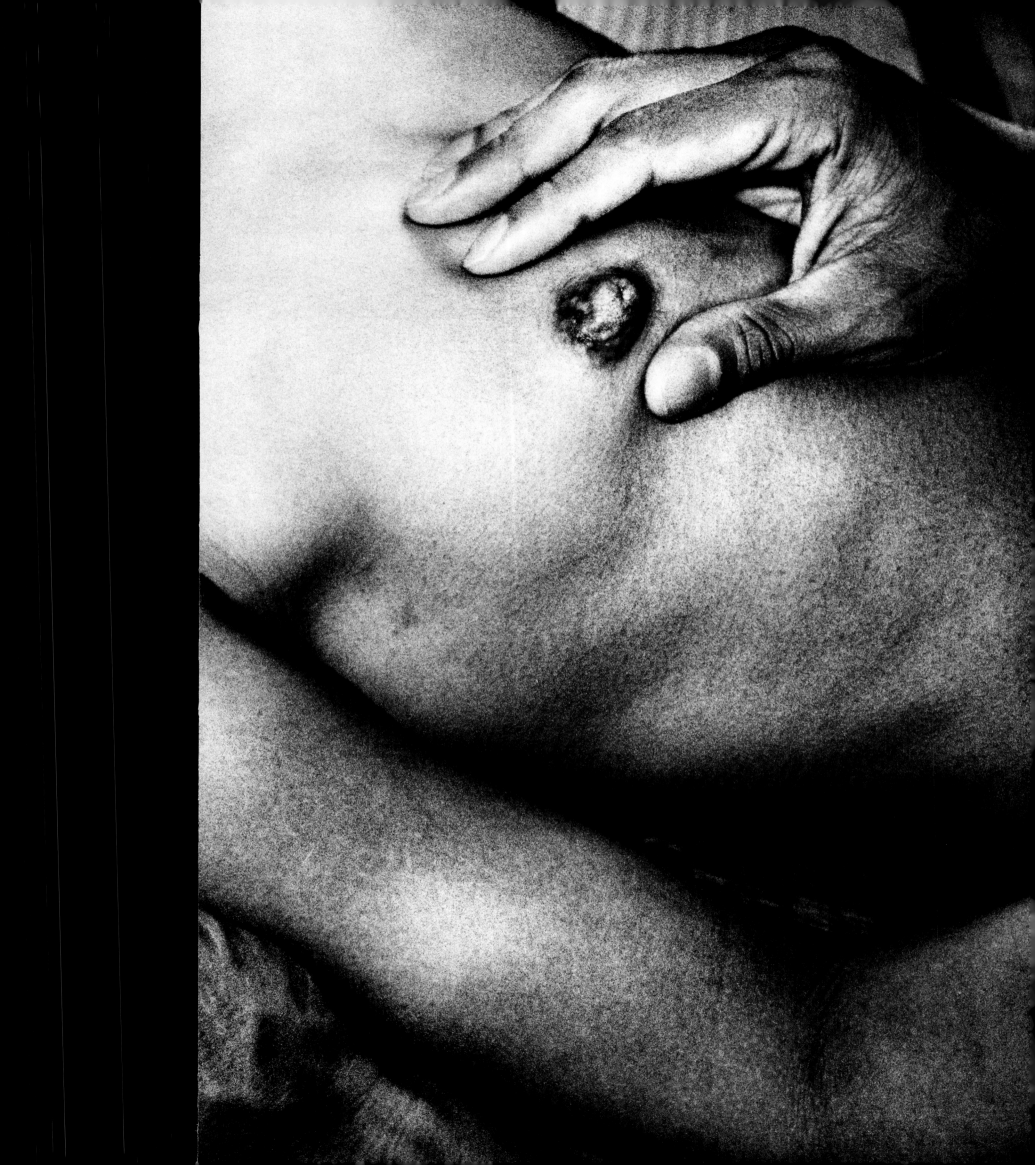

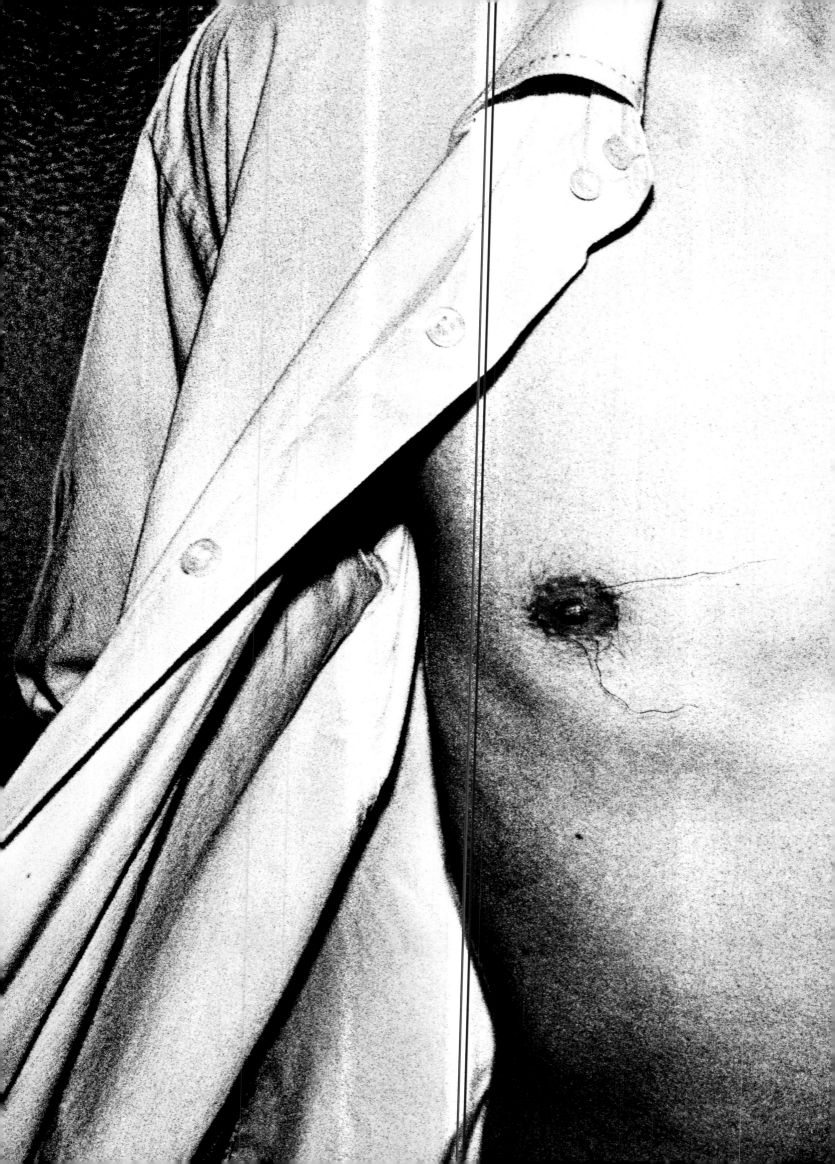

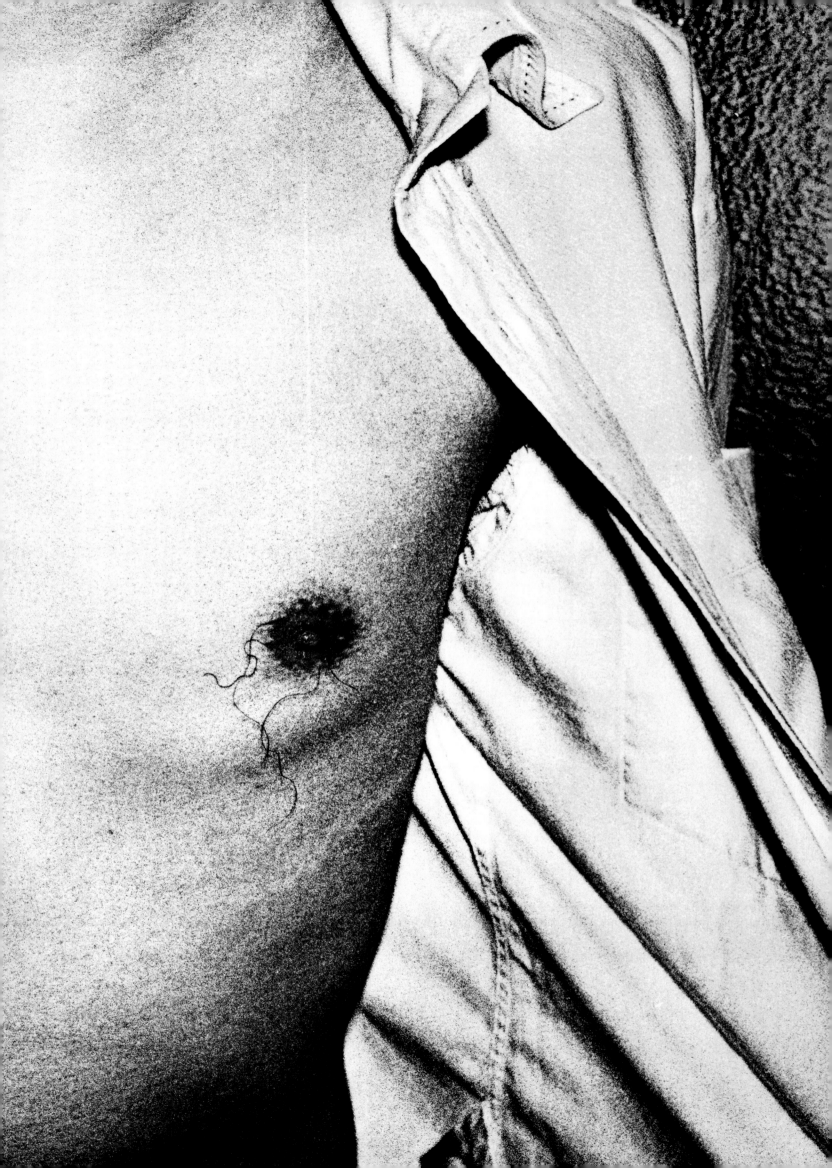

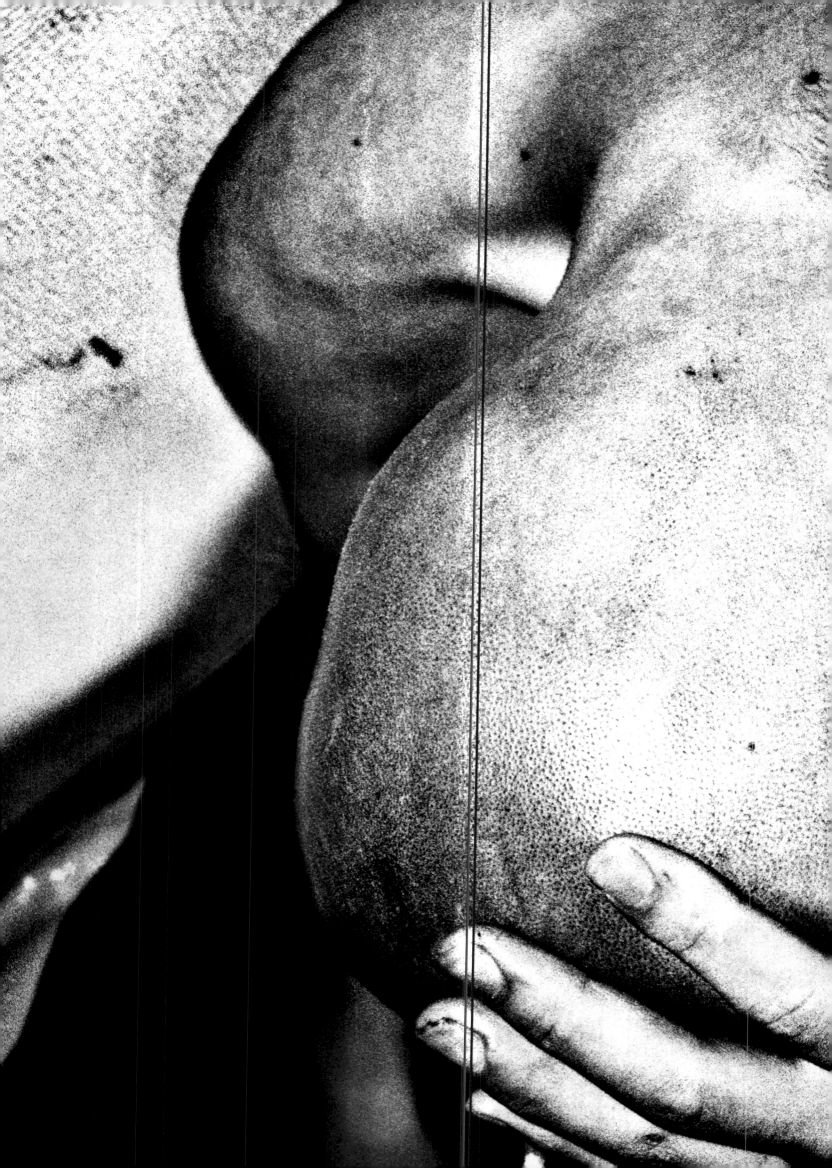

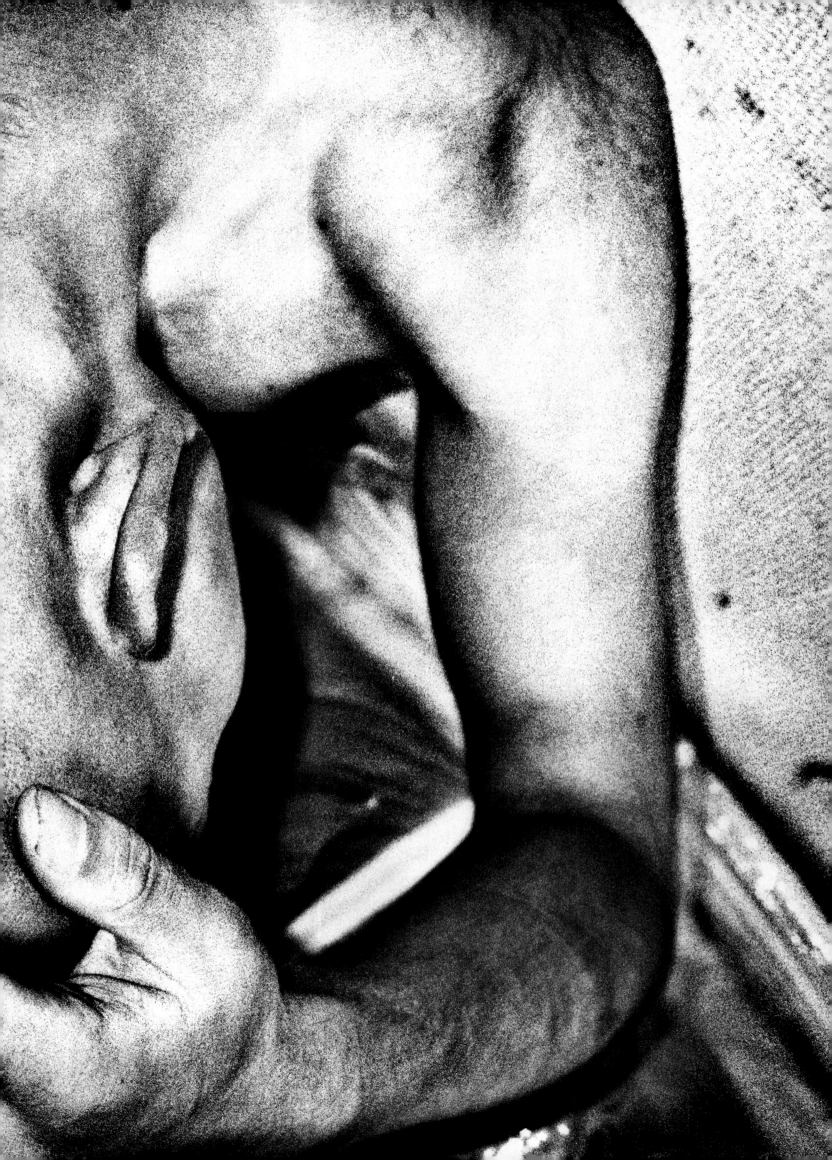

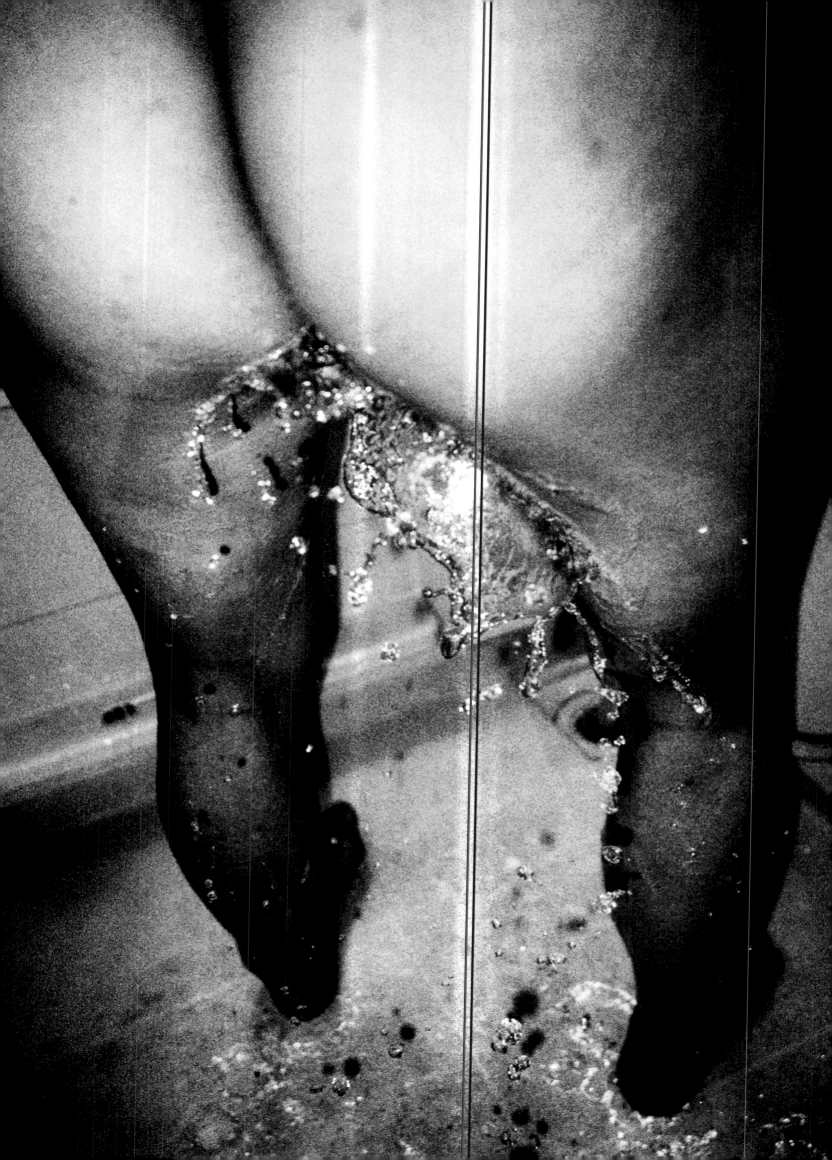

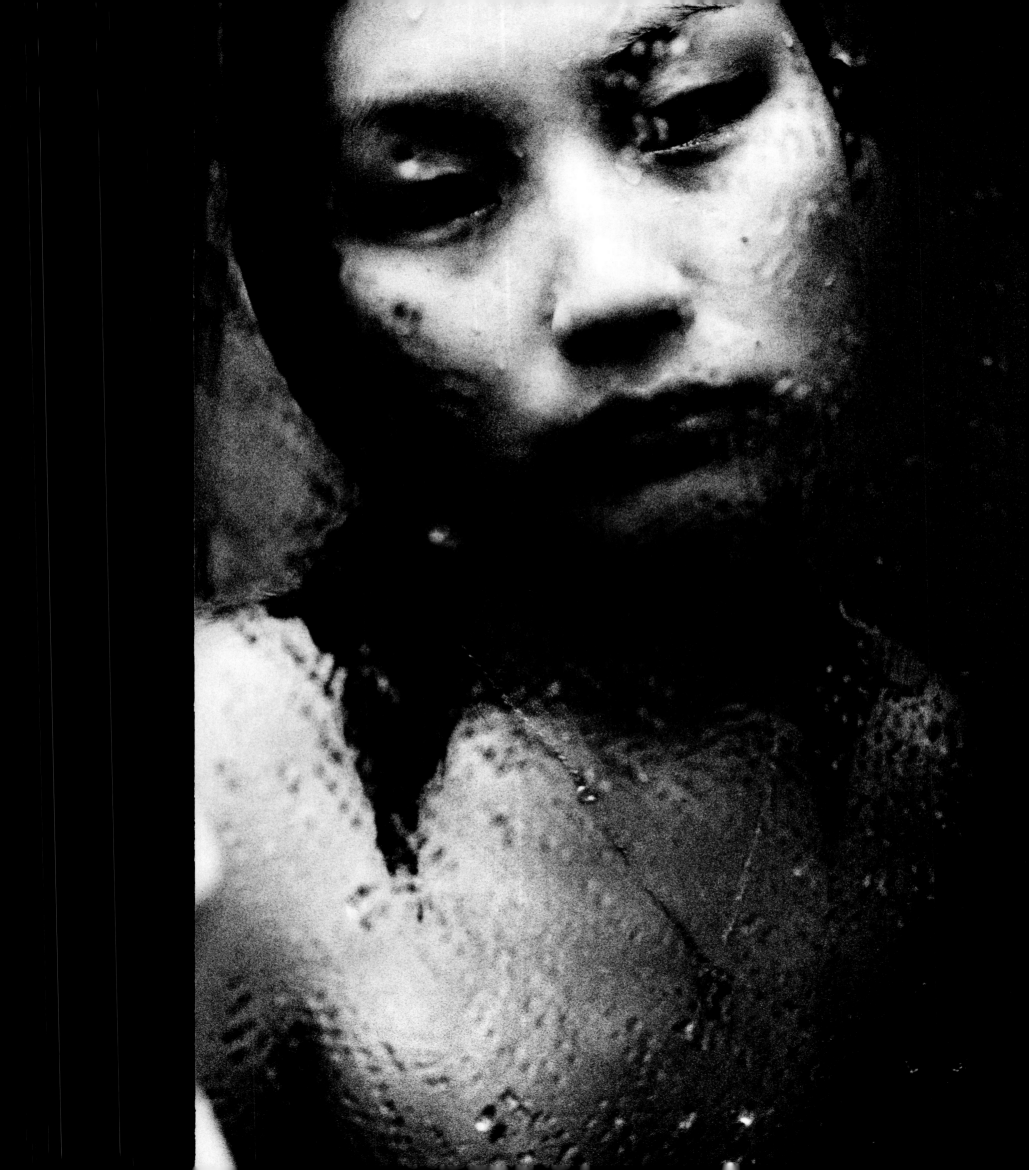

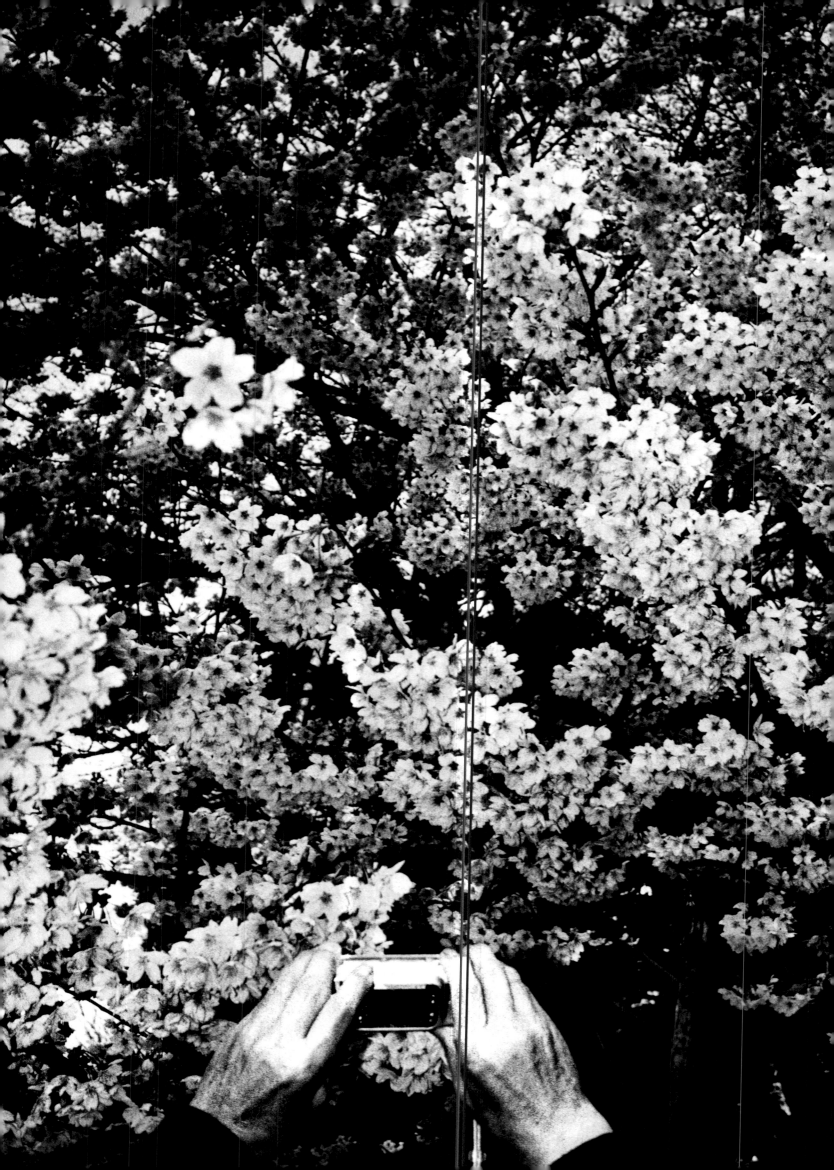

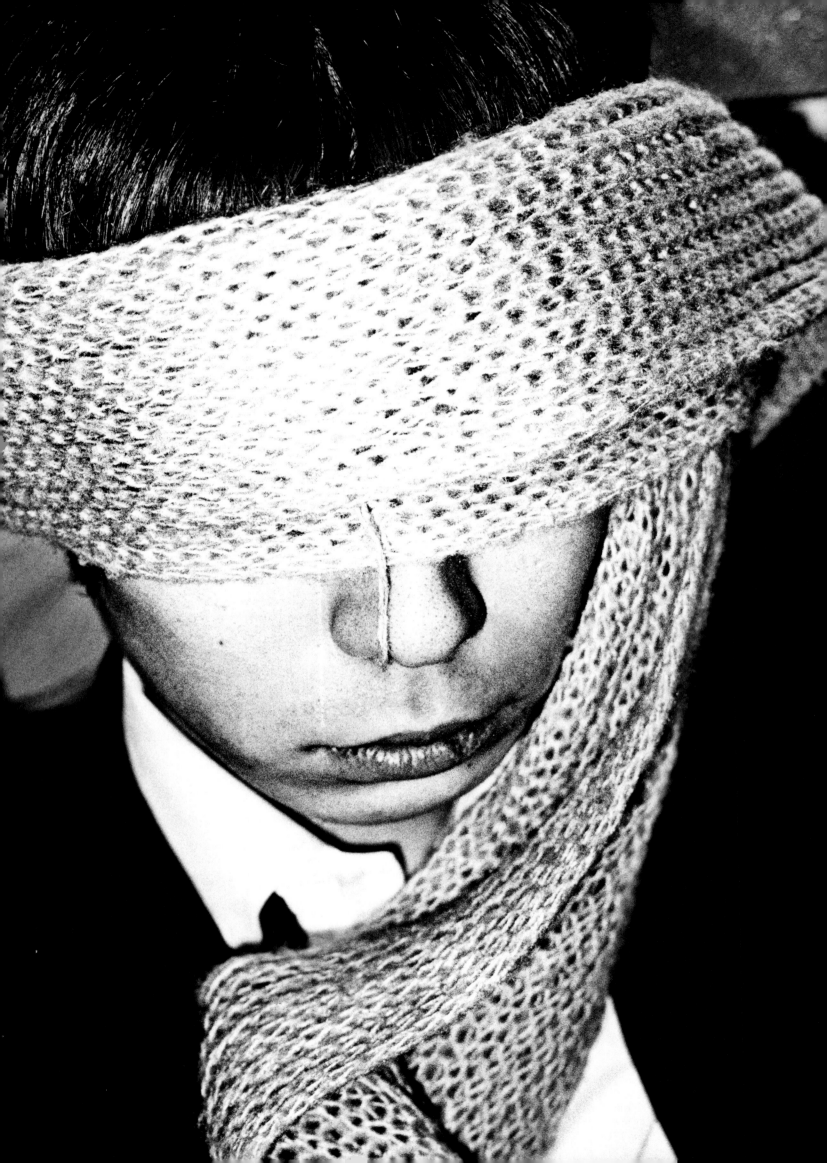

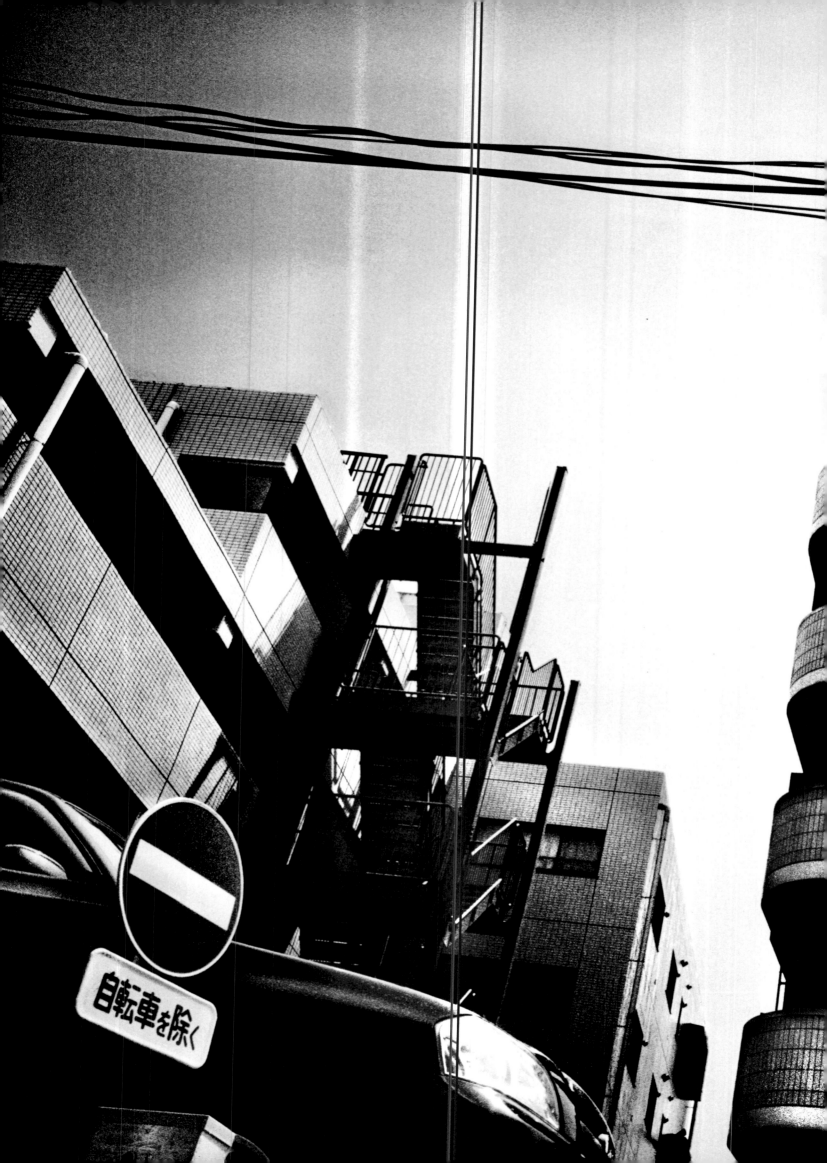

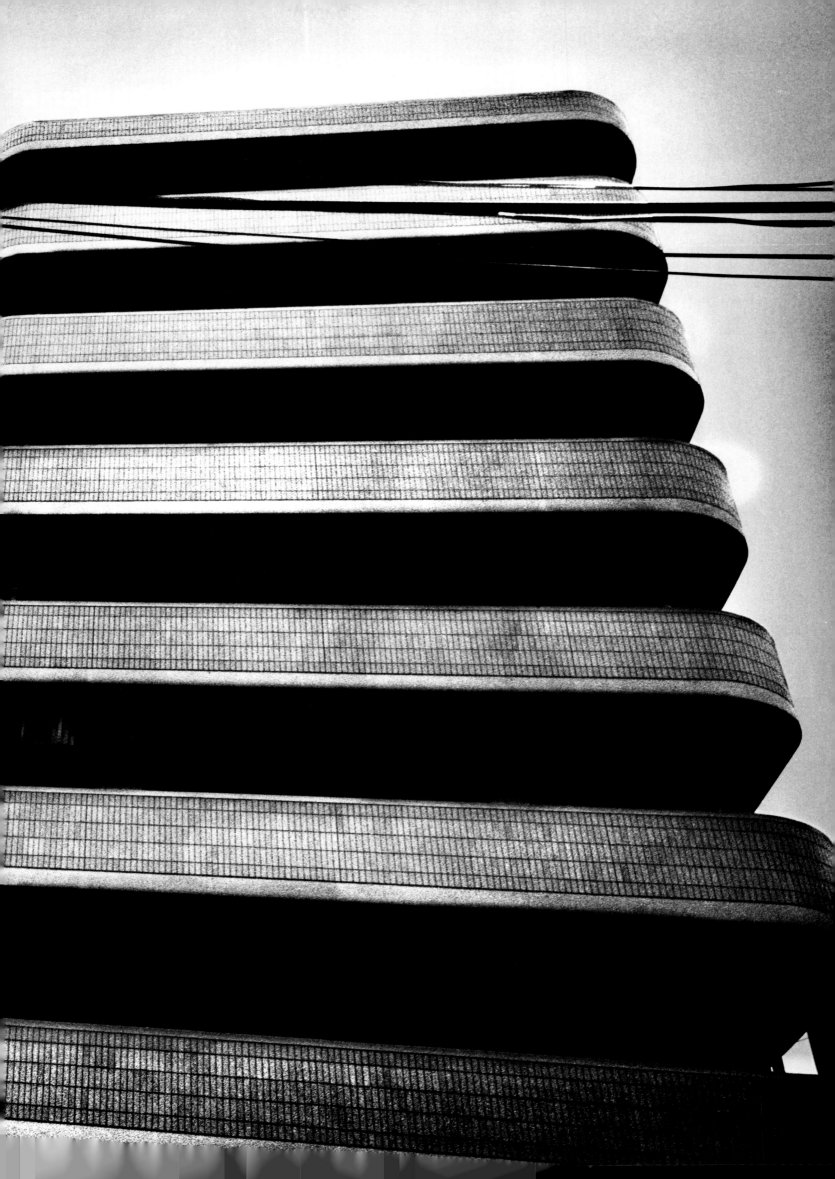

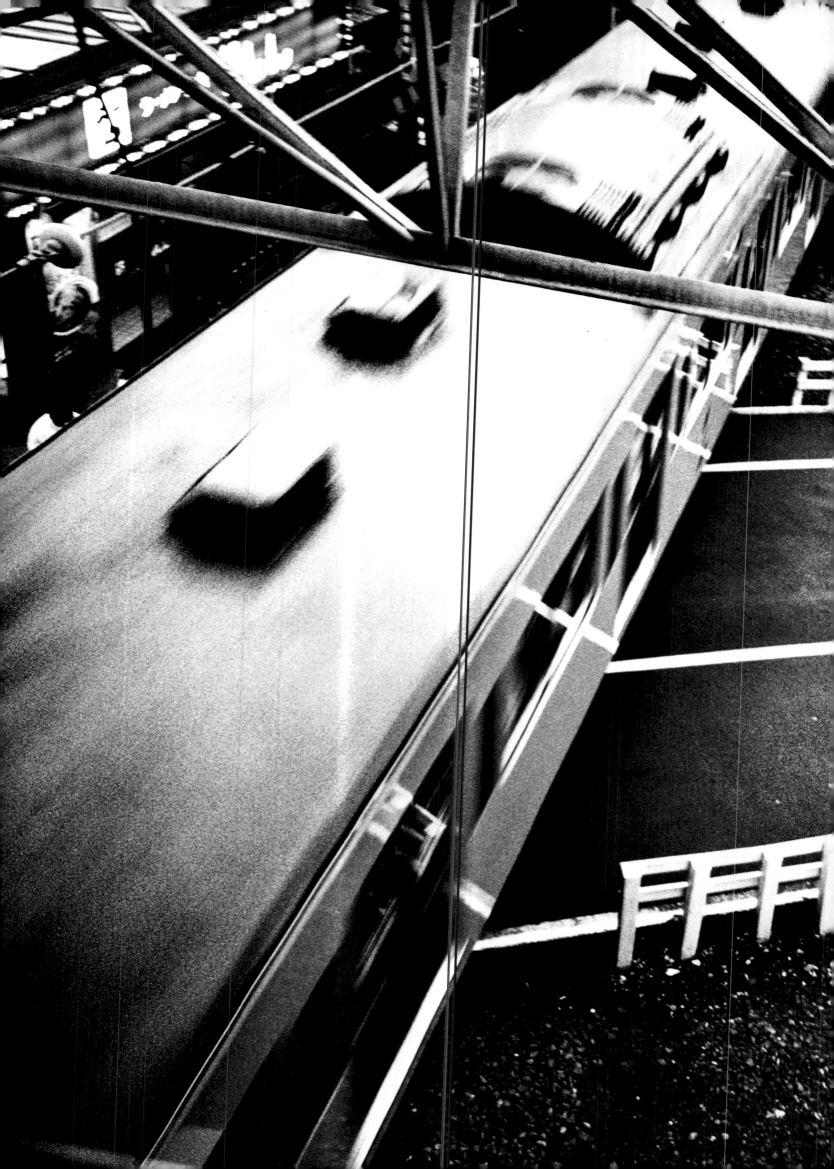

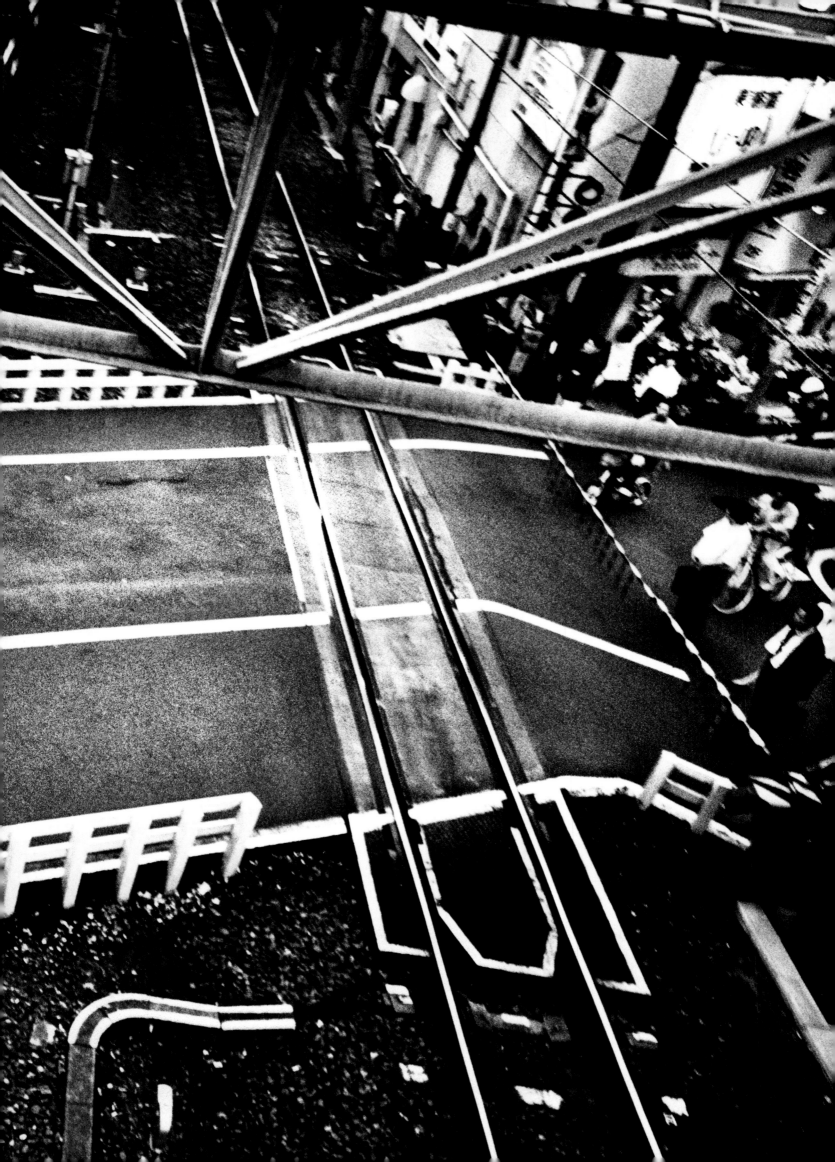

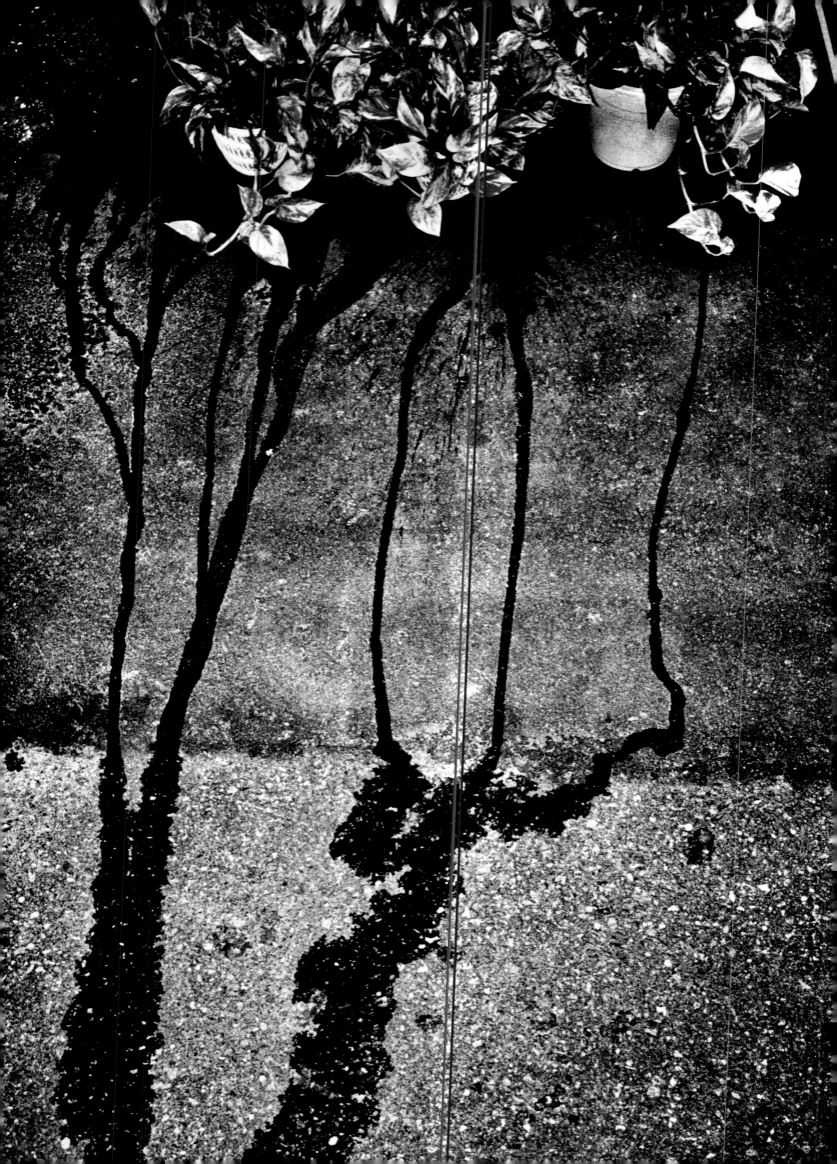

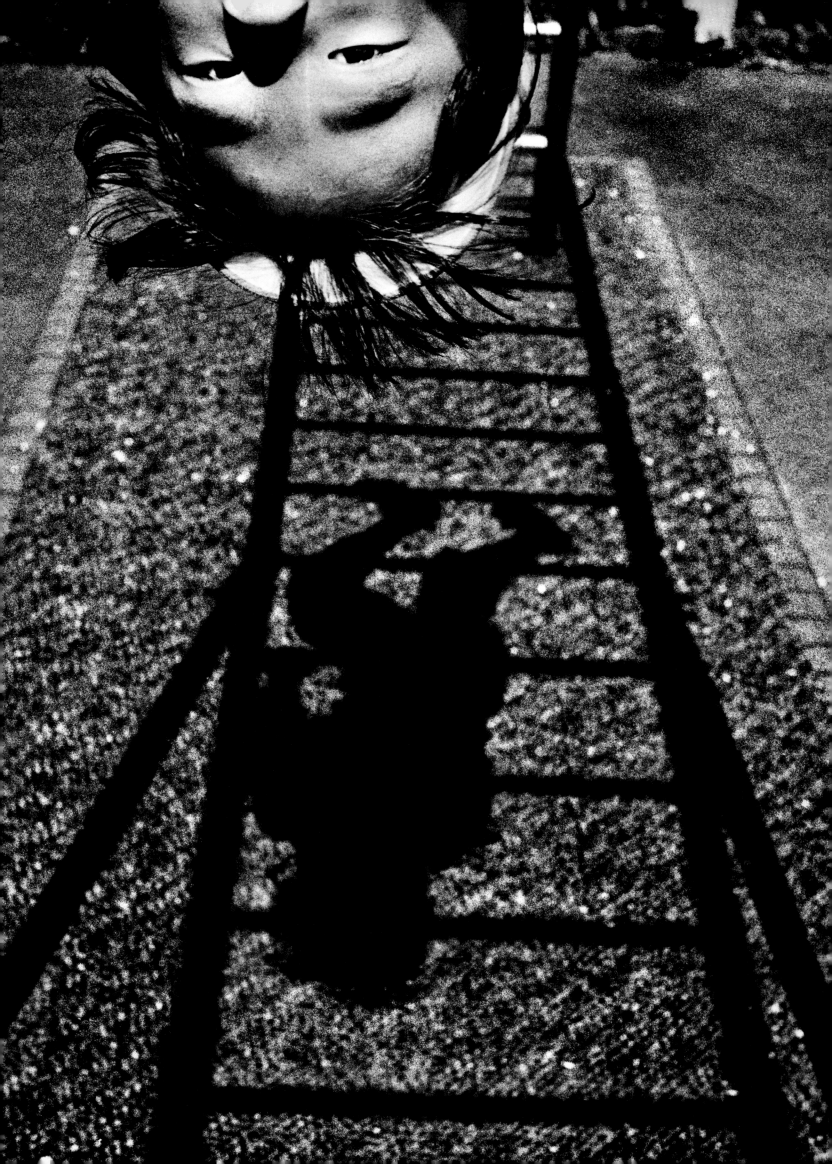

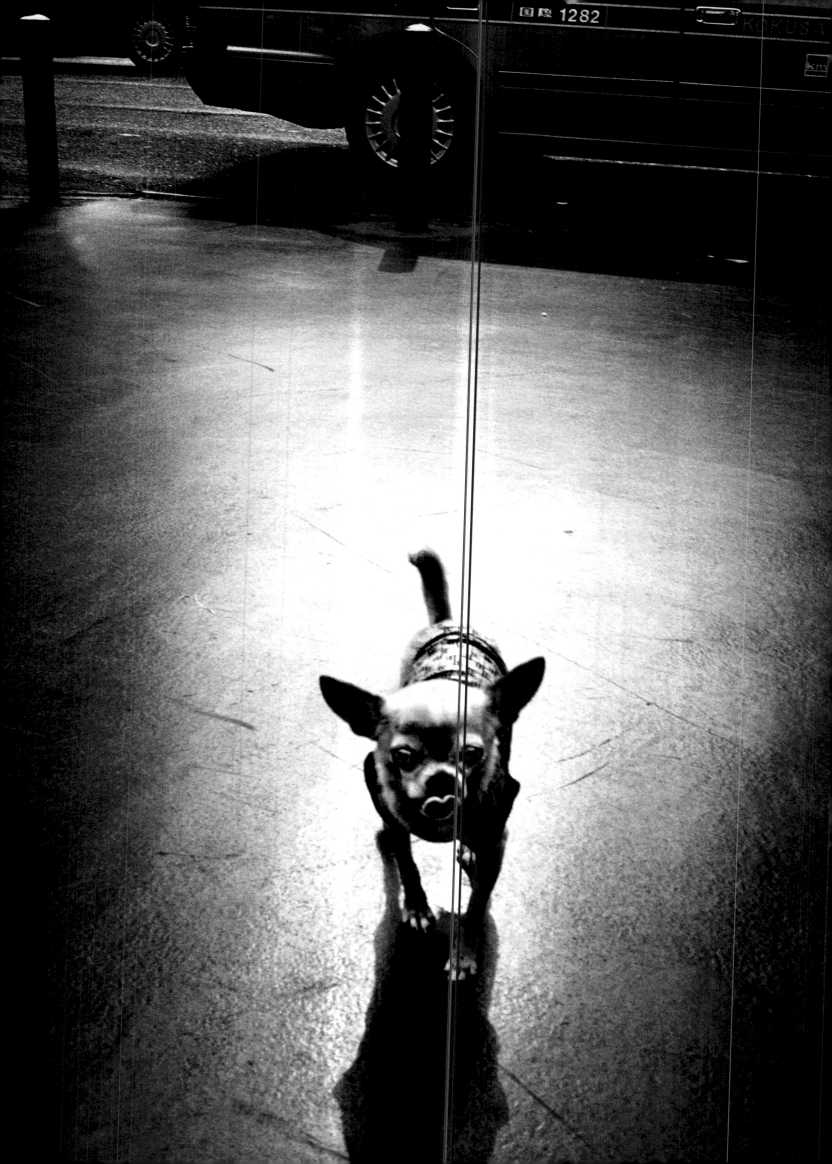

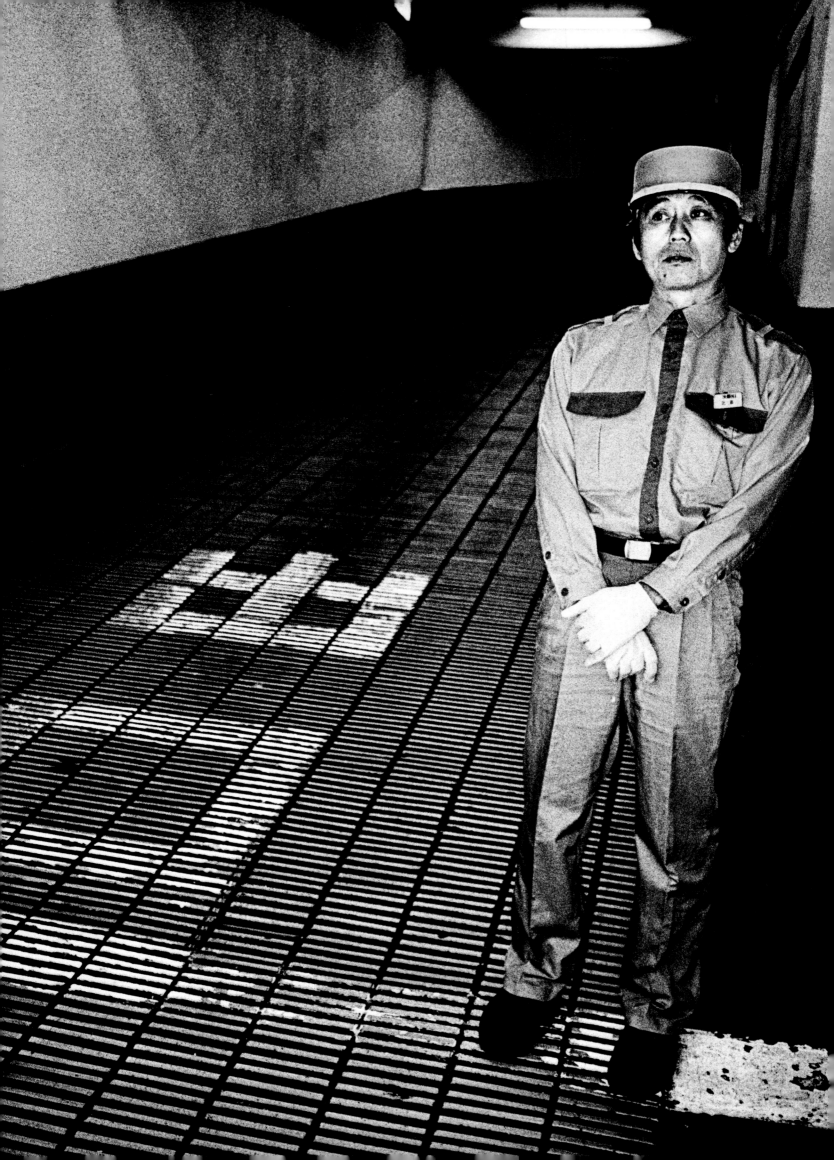

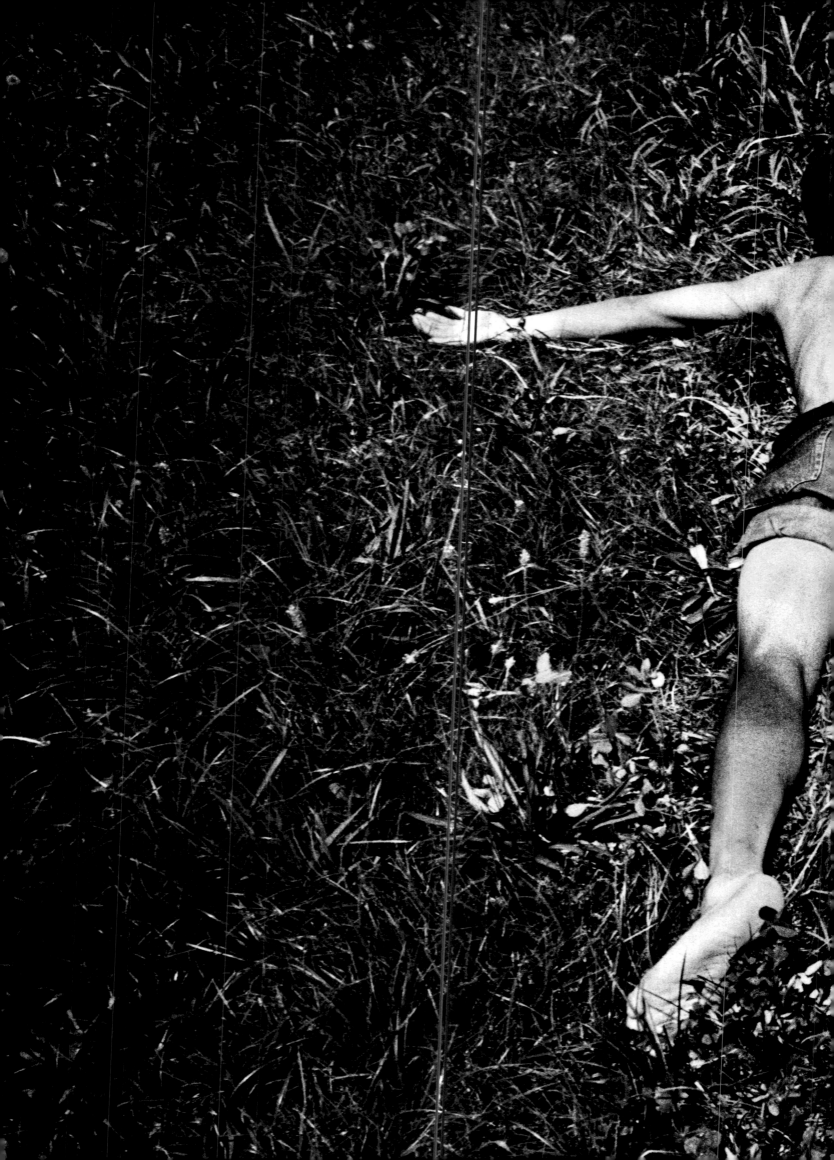

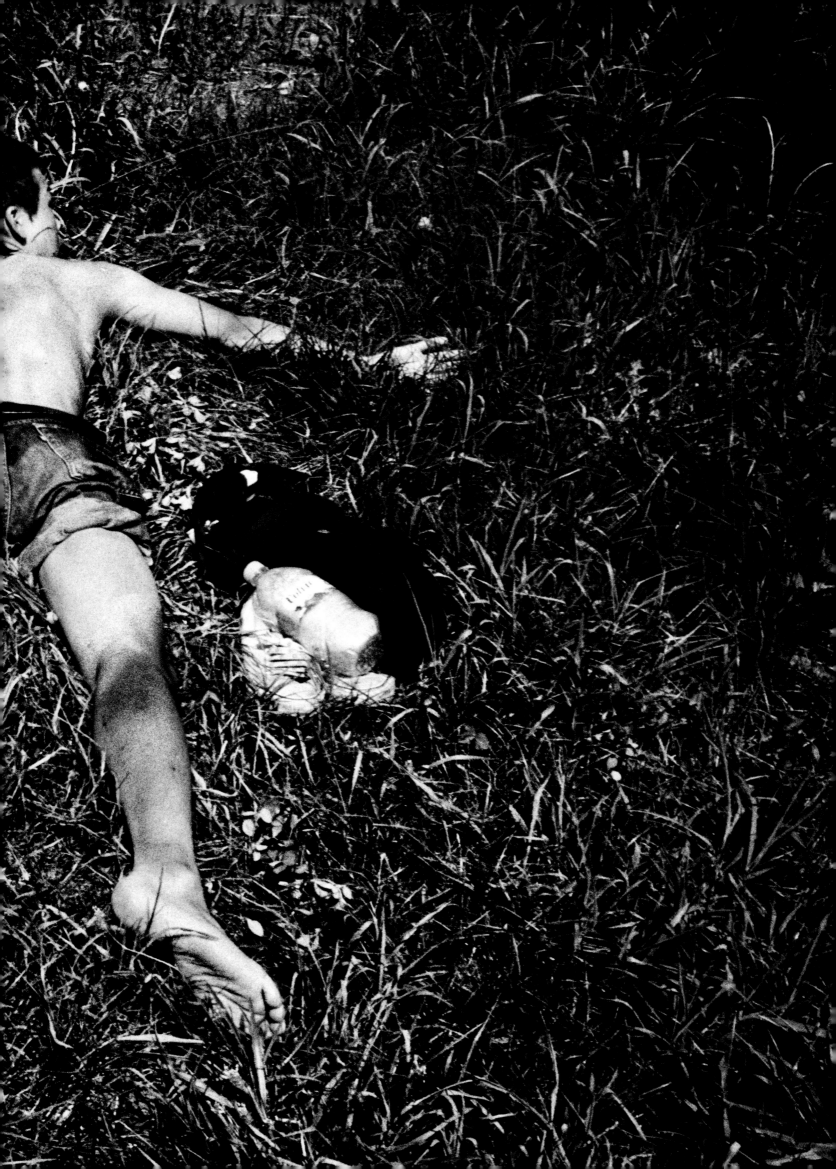

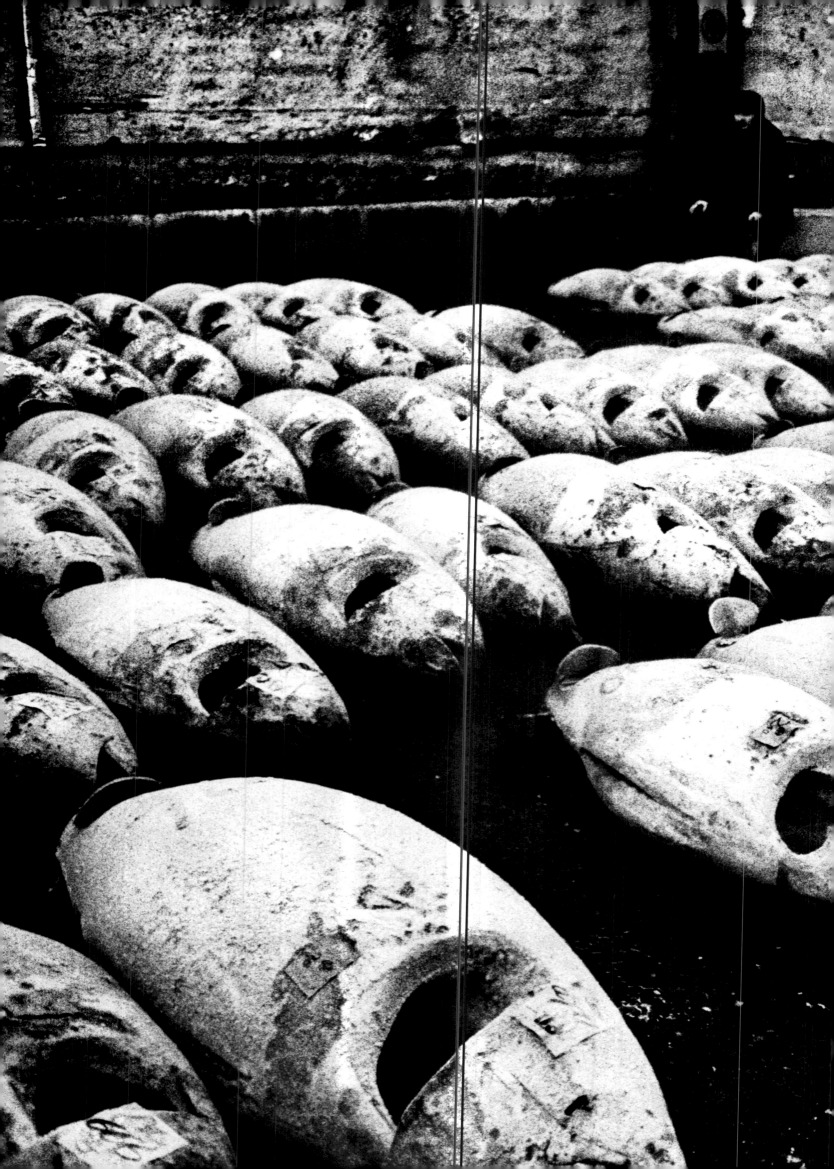

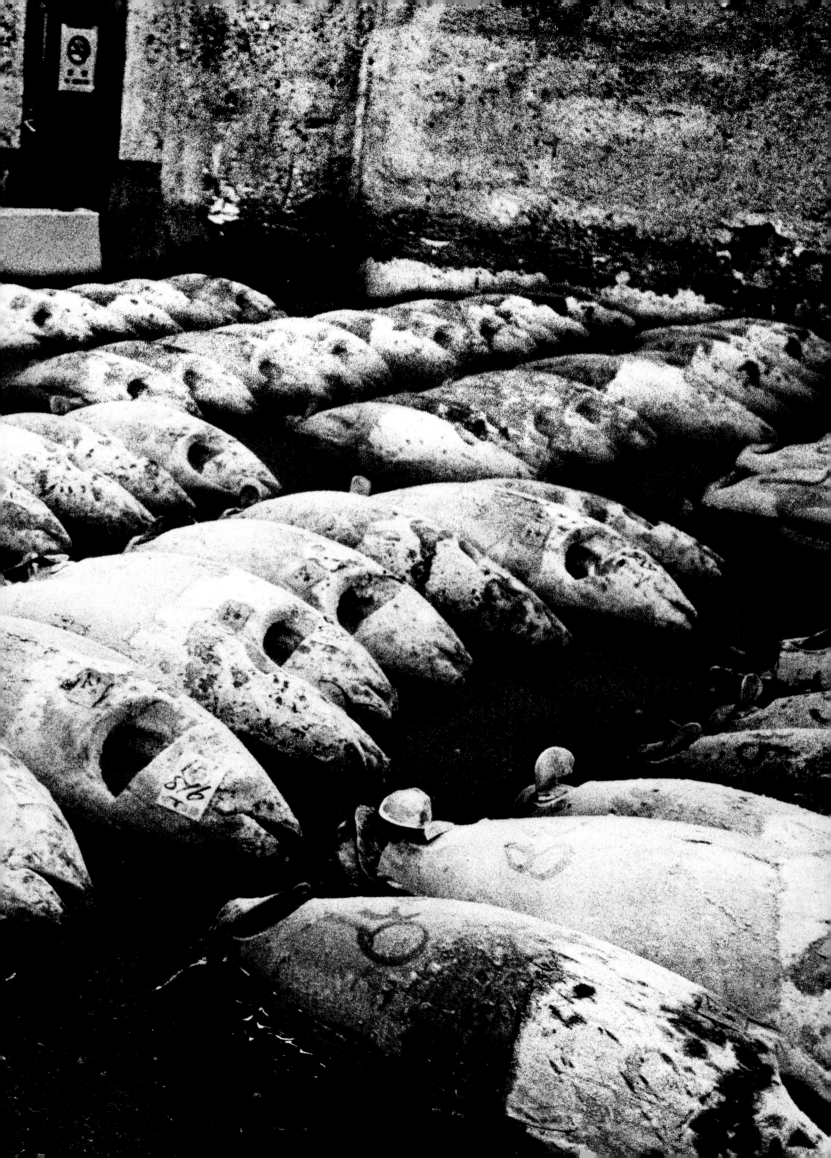

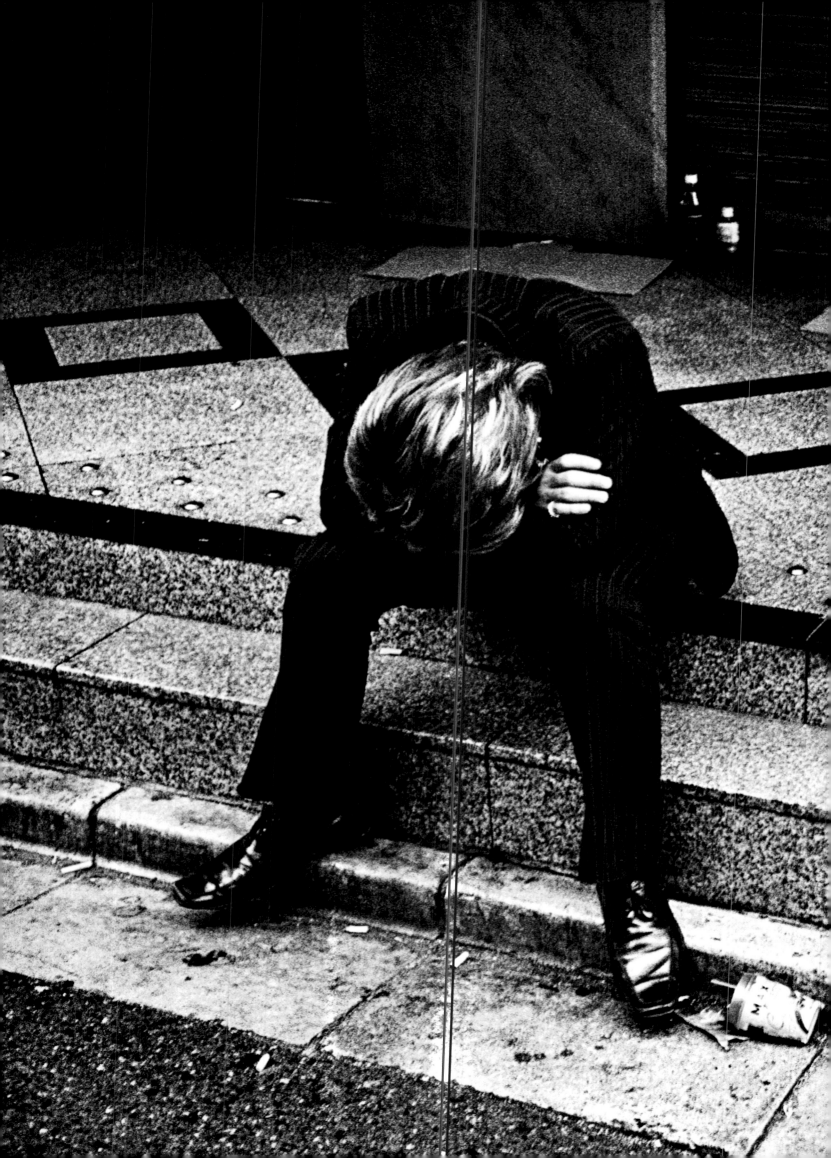

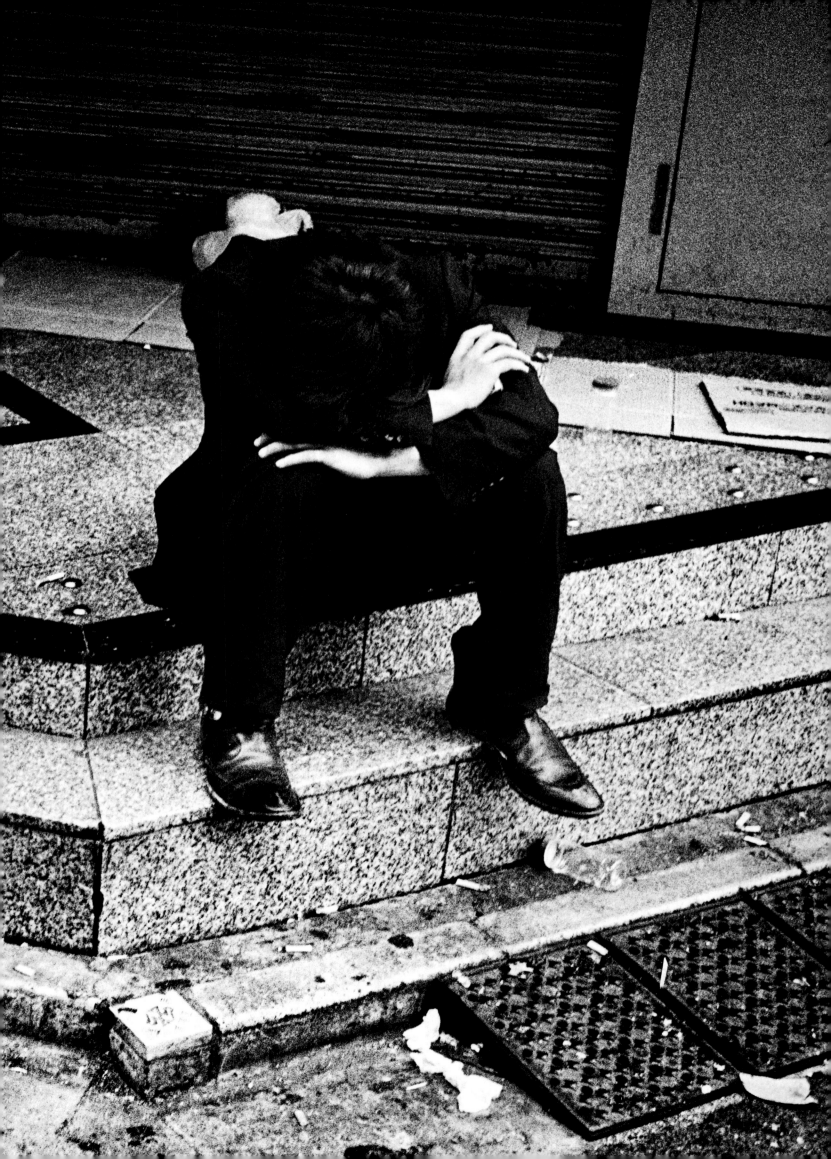

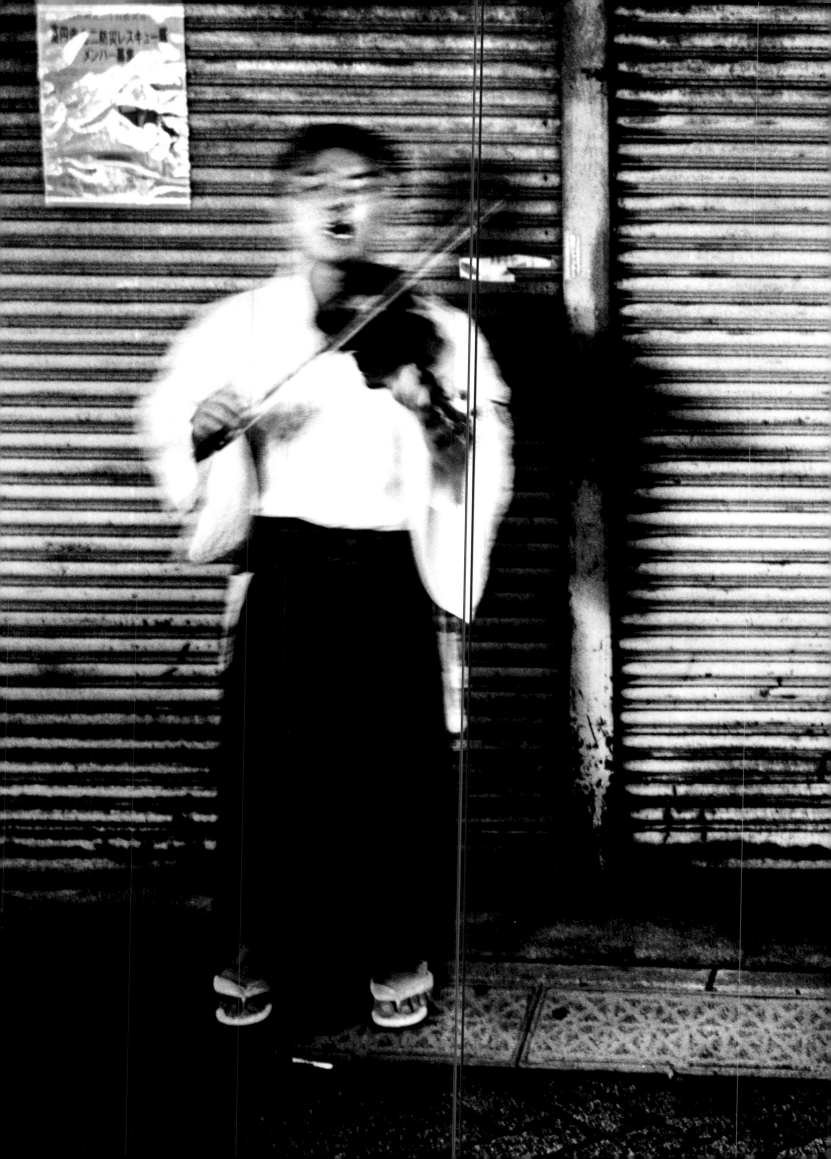

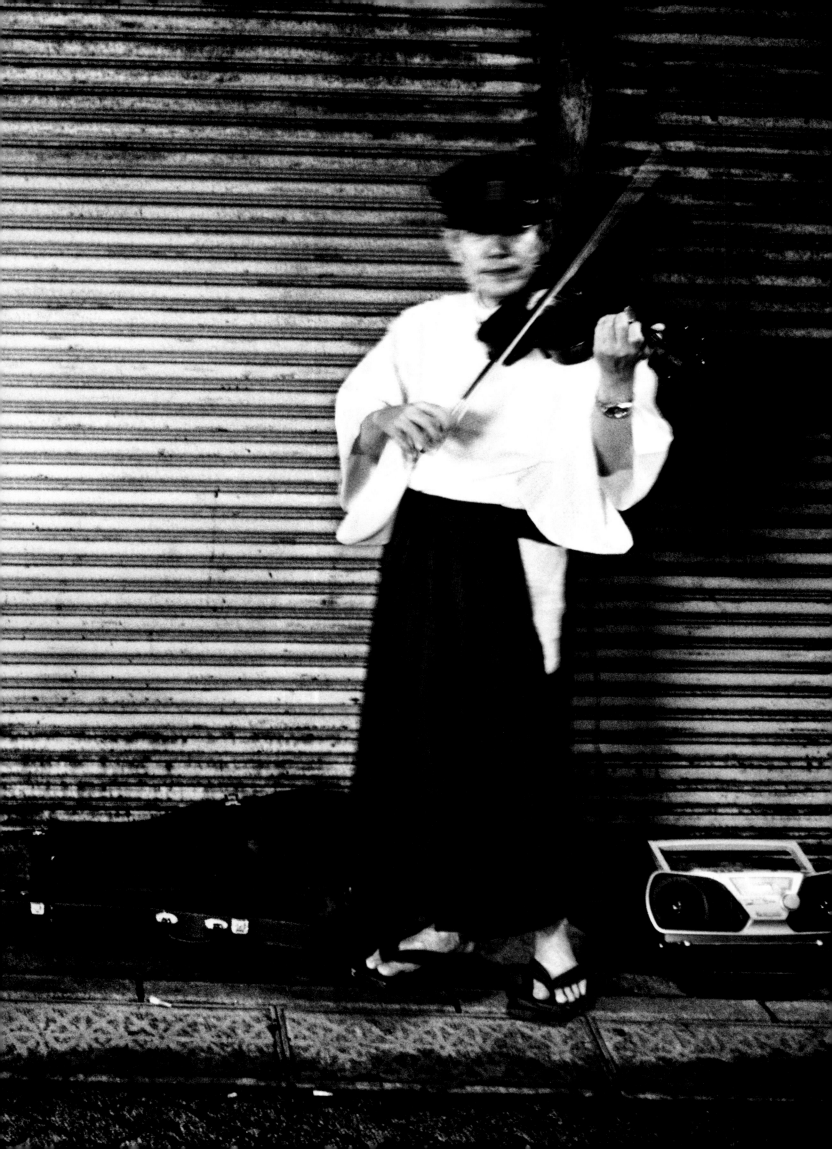

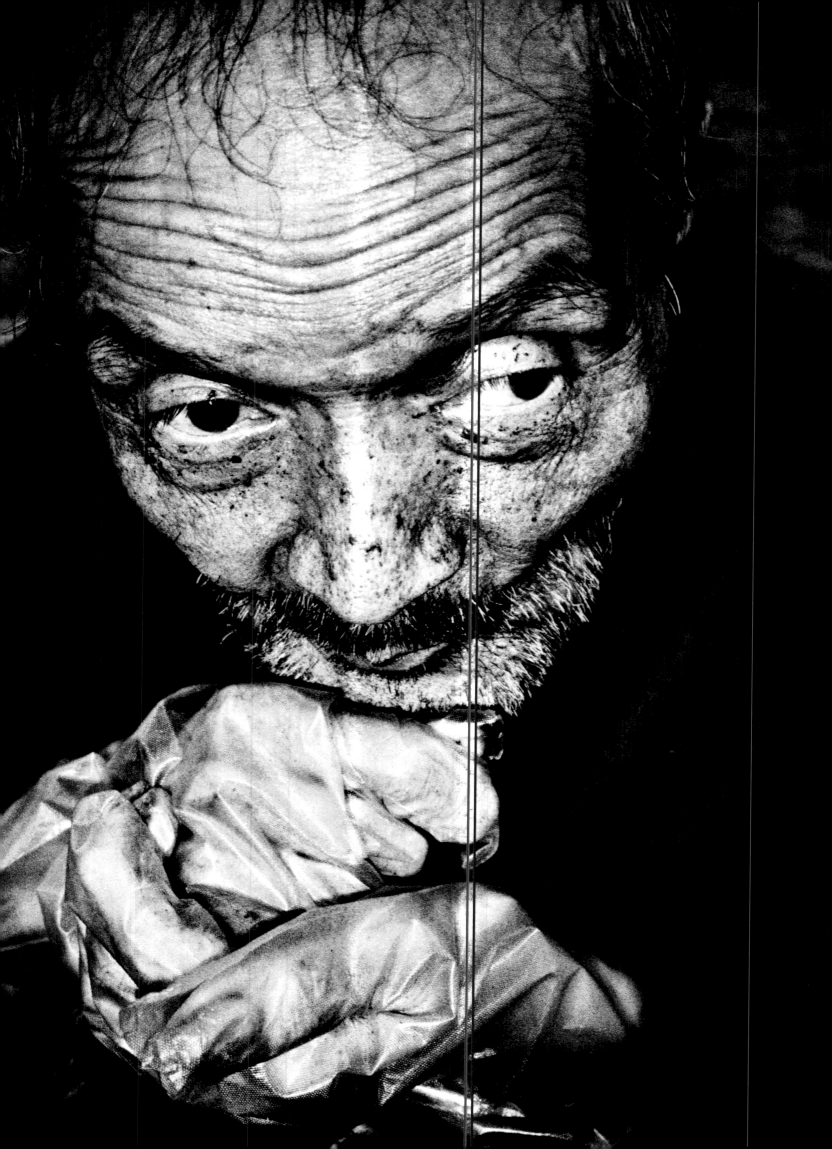

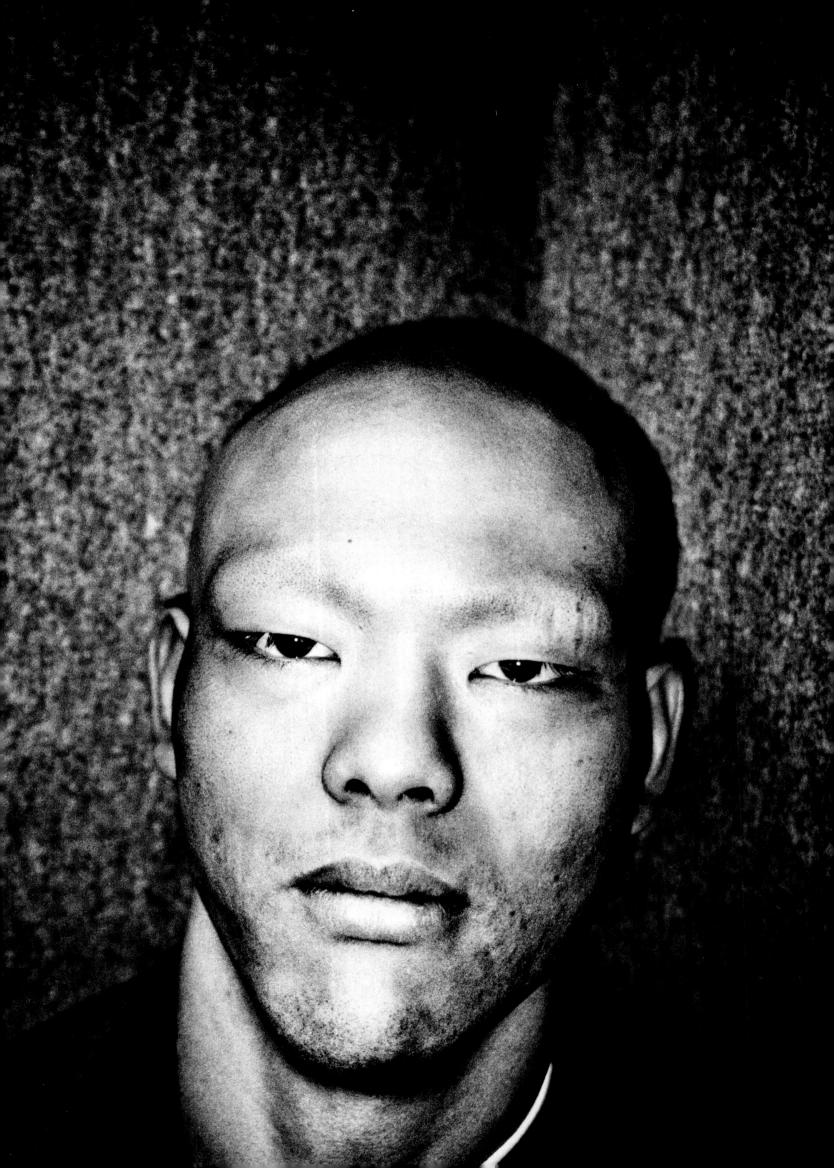

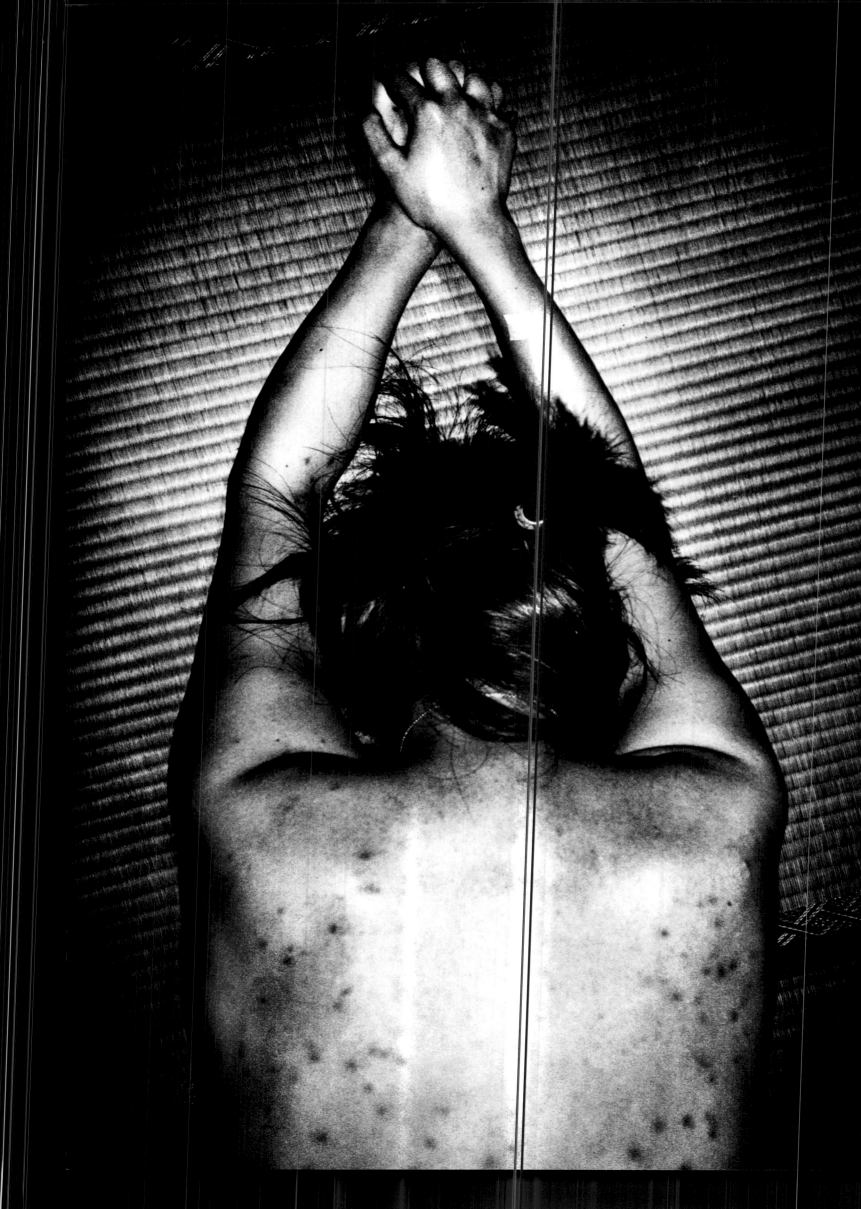

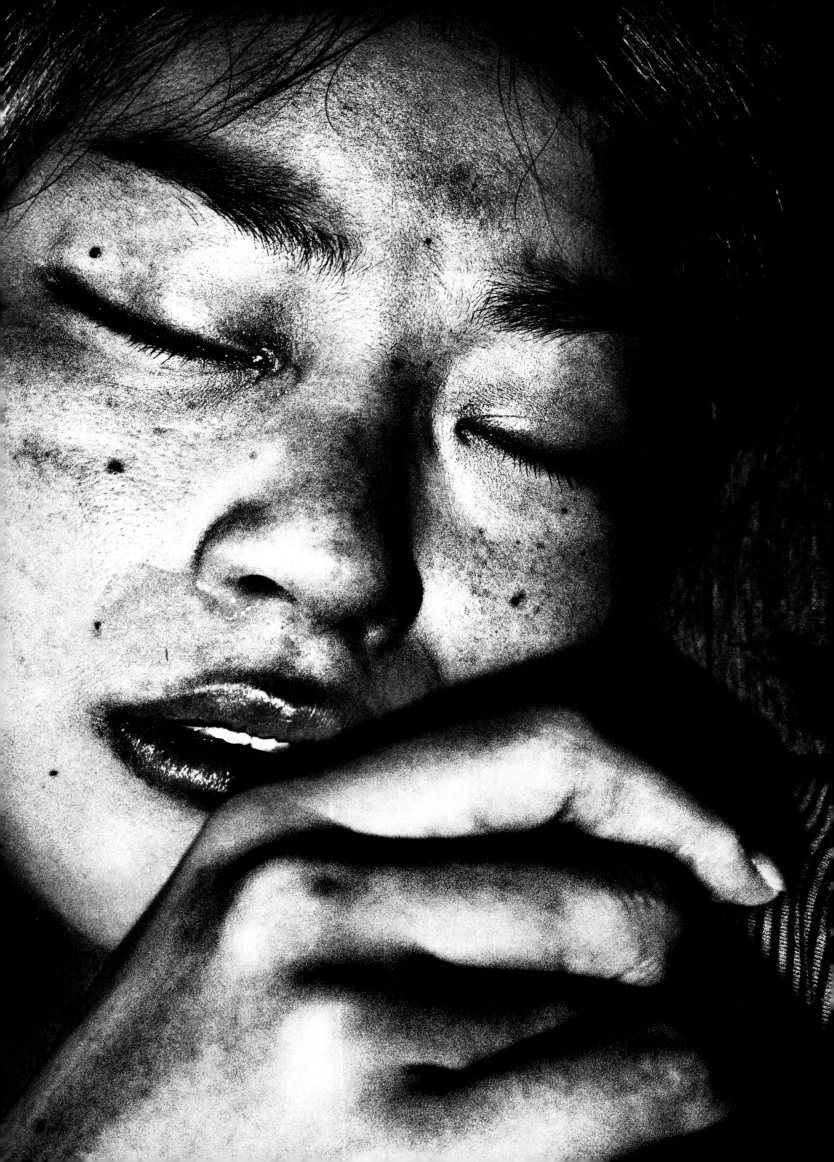

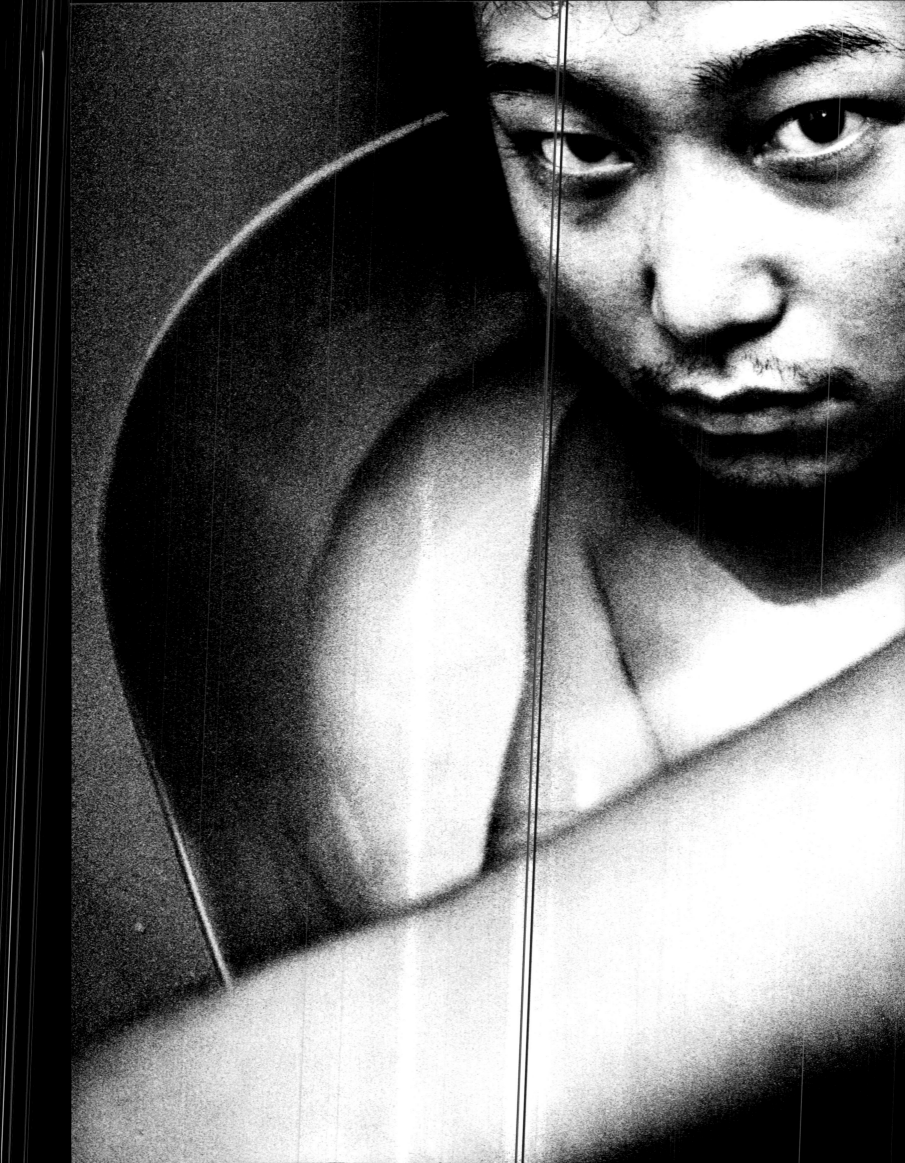

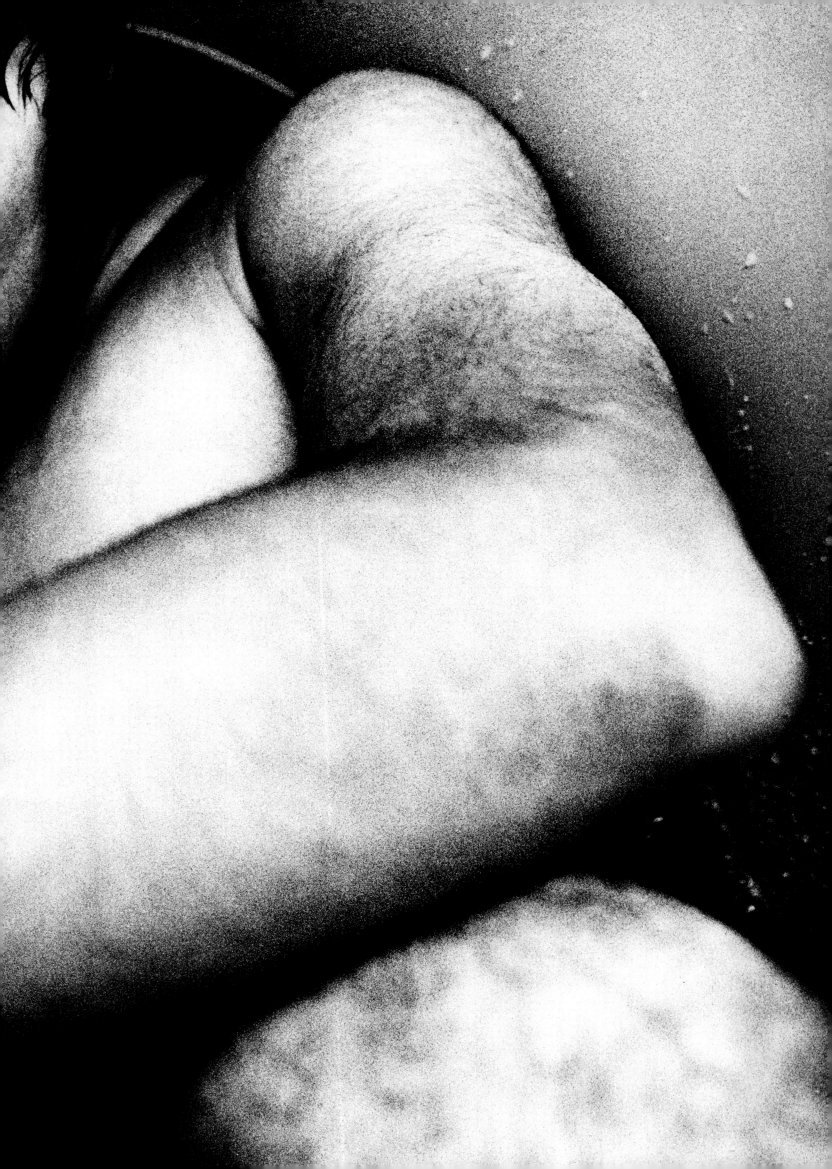

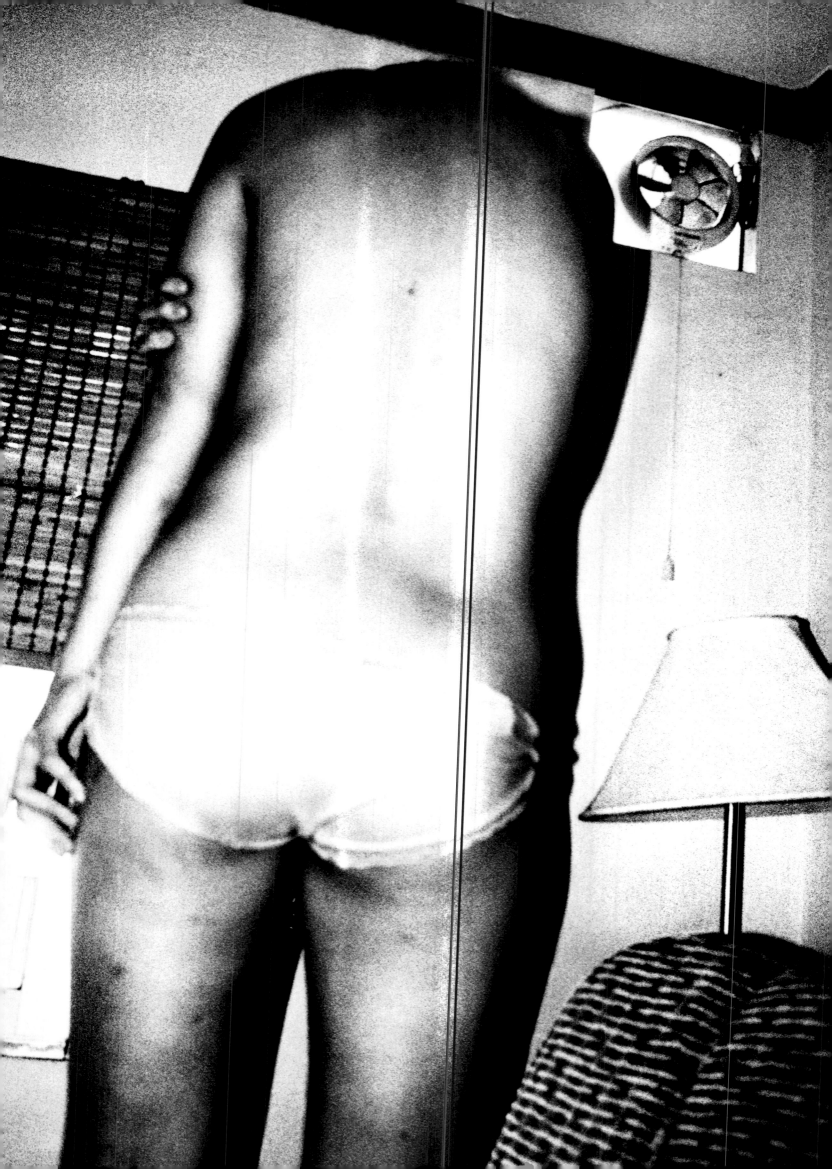

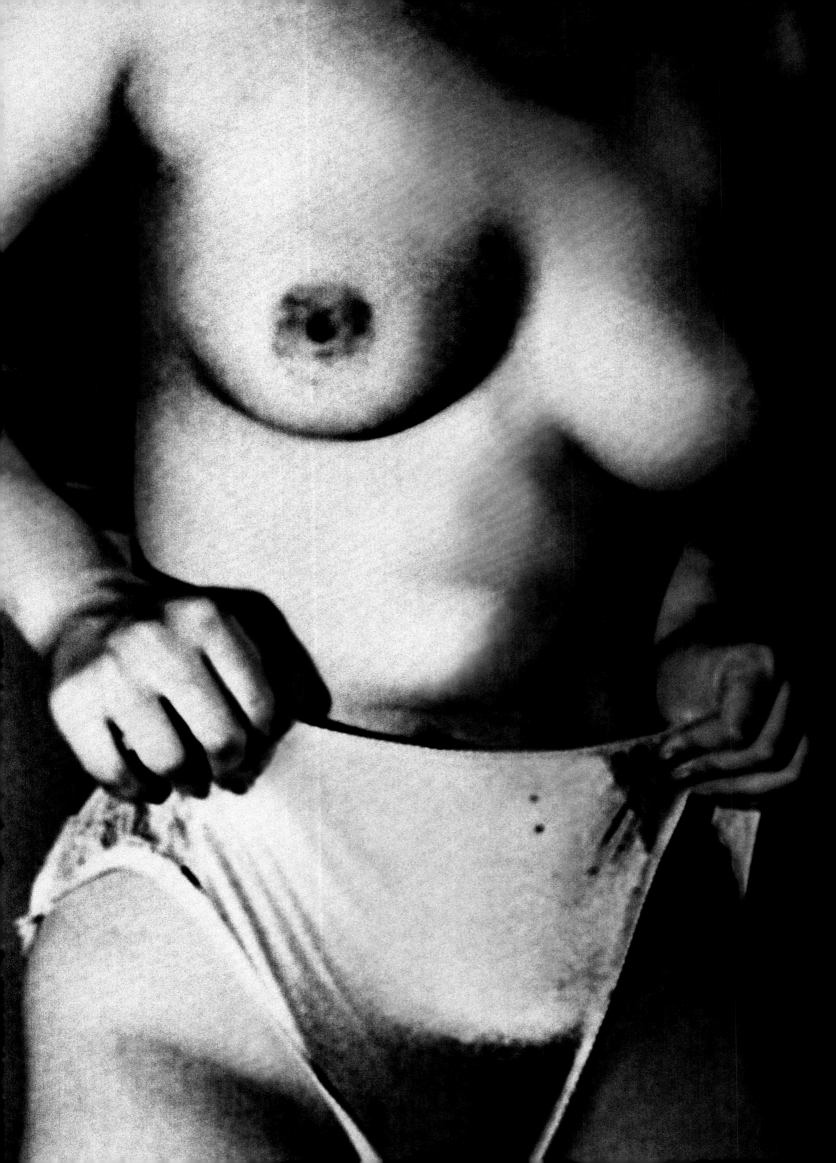

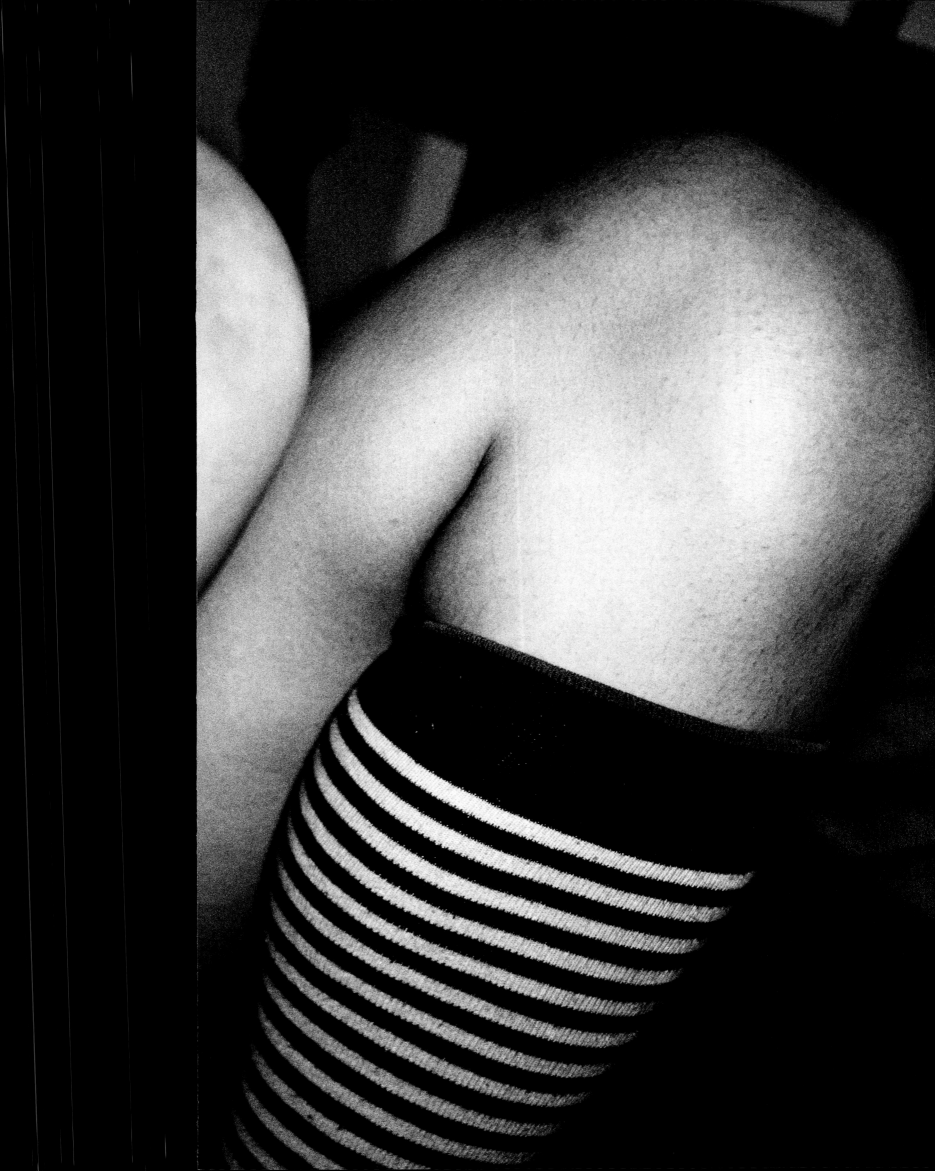

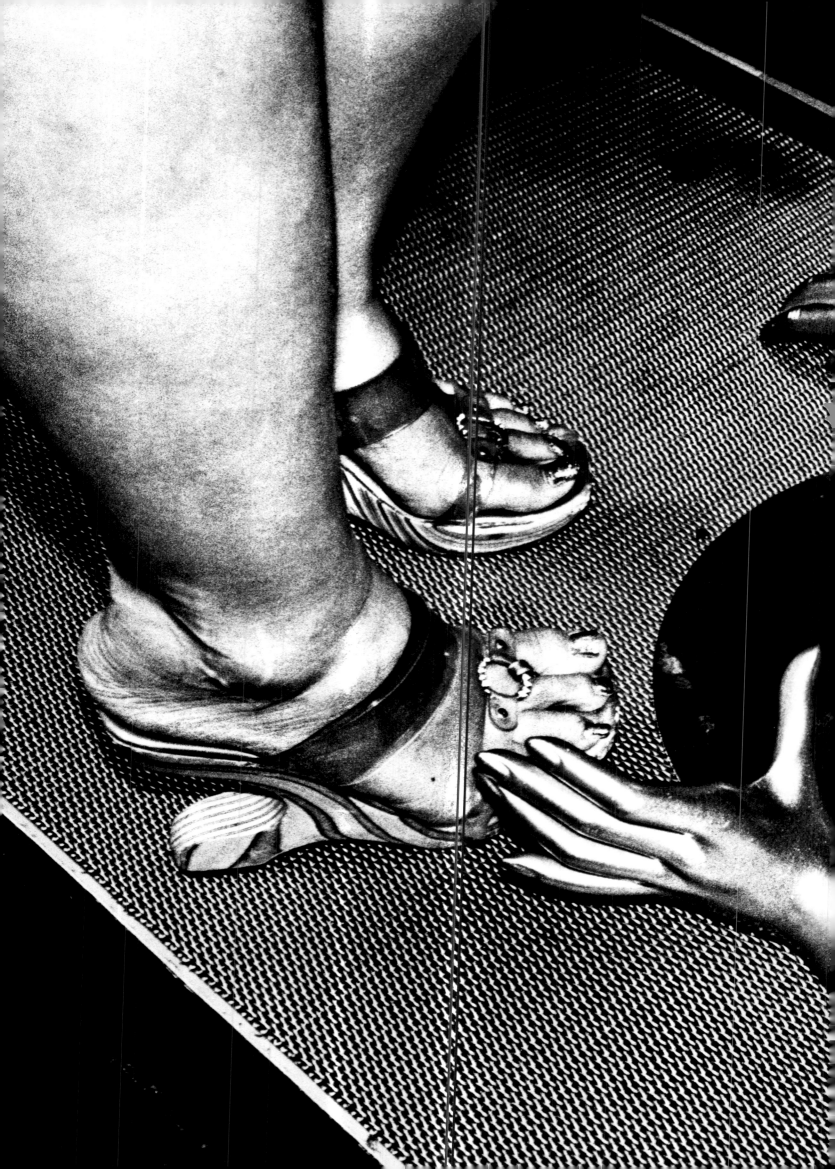

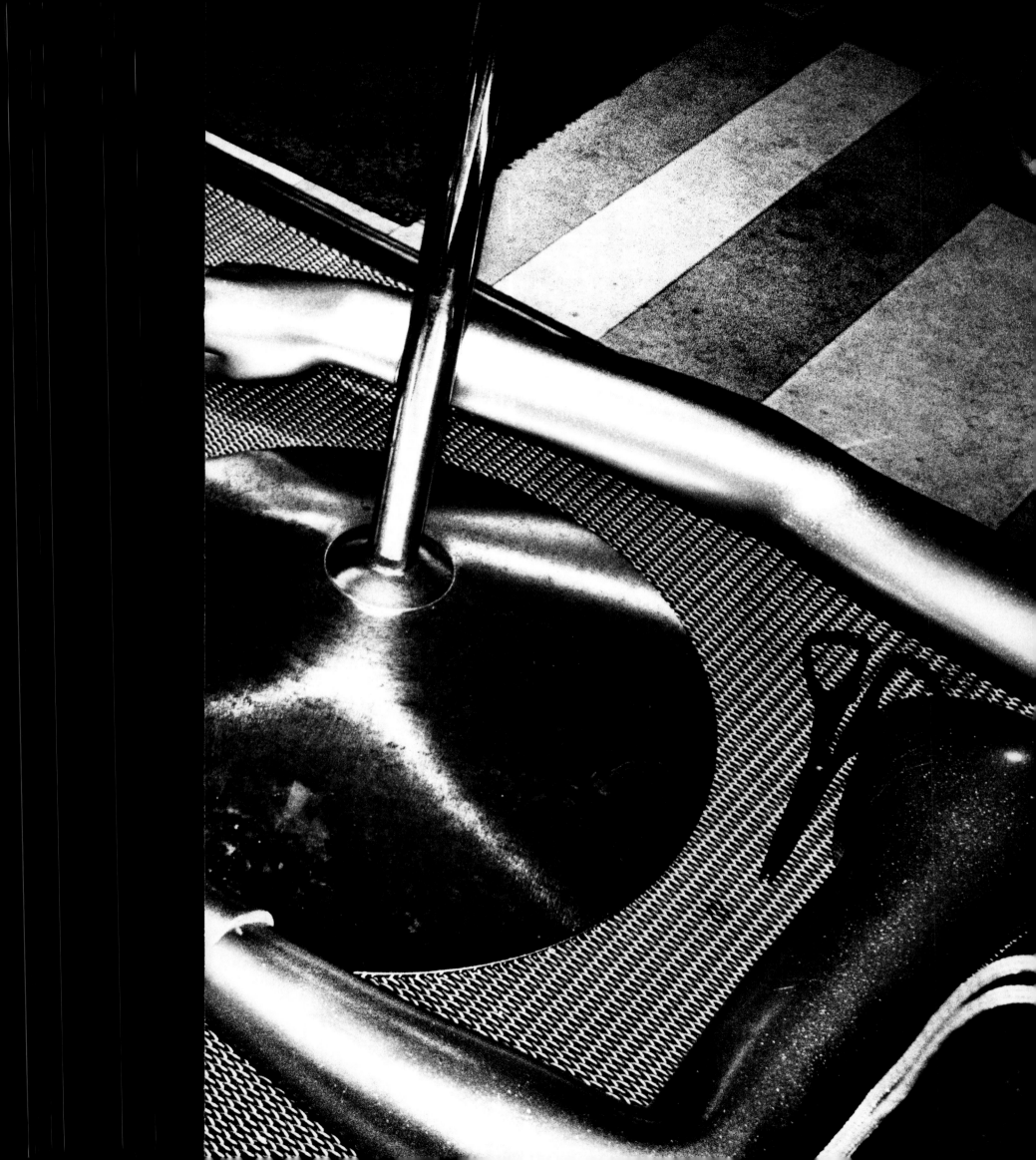

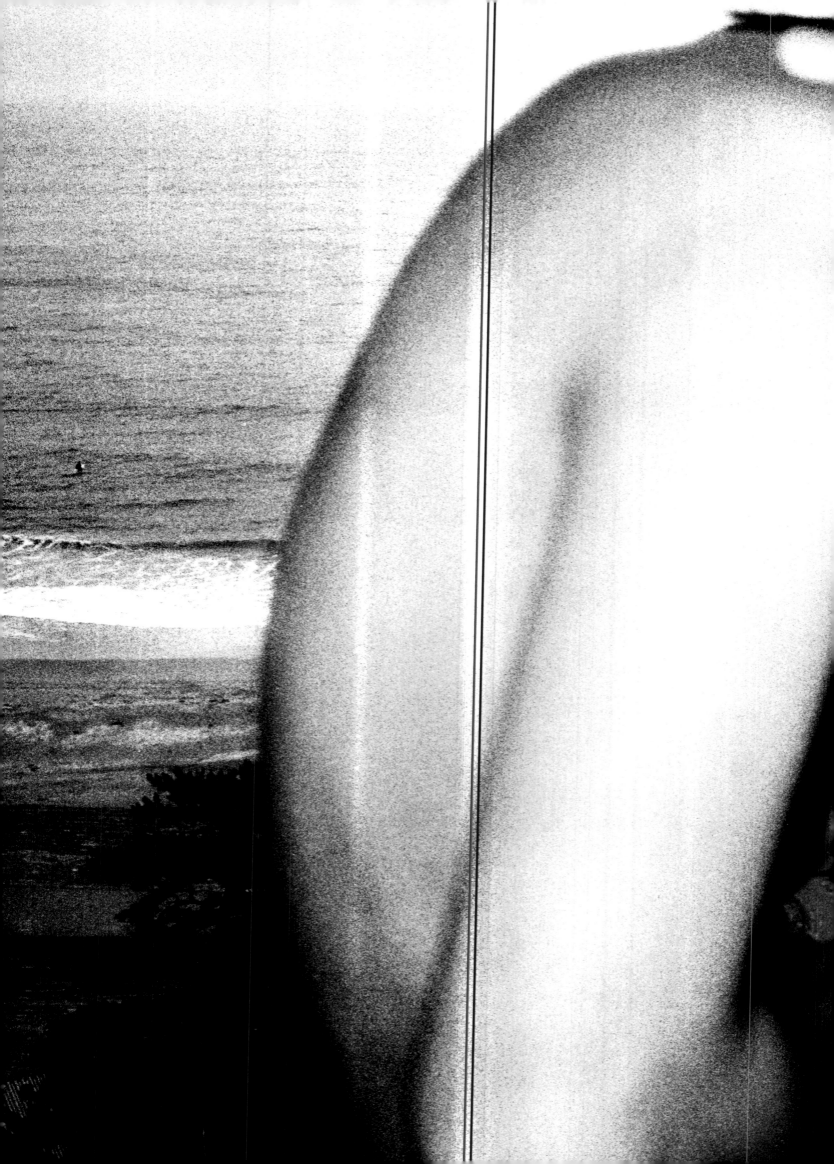

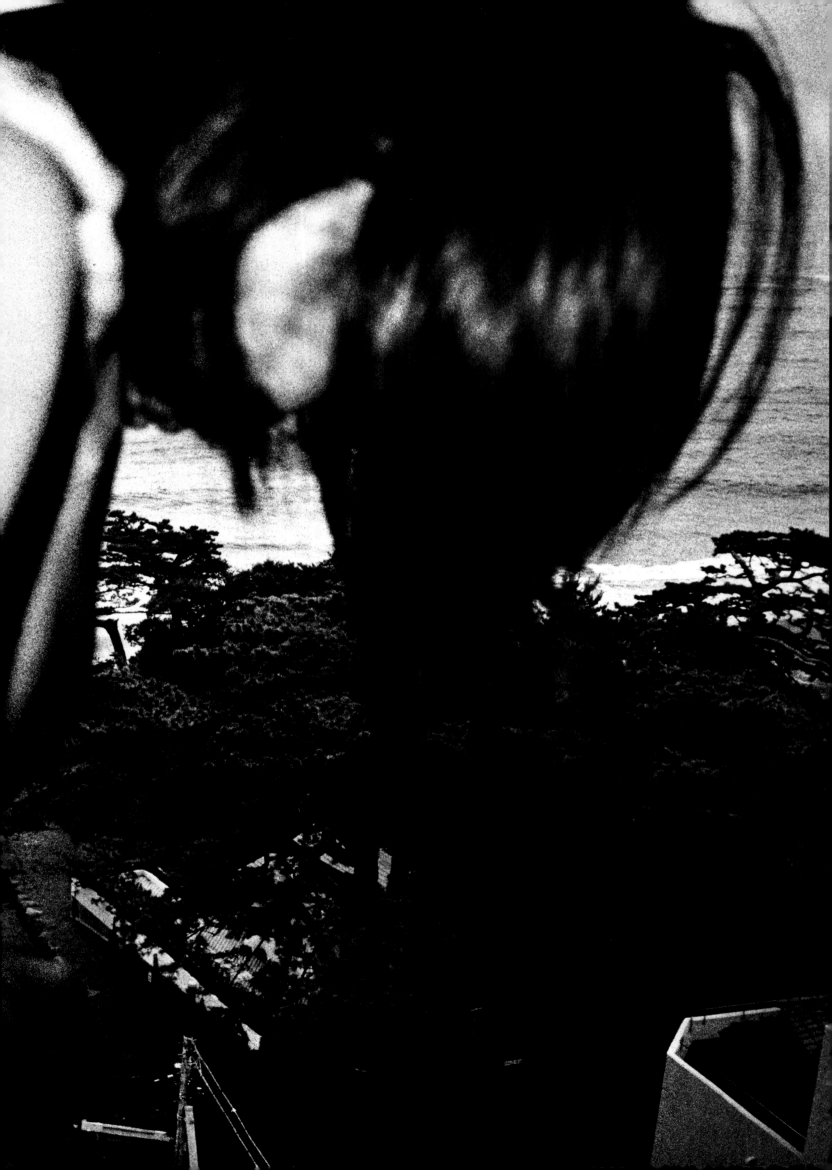

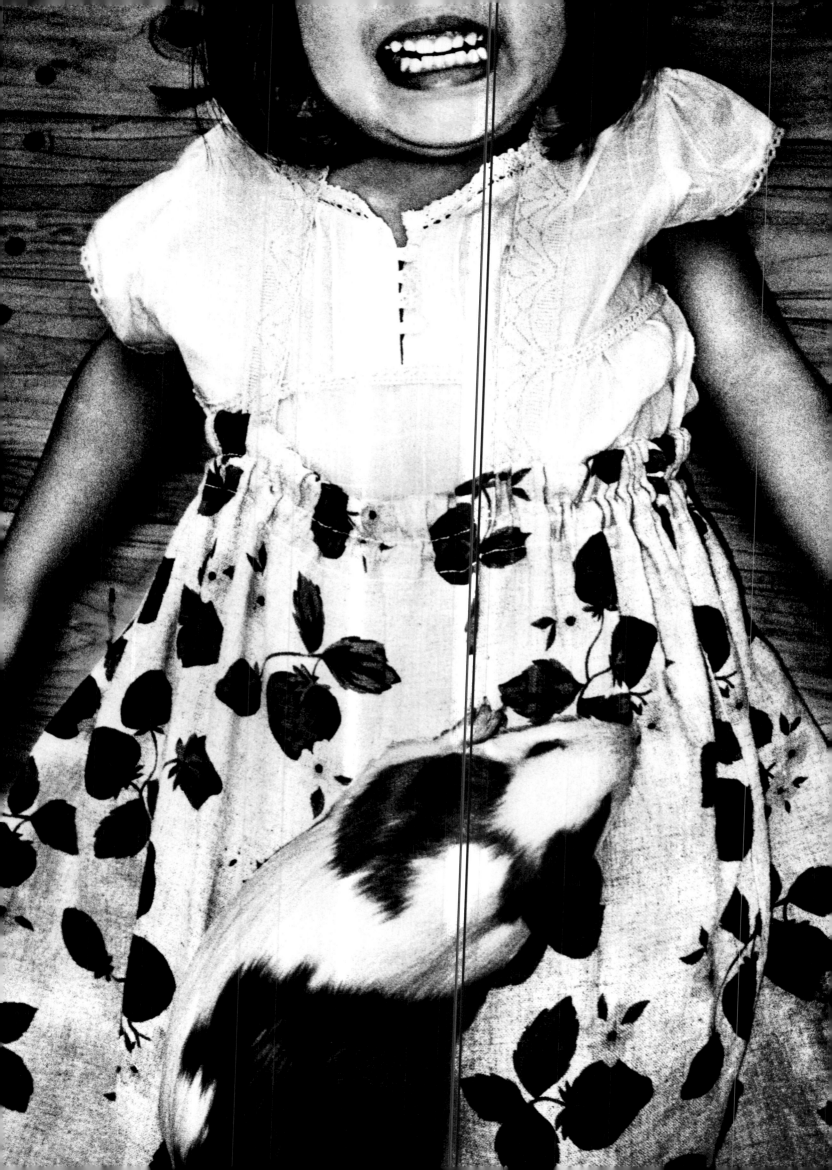

There are many people whose help and support have created this book, but most of all I would like to thank my girlfriend Sara and my family – my strongest critics are those I feel closest to. Thank you Sara, not only for your love and your trust, but also for your support of my work. To my mother Ulla Aue and to Torben Stroyer for all your efforts and advice. To my brothers Thomas Aue Sobol and Frank Sebastian Hansen for continually helping me to make decisions about the work.

I would like to offer my very grateful thanks to my friend Per Folkver, who contributed his great talent by editing this book with me on a tiny island in Denmark.

To all the people I met in Tokyo, who shared their time with me and let me photograph them in the streets or in their homes – thank you for your trust. Especially Kumi and Kazu. And to Yuta-san for assisting me in Tokyo.

Sincere thanks to Dr. Andreas Kaufmann (Leica) and to the seven European publishers – Dewi Lewis Publishing, Actes Sud, Apeiron, Edition Braus, Lunwerg Editores, Mets & Schilt and Peliti Asociati – for their belief in this project.

Finally, I acknowledge the generous support of The Danish Arts Agency, Politikens Fund, Palle Fogtdal and the Johanne and Aage Louis Hansens Fund.

I came to Tokyo for the first time in the spring of 2006. My girlfriend Sara had got a job there, and so I decided to move with her to explore the city in which she had grown up. It was a society I had never experienced before, one of which I had little knowledge and to which I had no real sense of relationship.

Initially I felt invisible. Each day I would walk the streets without anyone making eye-contact with me. Everyone seemed to be heading somewhere – it was as if they had no need of communication. Most mornings I would take the Chuo-line from Nakano to Shinjuku, and even though the train would be packed with salary-men and school girls in uniform, I rarely heard a word being spoken.

Though Tokyo and its people seemed unreachable, I felt drawn to the tight and confined reality of the metropolis. My feeling of isolation and loneliness was overwhelming – it was something I had to find a way to change. And so I began taking my pocket camera out with me on the streets and in the parks. Rather than focusing on the impressively tall buildings and the eternal swarm of people, I began searching for the narrow paths and the individual human presence in a city that felt both attractive and repulsive at the same time. I wanted to meet the people, to get involved in the city, to make Tokyo mine.

The pictures in this book are a recording of what I saw and the people I met during the following eighteen months.

In my attempt to understand Tokyo and its people, I found myself returning to the same streets and parks again and again. There were certain areas in Shinjuku and Yoyogi-park that always captured my interest, and inevitably they became the places that I felt closest to. I think that it was meeting the people there, on a one to one basis, that helped to give me a better impression of what it means to be a part of Tokyo today.

Some of those I photographed became my friends, others I shared only a short moment with. The pictures are something that grew from these meetings – pictures I took out of curiosity, and to help me remember how I felt that day, my experience of the city. When I photographed I tried to work by instinct as much as possible so as to connect and involve myself with the places I visited and the people I met. Taking snapshots supports the feeling of something unpredictable and playful. I believe it is when pictures are unconsidered and irrational that they come to life; that they evolve from *showing* to *being*.

Jacob Aue Sobol
Nogata, Nakano-Ku, Tokyo

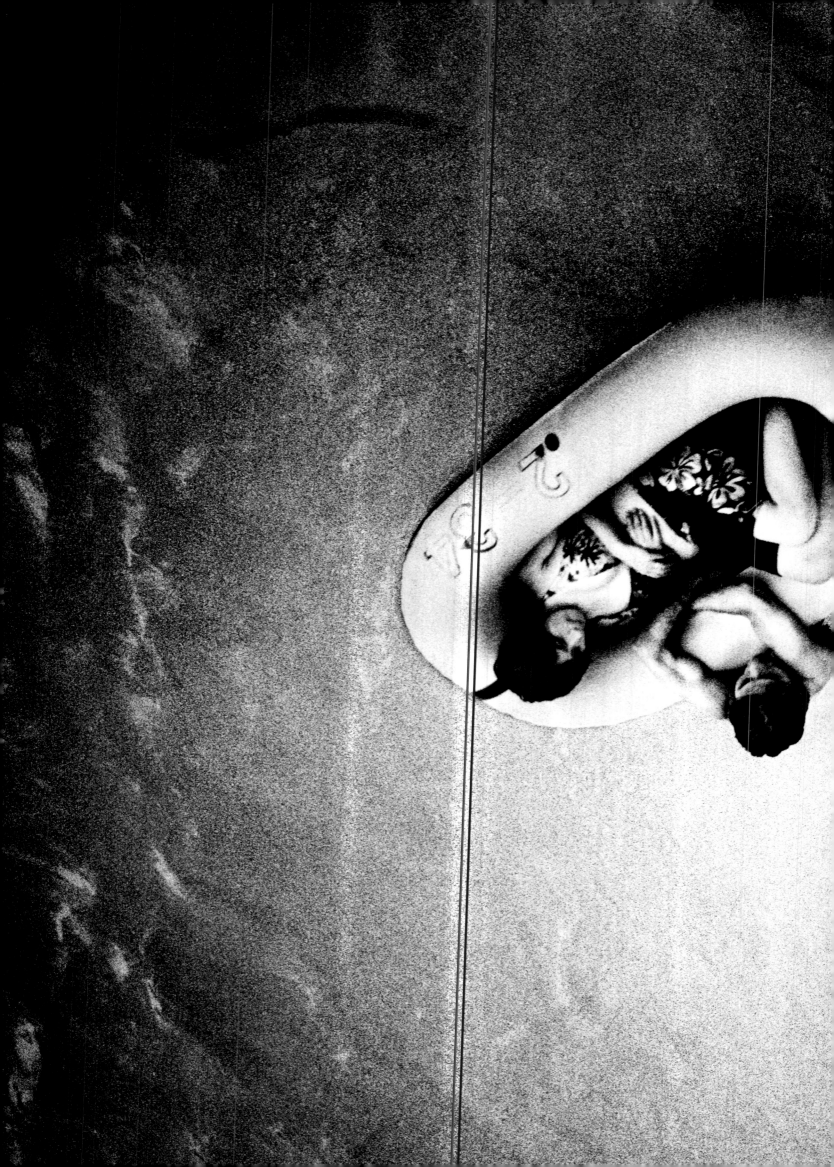

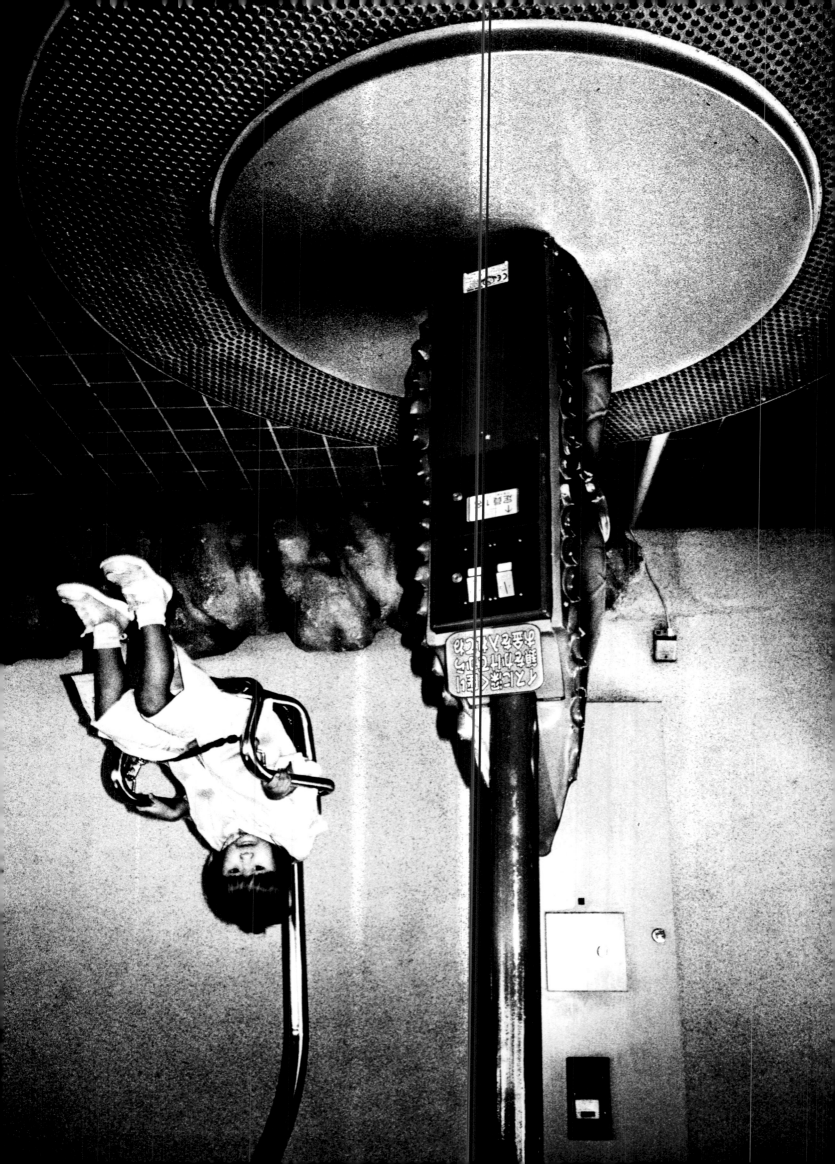

Jacob Aue Sobol was born in Copenhagen, Denmark, in 1976. He lived in Canada from 1994-95 and Greenland from 2000-2002. In Spring 2006 he moved to Tokyo, living there 18 months before returning to Denmark in August 2008. After studying at the European Film College, Jacob was admitted to Fatamorgana, the Danish School of Documentary and Art Photography in 1998. There he developed a unique, expressive style of black-and-white photography, which he has since refined and further developed.

In the autumn of 1999 he went to live in the settlement Tiniteqilaaq on the East Coast of Greenland. Over the next three years he lived mainly in this township with his Greenlandic girlfriend Sabine and her family, living the life of a fisherman and hunter but also photographing. The resultant book *Sabine* was published in 2004 and the work was nominated for the 2005 Deutsche Börse Photography Prize.

In the summer of 2005 Jacob travelled with a film crew to Guatemala to make a documentary about a young Mayan girl's first journey to the ocean. The following year he returned by himself to the mountains of Guatemala where he met the indigenous family Gomez-Brito. He stayed with them for a month to tell the story of their everyday life. The series won the First Prize Award, Daily Life Stories, World Press Photo 2006.

In 2007 Jacob became a nominee at Magnum Photos. He is represented by the Yossi Milo Gallery in New York.

www.auesobol.dk